D0131650

A Guide to
Staying Ahead of the
Workflow Curve

Digital
Photography
Best Practices
and Workflow
Handbook

Digital Photography Best Practices and Workflow Handbook

A Guide to Staying Ahead of the Workflow Curve

Patricia Russotti

Richard Anderson

AMSTERDAM • BOSTON • HEIDELBERG LONDON
NEW YORK • OXFORD • PARIS • SAN DIEGO
SAN FRANCISCO • SINGAPORE • SYDNEY • TOKYO

Focal Press is an imprint of Elsevier

ELSEVIER

Focal Press

Focal Press is an imprint of Elsevier
30 Corporate Drive, Suite 400, Burlington, MA 01803, USA
Linacre House, Jordan Hill, Oxford OX2 8DP, UK

© **2010 Patricia Russotti and Richard Anderson. Published by ELSEVIER Inc. All rights reserved.**

No part of this publication may be reproduced or transmitted in any form or by any means, electronic or mechanical, including photocopying, recording, or any information storage and retrieval system, without permission in writing from the publisher. Details on how to seek permission, further information about the Publisher's permissions policies and our arrangements with organizations such as the Copyright Clearance Center and the Copyright Licensing Agency, can be found at our website: www.elsevier.com/permissions.

This book and the individual contributions contained in it are protected under copyright by the Publisher (other than as may be noted herein).

Notices

Knowledge and best practice in this field are constantly changing. As new research and experience broaden our understanding, changes in research methods, professional practices, or medical treatment may become necessary.
Practitioners and researchers must always rely on their own experience and knowledge in evaluating and using any information, methods, compounds, or experiments described herein. In using such information or methods they should be mindful of their own safety and the safety of others, including parties for whom they have a professional responsibility.
To the fullest extent of the law, neither the Publisher nor the authors, contributors, or editors, assume any liability for any injury and/or damage to persons or property as a matter of products liability, negligence or otherwise, or from any use or operation of any methods, products, instructions, or ideas contained in the material herein.

Library of Congress Cataloging-in-Publication Data
Russotti, Patti.
Digital photography best practices and workflow handbook : a guide to staying ahead of the workflow curve / Patricia Russotti, Richard Anderson.
 p. cm.
Includes index.
ISBN 978-0-240-81095-9
1. Photography–Digital techniques. 2. Project management. 3. Workflow. I. Anderson, Richard, 1949- II. Title.
TR267.R87 2010
775–dc22

2009030652

British Library Cataloguing-in-Publication Data
A catalogue record for this book is available from the British Library.

ISBN: 978-0-240-81095-9

For information on all Focal Press publications visit our website at www.elsevierdirect.com

09 10 11 12 13 5 4 3 2 1

Printed in Canada

Working together to grow
libraries in developing countries

www.elsevier.com | www.bookaid.org | www.sabre.org

ELSEVIER BOOK AID International Sabre Foundation

Contents

By Therese Mulligan
Administrative Chair,
Photographic Arts
Director, SPAS Gallery
School of Photographic Arts and Sciences (SPAS)
Rochester Institute of Technology

CONTENTS

Please visit dpBestflow.org for updated information, the latest advances in workflow, and QuickTime movie tutorials

Acknowledgements

FROM PATRICIA RUSSOTTI:

This project first began three years ago during a discussion at an SPE conference in Miami with Diane Heppner, then Acquisitions Editor for Focal Press. I would like to extend my thanks to Diane for being supportive of this project from the very beginning.

Since that time, it has been my great pleasure to work with Cara Anderson, Senior Acquisitions Editor and Danielle Monroe, Associate Acquisitions Editor at Focal. Two of the most patient, encouraging professionals – what a great team! One could not ask for a better group to work with. I also know there are many behind the scenes people that make these productions possible – many thanks to all of you.

I want to acknowledge the people who introduced me to imaging at large and gave me strategies to view complex systems, break them down, make them understandable, and still be able to maintain currency. I need to start with Dr. Gerald LaMarsh, a Professor at Monroe Community College who led me to his former teachers, Dr. Warren Stevens and Dr. Denny Pett, both Professors at Indiana University. They taught me that a life in academia is about staying open-minded and looking for new ways to understand what you think you already know. During that time I was also fortunate to study with Henry Holmes Smith, a gifted artist and educator, who always offered an alternative way of looking at and seeing things. These wonderful teachers provided my foundation for a career in imaging and education. And of course, I am always grateful for the opportunities that have been provided to me and for the students I have taught during my career at the Rochester Institute of Technology.

I would like to thank my co-author Richard Anderson for his determination to spread "the word" and for sharing his knowledge. There are always many people to acknowledge when a project is completed. Richard mentions many of them in his acknowledgments and I add my thanks to each of them as well.

A very special thanks to Dr. Therese Mulligan, Administrative Chair, Photographic Arts School of Photographic Arts and Sciences at RIT for her ongoing support and for writing the introduction to this book.

Many thanks to the following industry luminaries for providing inspiration, tools, and endless information: Bruce Fraser, Jeff Schewe, John Paul Caponigro, and Julieanne Kost.

Greg Barnett, my buddy, partner, digi guru, and the voice of reason, this book would not have been completed without your endless support, humor, and help. I thank you from the bottom of my heart.

I am also blessed with a circle of friends who are always there to listen, diffuse, and support – you know who you are, I love you each for giving such gifts.

My father, Louis James Russotti, gave me the gift of looking at the world and the interest to render it from my heart.

And Blaise Raphael Russotti, my son, who has been so patient and teaches me something new every single day – this is for you.

Blaise Raphael Russotti

FROM RICHARD ANDERSON:

The U.S. Library of Congress has provided funding and support for much of the research that went into this book, the supporting website dpBestflow.org, and the seminars that follow through the National Digital Information Infrastructure Preservation Program (NDIIPP). This important program aims to preserve digital content, which is fast becoming the primary source data for our entire culture. Our part in it is to help image creators to think about their work in terms of preserving it for future generations, which is no easy task.

I'd like to thank Martha Anderson, Caroline Arms, Phil Michel, and Carl Fleischhauer for their vision and support throughout this project.

The American Society of Media Photographers (ASMP) provided the structure for the larger project making this book possible. ASMP has provided unstinting support to me through the creation and support of UPDIG and now dpBestflow. I would like to particularly thank Susan Carr, Eugene Mopsik, Peter Dyson, Vic Perlman, Chris Chandler, and Elena Goertz for standing behind me through thick and thin. The ASMP Board of Directors has always supported my vision for this project and I humbly thank them.

This book would not have been possible without the efforts of my co-author, Patricia Russotti, a long time professor at Rochester Institute of Technology. Patti knows workflow, and more importantly, she knows how to teach it. Patti also introduced me to other members of the RIT community who contributed important elements such as the glossary (Greg Barnett) and camera testing (Mike Dear and Natalie Russo).

I can't imagine a better publisher than Focal Press, especially the team of Cara Anderson and Danielle Monroe. Their constant encouragement and guidance made this book possible. I'd like to also thank Harold Naideau and Jay Pastelak for their early reviews of the manuscript, which gave us valuable insight and helped us improve the book.

I have benefited from the advice and counsel of many members of the digital intelligentsia. Judy Herrmann and Mike Starck stand out as early adopters who opened my eyes to the possibilities of digital photography. Peter Krogh has patiently explained much of what happens "under the hood" and I am proud to be associated with him as part of the project team. Michael Stewart was the man behind the curtain during the UPDIG days and I always seek his advice on the really difficult questions. For color management understanding, I

always seek out Kevin DePalmer of GammaGraphix; he knows it like the back of his hand.

Our project has had important industry support, notably from: Adobe (Kevin Conner, John Nack, Eric Chan, Jeff Tranberry, and Peter Constable), Microsoft (Josh Weisburg), Bibble (Eric Hyman), Camera Bits (Dennis Walker and Kirk Baker), and Canon (Chuck Westfall).

Certain Web sites have proven invaluable for insight and understanding. They are too numerous to mention but the standouts are Luminous-Landscape.com, Robgalbraith.com, John Nack's blog, Cambridgeincolor. com, and dpreview.com

Very little of this book or this project would have been possible without the participation of my associate Dan Stack. Dan is responsible for many of the photos and illustrations contained in the book and he did most of the software and hardware wrangling in our quest to understand how things really work.

I'd like to dedicate this book to the memory of Bruce Fraser. I learned more about digital imaging and workflow from his books than from any other single source.

And finally, I'd like to thank my Valerie, my wife, and Nicholas, our son, for their support and understanding as I put in many extra hours beyond a normal commitment to work for the past few years. I still look forward to evening breaks in my work to read books with Nicholas at bedtime. We're now working our way through the Harry Potter books.

© Patricia Russotti

Introduction

"The only way to make sense out of change is to plunge into it, move with it, and join the dance."

—Alan Watts

"The illiterate of the future will be ignorant of the camera and pen alike."

—László Moholy-Nagy, "From Pigment to Light," 1936

Publications such as the present volume on digital image workflow are outward recognition of the transformation underscoring our ever-embracing digital world. Once used to describe the rational organization of labor and processes of industrial manufacturing, in the 1980s the term *workflow* took on a contemporary definition related to emergent digital technologies, in particular software processing. It addressed interactions between humans and machines via the objects, networks, data, and images digital technologies produce. For image-makers, particularly those involved with the photographic image, "workflow" constitutes a new technical ordering of the visual image—an ordering tied to the world-view transformation of visual culture.

As this book suggests, the burgeoning practice of digital imaging prompts a reorientation of visual literacy based on the intertwining engagement of the digital and the photographic. The digital mediates the photographic by absorbing, challenging, and reshaping its appearance, use, distribution, and meaning in visual culture. This mediation is not new. It is the expected result when new technologies impact older, existing ones. More than 160 years ago, photography itself proved a mediating agent on painting, and, in its turn, photography was mediated by film. Today, digital imaging technologies are compellingly persuasive and pervasive, subsuming both the still and moving image (film and television) in innovative mediating spaces, including software programs, the World Wide Web, and virtual reality, and affecting societal sites from the domestic and civic arenas to leisure and entertainment. From this perspective, then, the pedagogical objective of visual literacy in the digital realm is newly constructed by mining photography's mediating past, while simultaneously addressing its own mediation by the digital, negotiated in older (print) and newer (virtual) forms of display and user/viewer interaction.

To examine the dynamic interplay of new and older image technologies within social sites, one needs to look no further than the social utility, Facebook. With more than 200 million users worldwide, Facebook casts a wide local and global net over personal and public information, transforming the domestic sphere

of familial customs and the civic areas of government, school, the workplace, and the marketplace. For example, family snapshots once fixed on the supportive matrix of paper and album page are now carried on digital media, enabling outspread access and dissemination via computer or mobile upload to a Facebook user's homepage, social networks, or as a "tagged" hyperlink to depicted user "friends." With the ability to transfer an unlimited amount of image files, users have popularized Facebook's "Photos" application, with its album, face recognition, and tagging features, as the new depository of personal and family memories. Thus both the use and materiality of the domestic family picture have changed, although its photographic underpinning and appearance are largely unaffected. Consequently, the domestic image, along with its associated personal informational data, once relegated to the hermetic world of shoeboxes and album pages, is now on virtual public display, subject to the acquisition, management, and control of other users, as well as the marketplace. In the evolving realm of digital technologies, and as Facebook illustrates, the personal elides with the public, and the digital image, with its invisible trace of metadata, prompts a new awareness of personal responsibility toward the treatment of the digital image.

Like the printing press and the handheld snapshot camera, today's digital technologies comprise a further democratization of the image due to immediacy and global exchange at an economical cost, with immeasurable creative, interactive options. But with greater democratization and greater proliferation of the digital image comes a heightened responsibility for its care and preservation by maker and user alike. In contrast to its analog predecessor of film and paper, the digital image brings a wholly new administrative and technical workflow or constitution of capture, management,

reproduction, and dissemination. Central to all of these component parts is a digital file's metadata, which provides the traceable link between original image capture, processing, use, and subsequent migration and archival preservation. Long present in all image technologies, including analog photography, metadata in the digital realm offers innovative advantages with its ability to embed information and/or link information to single or collective image files. An experienced understanding of metadata, along with digital workflow, is of critical consequence to all makers and users of digital imagery, no matter their creative pursuits. Simply put, it establishes a skilled, learned pattern for the care and management of images, providing accessibility and, in turn, preserving much of their meaningful connections to contemporary visual culture and its evolving history.

While this publication takes up pedagogical strategies of instruction and knowledge pertaining to the digital image, it also emphasizes the contributions of the image-maker in shaping and defining aesthetic, informational, and cultural visual display. Technical processes, here defined as explainable steps and repeatable workflow, belie the explicit craft involved in digital imaging with the possibilities of creative expression. For the image-maker, this is the larger charge when learning and working with new image technologies as it was with older technologies, such as photography. Craftsmanship—the acquisition of skills by training, as this book proposes—posits personal responsibility for the digital image as grounded in experience and expertise. This approach is of utmost importance as student and professional image-makers navigate a digital landscape replete with the "new"—hybrid methods that intertwine the still and moving image in a hypermedia of connectivity and display. The call for visual literacy and

technical acknowledgment of the "new" is very much a vital component for understanding the "now" of our post-photographic era. As the still image continues to sustain its material presence on paper support, and virtual or immaterial creative expression gains in currency, craft must combine with renewed understanding and vision to celebrate, challenge, and refashion convergent aesthetic and cultural uses of the digital image. In this way, practitioners, along with users/viewers, will advance creative invention and the future prospects of our evolving image-oriented world.

Therese Mulligan Ph.D.
Administrative Chair, Photographic Arts
Director, SPAS Gallery
School of Photographic Arts and Sciences (SPAS)
Rochester Institute of Technology

Prior to her arrival at RIT in 2003, Therese Mulligan served as the curator of photography at George Eastman House, International Museum of Photography and Film, where she organized numerous exhibitions, as well as authored and edited articles and publications on historical and contemporary photography.

© Richard Anderson

Chapter 1

Digital Photography Best Practices and Workflow

"Everything flows and nothing stays."

—*HERACLITUS*

In the nostalgic days of analog photography, the amount of published information was minimal by today's standards. Many of the techniques used were recipes passed on from person to person, often producing barely legible copies from being duplicated so many times. How many books did you use if you were a student of analog photography? There were a handful of texts, serving as the "Photo Bibles" that were used over and over again. The books we learned the most from—for Patti, Ansel Adam's *The Camera, The Negative, The Print* and for Richard, David Vestal's *The Craft of Photography*, and for both of us, the Time-Life Books Photography Series—gave the information you needed to create your own vision. BUT these were the definitive photographic workflow for black and white and color analog photography. With the evolution of digital technology, there has been a concurrent explosion of publishing by large publishing groups as well as independents. In addition to the traditional book, there are now websites, downloadable podcasts, PDFs, DVDs, snippets of imaging TV spots, and so on.

Today, there is an industry that does nothing but publish books and materials about digital photography, Photoshop, Lightroom, Aperture, conversion to black and white, how to be the best digital fine art printer, shooting digital at night, underwater, recipe books, and downloads for every imaginable technique. Until now, there has not been a single unified resource that puts each of the seemingly disparate processes together. Our goal in this book is to create a harmonious map and guide between the disciplines that all

ultimately need to work together. In other words, we seek to unite and define all the things you need to do within a workflow.

During the last few years, the term *workflow* has migrated from a primarily print and publishing graphic arts industry meaning to an imaging-at-large term. As a result, the need has arisen for photographers, artists, trainers, and educators to integrate this concept and material into their vocabulary and curriculums. The problem this entails lies in the many definitions or views of workflow that exist depending on one's background and discipline. Consequently, these professionals are turning to a variety of online resources in hopes of finding the appropriate and accurate resources (not a simple or easy task), or to workshops and books.

So much information, so many options, always the feeling that you are missing some key elements as you work through a project—the sheer amount of information available often overwhelms people as they try to decide where to begin. We so often hear "just tell me what to do … I want to know it will work." This text provides the necessary components that will help build a cohesive workflow. This accumulated knowledge has become what we call best practices. Imaging professionals and educators will quickly find that we are about providing solutions.

The trick to writing (just like the trick to teaching) about a topic like best practices and workflow is to put things in a format that will offer a useful perspective and method but still leave room for people to find a personal adaptation. It's about methodology, consistency, and planning ahead. Everything will change and keep changing … and our hope is that people will not become stuck during the evolution of software and hardware. Consider how we still cannot get out from underneath DPI vs. PPI or only print at 300 PPI; more

resolution is always better than not enough, or any of the other "sacred truths" (often inaccurate) that have long since been disproven or have become obsolete.

This text is a coherent and concise guide that includes:

- A glossary to help define the elements of the best practices knowledge base
- The key aspects of digital photography workflow
- A list of resources and links to help you stay current and up to speed with the rapid changes in technology

WHO

This book is not a set of recipes that will make your images fancier. It is a field guide for photographers, image-makers, and anyone who will be touching an image file during its many stages. It is a handbook for knowing who should be doing what, with an eagle's view of workflow as well as all the iterations that a file will take on during its life span. This book is for anyone wanting to know the choices for developing a workflow to create consistent and reliable results in their work. Each of the disciplines represented in imaging is in need of the same information sets.

THE ACCUMULATION EFFECT

We read and follow books, trade journals, blogs, list serves, websites, and tweets, we attend workshops, and we talk with salespeople, students, teachers, and other professionals in imaging. How do you distinguish what is accurate information from what is just one person's preferred method or reflection on what he or she has learned? Upgrades and technological evolutions occur at break-neck speed. What we know becomes what we knew and is no longer valid or has been streamlined

and updated. It is often difficult to find the real knowledge of what works, or to understand which method will give you a consistent and appropriate result. When is it time to change methodologies to match the ever-accumulating updates in software and hardware?

Many of us have a solid analog background. But the current technology only requires this knowledge in limited places in a digital photographic workflow. Our digital careers are about living through the technological shifts and synthesizing what works and will continue to work as the technology evolves.

Planning, organization, consistency, pragmatic approaches, problem solving, critical thinking, and currency with technology are all part of living and working in the digital age. Yet the craft and aesthetic of imaging must not be forgotten and must be at the forefront as well as throughout the entire process. Most importantly, we need to accept the notion that a truly effective and efficient workflow is usually not a solo or solitary activity. Many of today's requisite skill sets may require a consultation with an expert in that particular step to ensure accuracy. Collaboration is not just a buzzword; it is a necessary part of our workflow.

Mastery is ongoing. Once you think you have a technique nailed down, another upgrade comes along, and a whole new approach to processing an image (PIEware, for example) becomes necessary. We must understand, apply, and maintain metadata, keywords, DAM, profiles, and color (how did purple, orange, and aqua come to live in an RGB and CMYK color correction world?). So, you wonder: will there be a time when I can just go and do my work and not have to learn something new? Probably not. . . . Yet—once we accept/embrace the reality of the discipline(s) and develop the habit of consistency in our workflow—we will find that the magic and the joy of making images will return.

It is sometimes difficult to get direct answers to specific questions; everyone has a position and wants to share that position with you. Who really knows the best path with the most accurate information? Many tools are currently incomplete or in the process of ongoing development. How do you work smart now? Accepting things verbatim may not always be the best way to go. You should use information to make enlightened decisions. There is a growing community of imaging experts, and dpBestflow is a culmination of the work of many of those experts.

To summarize, working with technology requires us all to:

- **Embrace the concept of integrated information and critical thinking to make good decisions.**

- **Have an open and informed mind. Learn to examine others' ideas with that open mind and allow yourself to adjust your position and known facts.**

- **Accept that things evolve and change.**

- **Be aware that "knowing" the solution before understanding the new process may hinder an otherwise appropriate action.**

- **Know that technology often becomes like religion and politics: be a good consumer and employ bipartisan tactics.**

- **Recognize that all software applications and workflows have issues—being wedded to one mind-set can hinder a better understanding of the process and a more efficient approach.**

- **Understand that flexibility is paramount—but consistency and discipline are essential.**

THE DPBESTFLOW AND UPDIG CONNECTION

Universal Photographic Digital Imaging Guidelines (UPDIG) aimed to fill the information vacuum that resulted from an entire industry's migration from analog (film) to digital photography. Film era standards and workflow were increasingly outmoded. Terminology, methods, and job descriptions needed to be redefined, invented, explained, and taught industrywide. In 2005, the UPDIG.org website was launched to address what photographers needed to know to ensure that:

1. Color is preserved as images are transferred from device to device and from the photographer's desktop to final output—whatever that might be.

2. Image files are delivered in the appropriate resolution and sharpness for intended use.

3. Images contain appropriate metadata (information contained within the file) to properly identify the creator, the copyright owner, the licensing information, and any other information that adds value to the images and makes them easily found.

4. Images are protected from accidental erasure or corruption and archived in a way that would make them available to future generations.

Bestflow is the practical application of the UPDIG principles as best practices and workflow. Workflow is the sequence of step-by-step procedures necessary to achieve consistent, repeatable results. Digital Photography Workflow can be described as a way of orchestrating the events that begin with planning and capture. Careful planning based on project goals and parameters is a necessary first step to proceed through the various options within a digital photography workflow:

- Planning
- Capture
- Ingestion
- Editing
- Optimization
- Proof
- Output/delivery
- Archiving

The UPDIG principles and mission are demonstrated by Bestflow when applied throughout the workflow.

Although there is an overwhelming amount of information about digital cameras, computer hardware, and software, and there are numerous courses, workshops, books, and websites that discuss various kinds of workflow, generally these resources discuss each piece of hardware and software in isolation. The present work is a collaborative compilation of what you need to know to make educated decisions about both software and hardware.

Bestflow's goals are …

- **To show how each piece of hardware and software might fit into the bigger digital workflow picture**

- **To help our audience understand how to choose hardware, software, and a work order that is optimal for their photography goals, as well as:**

- **To make informed decisions about choosing the correct workflow for your needs.**

- **To provide a framework for keeping up with the evolving digital photographic workflow.**

- **To outline realistic strategies to preserve digital image files (and the work that you do to them) for the short and, especially, the long term, for they are an important part of our history and culture.**

© Patricia Russotti

Chapter 2

Terminology and the Importance of Language

"The essence of any mistake consists in not knowing."

—*BLAISE PASCAL*
Entretien avec M. deSacci sur Epictete et
Montaigne, 1655

As you look through this book, you will notice that we have placed sections in a different order than one would usually find them in other books. We are placing the glossary up front where you will hopefully see it, peruse it and then revisit it frequently as you go through the various chapters. Why? We believe that having the correct understanding of a term will make all the difference in how you digest the information necessary for establishing your workflow. We have already referenced that there are many urban digital myths and sacred truths. We hope to bring light to these subjects and set the record straight. Language and communication are the tenets of an effective relationship. Photography used to be a fairly solo activity. Now, digital involves knowing photography but also having a foot (or much more) in the land of information technology (IT), color geeks, and other mystifying technical domains.

Understanding the language helps us achieve better, more specific answers when we ask more appropriate questions. This understanding helps us to avoid being railroaded by the "expert" we might meet at a trade show or on a shop floor. Using proper and specific terms to describe what we want from a service provider might mean that we get what we want the first time around. It just helps us do our jobs better and more efficiently. Of course, with knowledge comes responsibility. Knowing what are talking about also

means that we have to educate as we go about our business. It's inevitable that we will be sharing our knowledge; it's a good thing.

Here we are in 2009, and marketing materials for scanners still say DPI when touting their maximum resolution. The truth is, scanners only see SPI—samples per inch—when they are reading what they scan and then give us PPI, pixels per inch, the image that we view on the screen. We only get DPI, dots per inch, when ink or toner hits a substrate. Sigh. … See how much work we have to do?

DPBESTFLOW GLOSSARY

Terms for this glossary were chosen based on the present text. We wanted to be sure that if we used a term, you could find it here and hopefully help you understand our intentions

Absolute Colorimetric Rendering Intent One of the four rendering intents specified by the International Color Consortium (ICC) for handling out-of-gamut colors when converting from one color space to another. Absolute colorimetric preserves the white of the source (by adjusting the white of the destination) and then reproduces all in-gamut colors exactly. Out-of-gamut colors are *clipped* to the closest reproducible hue. Absolute colorimetric is designed primarily for proofing since it will simulate the output of one device (printer or press) to another by laying down the appropriate ink to reproduce the source (paper) white.

Acquire The process of transferring an image from the capture source (digital camera or scanner) to a computer. Acquire modules (sometimes in the form of a *plug-in*) are often supplied by equipment manufacturers to import images into an image editing program such as Photoshop.

Adobe Bridge A *browser application* produced by Adobe Systems as part of the Creative Suite. Its primary function is the file management hub of the Creative Suite. It can be used to open, manage, rate, and rename files as well as edit their *metadata*. Bridge can be used to open *raw* files using the Adobe Camera Raw plug-in and perform a wide range of workflow functions. It has a flexible user interface and is highly extensible using *JavaScript*.

Adobe RGB (red, green, blue) (1998) A *device-independent* color space (also commonly called a "working" space) developed by Adobe. It provides a relatively large gamut (that encompasses most CMYK print devices) that is gray balanced and perceptually uniform. It is widely used for image editing.

Algorithm In the context of digital imaging or photography, computer software code that performs a finite set of unambiguous instructions in a prescribed sequence. For example, raw file converters use algorithms to perform color filter array interpolations (*demosaicing*) or other complex mathematical computations.

Analog-to-Digital Converter (ADC) A device that converts continuous analog signals into discrete digital numbers. In the case of digital cameras, this signal would be the electrical charge (voltage) generated by photons striking sensor sites, which is then converted in digital data.

Anti-Aliasing Filter (AA Filter) An optical filter (also known as a low-pass filter) placed on the sensor to create a slight blur or softening that helps counteract aliasing or moiré interference. These patterns are created when the sensor cannot properly resolve high-frequency elements in the image. *Capture sharpening*

can be used to help restore the initial image sharpness lost by this process.

Archival Image An image that has been processed in such as way to prepare it for permanent storage and preservation. In the context of a digital image or photograph, this would typically be an original or a master file that has been saved using a documented *standard open file format* such as tagged image file format (TIFF) or digital negative (DNG) that preserves all of the original image data.

Archive A collection of images kept in secure, long-term storage. Archiving can take place at different stages of the workflow: original captures prior to processing and optimization, the *master files* that contain image optimization, and *working files* and their *derivatives* at the completion of job. Also see *Preservation*.

ASCII The acronym for American Standard Code for Information Interchange, which is a standard commonly used for encoding English characters with a corresponding number. ASCII codes are used by computers to display, store, and transfer text in a human-readable format. This formatting provides nearly universal access to the contents of the file and is widely used for text files that are intended for cross-platform use.

Automated In workflow terms, a word referring to operations that are automated to make them more efficient and consistent, and in less need of human intervention. Also commonly referred to as *batch processing*, these steps can take the form of scripts, actions, droplets, or dedicated applications.

Backup A system whereby copies of applications, image files, and other digital assets are preserved to ensure restoration of the data in the event of corruption, media, or system failure. Backups can be created at various stages in the workflow to ensure that image files are preserved. A number of different approaches and strategies can be employed in making backups, which include incremental, a mirror (or clone), or additive. In addition, a wide variety of both software and hardware solutions are available depending on the size and scope of your backup needs.

Banding See *Posterization*.

Bandwidth A term widely used to describe the speed and throughput of a device or communication network. The related term *broadband* refers to a high-speed Internet connection.

Batch Processing A process that automates repetitive tasks so that they can be to be done in an efficient and consistent manner. Rather than handle each file individually, when batched, a number of files are collected (or selected) together and sent for processing at the same time. Common examples of batch processes include renaming, *ingestion*, application of presets and metadata, or conversion to DNG.

Bayer Pattern Also known as a Bayer Filter, a mosaic color filter array (CFA) that is in wide use on most digital camera sensors. The pattern is comprised of individual RGB filters that align with the sensor elements (pixels) in a pattern of 50% green, 25% red, and 25% blue, with each pixel recording only one color value. A *demosaicing algorithm* is employed to *interpolate* the colors and create a photographic image.

Binary A numbering system employed by computers using only two digits, zero and one.

Bit Short for a binary digit using a value of either zero or one. It is the smallest unit of data used by computers.

Bit Depth Defines how many bits of tonal or color data are associated with each pixel or channel. For example, 2 bits per pixel only allows for black or white, and 8 bits provides 256 grayscale tones or colors. When referring to an 8-bit color image, 256 is multiplied (256 × 256 × 256) by the three primary (RGB) *channels* to create what is commonly called 24-bit color (with a possible 16,777,266 colors).

Bitmap A pixel-by-pixel representation of an image where each bit is mapped to a corresponding pixel or dot. Also commonly referred to as a *raster image* because the pixels are laid out in a rectangular grid or array.

Black Point In image editing, the tonal adjustment that sets the point at which the deepest shadow detail in the *histogram* is *clipped* to black.

Blu-ray Disc (BD) The next generation of optical storage media that uses a blue-violet laser, allowing for a higher density of data on a disc that is the same diameter as CD/DVD. Single-layer Blu-ray disks have capacity of 25 GB, and dual-layer can hold up to 50 GB. There are three formats: BD-ROM is read-only, BD-R is recordable or write once, read many (*worm*), and BD-RE is rewriteable. The RE format is not recommended for archiving digital image files because they can be accidentally overwritten or erased.

Bootable Clone Typically, either an external or additional internal hard drive that is an exact duplicate of a computer's main (system) drive. It allows the user to boot the computer from this drive instead of the main drive.

Born Digital Original images that were created by a digital camera or scanner (*scan-o-grams*) as opposed to images scanned from film or prints.

Brightness The overall intensity of an image, or the degree to which a color sample (or tone) appears to reflect light.

Browser Application Software applications such as Adobe Bridge or PhotoMechanic that allows the user to view, edit, and make various modifications to digital images or other assets. They can also be referred to as organizers. A browser works by pointing it at a live folder or drive containing images, but it does not keep track (unlike a *cataloging application*) of the files and corresponding metadata in a permanent fashion. They are not considered optimal for *digital asset management*.

Buffer In a camera, memory that can hold a number of images while the camera writes them to the media card in the background. The buffer allows for bursts of images to be captured while files are being written.

Byte A binary unit computer data that typically consists of 8 bits.

Cache In computers, a bank of high-speed random access memory (RAM) used for temporary storage of data that is likely to be reused. This provides increased performance by not having to read the data or instructions from a slower source. In software applications, either RAM or disk-based storage serves a similar purpose.

Calibration Adjusting or modifying the behavior of a device (such as a printer or monitor) to bring it into a known specification or state. Calibration is often

performed as the first step in building a *color profile* for the device.

Camera Calibration Panel (Adobe) Provides slider-based controls in Adobe Camera Raw and Lightroom that allow the user to adjust the behavior of the built-in, default camera profiles. Another tool provided by Adobe, the *DNG Profile Editor*, provides a more flexible method for creation or adjustment of camera profiles. These should not be confused with *ICC profiles*; rather, they are an Adobe-specific solution to camera profiling.

Camera Raw Proprietary *raw file* formats designed to hold image data and *metadata* generated by digital cameras. These formats are nonstandard and undocumented, although they are usually based on the TIFF/EP file format standard.

Camera Scans A setup that utilizes a digital camera to copy film originals as opposed to using a conventional film scanner.

Capture The process of acquiring/recording data in a digital format. This could be in the form of a photographic, moving image, or an audio recording. Also see *Image Capture*.

Capture Sharpening The initial image-sharpening step that compensates for blurring created by anti-aliasing filters, other optical defects, or softness introduced during raw conversion. Capture sharpening is not intended to be the ultimate or final sharpening of the image. Also see *Output Sharpening; Sharpening*.

Card (Media Card) A nonvolatile memory device used to store images and data for digital cameras. A variety of formats are currently in use, such as compact flash (CF), secure digital (SD), smart media (SM), and memory sticks. Each format has different capacities and access speeds.

Catalog Application Also known as digital asset management (DAM) applications. Microsoft Expression Media, Extensis Portfolio, and Cantos Cumulus are examples. They are designed to build catalogs (databases) of images (and other assets), associated metadata, and previews. They also provide further utility by creating organizational sets or groups that can associate files, independent of the original storage hierarchy. These applications also differ from a *browser* in that they do not necessarily show the live contents of a drive or folder. The actual files being displayed do not have to be connected to the computer in order to display their catalog record.

CatalogingPIEware Parametric Image Editing (PIE) applications, which provide cataloging (*digital asset management—DAM*) capabilities by use of an underlying database structure. Adobe Lightroom and Apple Aperture are examples. Also see *PIEware*.

CCD (Charged-Coupled Device) A type of image sensor commonly employed in digital cameras and scanners. It is a light-sensitive integrated circuit that converts light into an electrical charge (analog signal), which is then further processed by an *analog-to-digital converter* (ADC). CCD architecture differs from the other common sensor type (CMOS) in the way that it processes the electrical charges captured by the sensor elements (pixels).

Channel Digital images separate color information into individual channels that represent the components such as red, green, and blue (RGB). If viewed individually, the pixel information contained in the channel is

a grayscale representation for that color. When all of the channels are combined, a full color image results.

Chromatic Aberration (CA) Also known as color fringing or halos, is caused when a camera lens does not focus the different wavelengths of light onto the exact same focal plane. The effect is visible as a thin-colored halo around objects in the scene, often the border between dark and light objects.

CIE (International Commission on Illumination) Also known by its French title (Commission Internationale de l'Eclairage), the CIE is an international, non-profit organization recognized for research and standards pertaining to light, illumination, color, and color vision. The CIE 1931 XYZ color space was the original, mathematically based color model developed (by CIE) to describe human color perception and vision. The *CIELAB* color space in wide use today is a derivative of the 1931 model. CIE also defined the Standard Illuminants (some examples being A, B, C, D) which are essentially profiles for the spectra of visible light that each of the illuminants represent.

CIELAB (L*a*b*, LAB) A color model (or space) designed to represent all of the colors encompassed by human vision. It is based on color *opponency* with three primaries: L* represents lightness, a* represents red-greenness, and b* represents yellow-blueness. It was designed to be as close to perceptually uniform (meaning a change in a primary color will yield a visual change of the same degree) as possible. CIELAB is an important component of color management systems in that it typically acts as the PCS (profile connection space) that serves as the intermediary in color transformations between profiles.

Clipping The loss of either highlight or shadow details when tonal information is driven to pure white or black. For example, overexposure can produce clipping by driving highlights that should contain detail to pure white. Clipping can also be introduced in the image-processing stage either intentionally as a creative effect or unintentionally as a result of excessive corrections. Saturation clipping can occur when colors are pushed beyond the gamut of a color space.

CMOS (Complementary Metal Oxide Semiconductor) A type of image sensor commonly employed in digital cameras and scanners. It is a light-sensitive integrated circuit that converts light into an electrical charge (analog signal), which is then further processed by an *analog-to-digital converter* (ADC). CMOS architecture differs from the other common sensor type (CCD) in the way that it processes the electrical charges captured by the sensor elements (pixels).

CMYK (Cyan, Magenta, Yellow, Key (Black)) Also commonly referred to as process color, it is a subtractive color model using cyan, magenta, yellow, and black inks in color printing.

Color Filter Array (CFA) A mosaic array of color filters placed over the pixel elements of an image sensor to record color information. The *Bayer pattern* is most commonly used and is comprised of 50% green, 25% red, and 25% blue filters. There are variations on the pattern that include other color filters in an attempt to achieve better accuracy. An entirely different approach has been developed by Foveon, which uses three layers of sensors that respond to the way light wavelengths penetrate to different depths of the silicon. This allows the sensor to capture full color at every pixel and does not require demosaicing.

Color Model A system designed to specify color information numerically; *RGB*, *CMYK*, and *CIELAB* are examples.

Color Profile Also known as an *ICC* profile; defines the information required by a *color management system* (CMS) to make the color transforms between color spaces. Color profiles can be device specific (such as monitors, scanners, or printers) spaces or abstract editing (or working) spaces.

Color Separation Commonly referred to as the process for converting RGB color into CMYK for printing. It is the process of separating the original color components of an image in preparation for conversion to the destination.

Color Space A geometric (usually three-dimensional) representation of colors that can be produced by a color model. Multiple color spaces can share the same color model. Color spaces can be further defined as *device dependent* or *device independent*.

Compact Disc (CD) A widely used type of optical storage media for digital files and data with a capacity of up to 700 MB. There are three formats: CD-ROM is read-only, CD-R is recordable or write once, read many (*worm*), and CD-RW is rewriteable. The RW format is not recommended for archiving digital image files because they can be accidentally overwritten or erased.

Compression The process of reencoding digital information using fewer bits than the original file or source. This reduces transmission time and storage requirements. A number of different algorithms in use provide either *lossy* or *lossless* compression. JEPG is a common file format that employs lossy compression to achieve significantly smaller file sizes but at the expense of image quality.

Content Management System (CMS) Broadly defined, content management systems are used to create, view, edit, index, review, search, publish, and archive various forms of digital assets. This is often done in a collaborative format. Widely used on the Web, applications such as WordPress have popularized the use of content management for blogging and websites. *Digital asset management* (DAM) is also a type of CMS.

Controlled Vocabulary (CV) A structured approach to developing a consistent vocabulary of terms and or phrases that are used to aid and improve upon searches. As it relates to a digital photography workflow, a controlled vocabulary is commonly used to build a hierarchical *keyword* system or catalog. Creating and using a CV can help ensure that keywords will be applied in a consistent manner, which when combined with digital asset management, significantly aids in the search and retrieval of images.

CPU (Central Processing Unit) An electronic circuit that can execute computer programs, often simply referred to as the processor. Most current desktop/laptop computers use either Intel or Advanced Micro Devices (AMD) CPUs.

CRT (Cathode Ray Tube) A largely obsolete computer display (monitor) device that has been replaced by liquid crystal display (LCD) and most recently, light-emitting eiode (LED) display technology.

Demosaicing The process of reconstructing (*interpolation*) color images captured with CCD or CMOS sensors using *color filter arrays (CFAs)*. Different demosaicing algorithms are used by the various raw converter applications. As a result, each algorithm/converter combination will provide different results with the same image. Digital cameras also employ on-board demosaicing algorithms in the process of creating Joint Photographic Experts Group (JEPG) files.

Derivative Files Additional files created from an original or *master file*, which have been prepared for final print output, web display, or some other form of *repurposing*.

Device-Dependent Color A *color model* or *color space* that describes the unique characteristics of a specific device. Building a *color profile* of a device is a method by which this description can be created.

Device Independent Color A color model or color space that uses unambiguous color numbers that do not depend on a specific device. CIELAB is device independent because a specific set of numbers always represents the same color regardless of the device.

Digital Asset Any digital content (photograph, video, text, music, etc.) that you have the right to use by virtue of being the creator or having been granted permission or a license.

Digital Asset Management (DAM) Can be broadly defined as the decisions, workflow, and tasks that involve: ingesting, editing, organizing, annotating, cataloguing, storing, and retrieving digital assets. This can be done with a dedicated asset management solution or a workflow employing multiple software applications.

Digital Noise Typically described as the unwanted color or luminance variations of pixels that degrade the overall quality of an image. Digital noise is often equated with excessive film grain in analog photography. Noise can result from a number of different sources, including a low *signal-to-noise ratio*, the use of high ISO settings, long exposures, stuck sensor pixels, and demosaicing artifacts. It can range in appearance from random color speckles (sometimes called the Christmas lights effect) to a luminance-based grain-like effect, or banding. A variety of in-camera and software-based noise reduction solutions are available. Digital noise can also be intentionally added to an image to enhance the effect of grain or to reduce banding (caused by *posterization* or the failure of an output device to render subtle tones) in large areas of continuous tone or color such as a blue sky.

Digital Versatile/Video Disc (DVD) A widely used type of optical storage media for digital files and data with a capacity of up to 4.7GB. There are three formats: DVD-ROM is read-only, DVD-R is recordable or write once, read many (*worm*), and DVD-RW is rewriteable. The RW format is not recommended for archiving digital image files because they can be accidentally overwritten or erased.

Display Data Channel (DDC) A VESA (Video Electronics Standards Association) specified communication channel between the computer display (monitor) and the graphics adapter. It allows the graphics adapter to adjust monitor parameters such as brightness and color balance. It can also provide for automated calibration on monitors that have been designed to incorporate that feature.

DNG (Digital Negative) A publicly documented, royalty-free, *open standard file format* developed by Adobe Systems that provides a standardized alternative to proprietary *camera raw* files. The DNG specification incorporates rich metadata support along with embedded previews, camera profiles, and "maker notes" (private or proprietary metadata). DNG can employ lossless compression that can result in a significant file size reduction over the original proprietary raw. It is also being promoted as an *archival image* format since

it is fully documented and has been submitted to the **International Organization for Standardization** (*Organisation internationale de normalisation*), widely known as **ISO**.

DNG Profile Editor A free utility provided by Adobe Systems to aid in the creation or customization of DNG camera profiles used in their Camera Raw and Lightroom applications. These should not be confused with *ICC profiles*, rather; they are an Adobe-specific solution to camera profiling.

Downloading See *Ingest*.

DPI (Dots per Inch) The measurement of print resolution expressed in the number of dots of ink laid down either horizontally or vertically per inch. A higher number indicates a greater amount of output resolution. This term is not to be confused with *pixel per inch (PPI)*. There is not necessarily a direct correlation between DPI and PPI.

Dynamic Range In the context of photography, describes the difference (ratio) between the brightest and darkest measurable light intensities of a scene or image. From initial capture to final output, there can be an extremely large difference in the size of the dynamic range that each device is capable of capturing or reproducing. Dynamic range is commonly expressed in the number of f-stops that can be captured or the contrast ratio of the scene or device.

Edit The process of selecting, ranking, and organizing images. This can include deleting outtakes, applying star ratings, color labels, and metadata to files, along with sorting according to content. The term *edit* is also used to generally describe the process of applying image-processing steps.

Exposure The total amount of light that strikes the sensor (or film) during an image capture. An "optimal" exposure in digital terms would take full advantage of the dynamic range of the sensor without underexposing the shadows or overexposing the highlights. Underexposure can result in the possibility of *clipping* shadow details to black and introducing digital noise. Overexposure runs the risk of clipping highlight details to pure white.

ETTR (Expose to the Right) An exposure technique used with raw image capture in digital photography. ETTR takes into account the linear response of sensors when capturing light and allowing for the maximum use of the dynamic range. In addition, this technique can improve the *signal-to-noise ratio* (SNR) that in turn, reduces *digital noise*. A raw file records *linear data* where the brightest f-stop can potentially contain up to one-half of all tonal information within the image. The object of ETTR is to expose the image so that the raw data fully populates the right-hand side of the histogram without clipping highlights to pure white. Most cameras provide a certain amount of headroom that provides a cushion should the exposure be a little too aggressive with the brightest highlights. *PIEware* is used to post process the image in such a way as to restore a pleasing visual balance.

File Delivery The hand-off of digital image files in a finished format. This can range from optimized, sized, and sharpened press-ready images to low-res JPEGs for a designer's layout. File Delivery can be in a physical format such as optical media (CD/DVD) or a hard drive. Delivery can also take place electronically via FTP (file transfer protocol) or through a web-based service such as YouSendIt.com.

File Format The structure of how information is stored (encoded) in a computer file. File formats are designed to store specific types of information, such as JPEG and TIFF for image or raster data, AI for vector data, or PDF for document exchange.

Flash (Adobe Flash) A software application (and the accompanying ActionScript programming language) and file formats (SWF and FLV) for the development of vector and bitmap-based interactive, cross-platform, media. In wide use on the Web, Flash is used to create interfaces, *web galleries*, and entire websites. Flash objects or "movies" can be embedded in web pages and other file formats or run in a standalone player.

FTP (File Transfer Protocol) A standard network protocol used to transfer digital files between computers and servers via the Internet or a local area network. Typically, an FTP client application is used to connect to the server or destination (host) computer to initiate the transfer. FTP connections can be configured to require password authentication or anonymous user connections.

Gamma In digital imaging, the term *gamma* is commonly used to describe the nonlinear behavior of a device's tonal response. Gamma curve is used to describe a curve (sometimes called a tone reproduction curve—TRC) that affects the relationship between the shadow, midtones, and highlights of an image or device. Gamma encoding is used to describe the process of converting linear data (raw capture) into a nonlinear color space. Also see *Monitor Gamma*.

Gamut The range of color (and density/tonal values) that can be produced by a capture or output device or represented by a color space.

Gigabyte (GB) A binary unit of computer data or storage that consists of 1024 *megabytes*. Hard drive manufacturers have standardized 1 gigabyte at 1000 megabytes of storage.

Grayscale A monochromatic digital image file with pixel values that use shades of gray to represent tonal information. The term *grayscale* is often used to describe a digital black and white photograph.

HDR (High Dynamic Range) A process that combines multiple exposure variations of an image to achieve a *dynamic range* exceeding that of a single exposure. Tone mapping algorithms are used to blend the exposures into a high-bit (typically 32 bits) file format that can then be converted to either 8 or 16 bit for printing or web display. Depending on the type of tone mapping and the degree to which it is employed, the resulting images can range from natural looking to very surreal.

Highlight Recovery Many PIE applications provide a highlight recovery function that will attempt to recover (reconstruct) any highlights lost to *clipping*. It requires that at least one *channel* is not clipped to pure white. Most cameras provide a certain amount of exposure headroom that can assist in the recovery.

Histogram A graphical representation of tonal and color distribution in a digital image. This is typically based on a particular color or *working space* by plotting the number of pixels for each tonal/color value. It can be used to interpret photographic exposure and reveal shadow or highlight *clipping*.

HTML (Hyper Text Markup Language) A markup language that uses a defined set of tags to create and

publish web pages. These tags define elements such as links, paragraphs, lists, and other attributes of text and images. The World Wide Web Consortium (WW3) maintains the HTML specification.

ICC (International Color Consortium) The international organization responsible for the development and continued advancement of the ICC Profile Specification. This specification defines the architecture and formatting that is the foundation for open, vendor-neutral, cross-platform color management systems (CMS) and color-managed workflows.

ICC Profile See *Color Profile.*

IIM (Information Interchange Model) A file structure and set of metadata elements developed in the early 1990s by the International Press Telecommunications Council (IPTC) and Newspaper Association of America to standardize the exchange of news information and data. These metadata elements are referred to as the IPTC header (or more commonly as the IPTC metadata) in digital image files. Although the Adobe Extensible Metadata Platform *(XMP)* has largely replaced the IIM structure, the IIM attributes are defined in the IPTC Core Schema for XMP. Most applications that read and write metadata can keep the XMP and IIM metadata attributes synchronized.

Image Capture The process of using devices such as digital cameras or scanners to capture images in a digital format. The resulting files are then further processed to arrive at a final image.

Image Compression See *Lossless Compression; Lossy Compression.*

Image Editor See *PIEware; Raster Image.*

Image Preview A term that broadly describes the use of a proxy image in a variety of applications. These applications can range from small thumbnails used as image links in web pages to full, screen-sized JEPGs rendered out by PIEware using image-processing parameters. Camera Raw files contain embedded previews created by the camera, which can then be displayed by various applications. DNG files have the ability to embed image previews of varying sizes.

Ingest (Ingestion) The process of downloading digital camera image files from media cards that can include renaming, applying metadata, handling image-processing presets, effecting DNG conversion, and performing initial backups. Dedicated applications (sometimes called downloaders) such as ImageIngester or Photo-Mechanic fully automate the process and provide a wide variety of options. Or PIEware such as Lightroom or Aperture can perform ingestion as part of their overall workflow.

Interpolation In the context of digital photography, interpolation is most often referred to as the process of resampling an image to either add or remove pixels. Several algorithms (nearest neighbor, bicubic, bicubic sharper, etc.) can be employed depending on the type of image data and whether the goal is to increase or reduce file/image size. The Image Size dialog box in Photoshop is commonly used for this process, although several other standalone products or *plug-ins* are available as alternatives. A different type of interpolation is used in the *demosaicing* stage of raw file processing, which reconstructs the color information from the camera sensor's *color filter array.*

IPTC (International Press Telecommunications Council) The international organization that develops and maintains technical standards for news exchange.

It is responsible for the IPTC Photo Metadata Standard, which consists of the IPTC Core and Extension schemas.

ISO (International Organization for Standardization) A nongovernmental organization that develops and publishes international standards. In photography, ISO refers to the standard for measurement of the sensitivity of film or digital sensors to light. ISO also publishes and maintains the specifications for several *standard open file formats* used in digital photography.

JavaScript A computer scripting language commonly used to provide interactivity in web pages. It is also used to provide extensibility in software applications such as Adobe Photoshop or Bridge.

JBOD (Just a Bunch of Disks) A data storage configuration that typically consists of a multiple-disk enclosure in which each hard drive is independent. Benefits include the ability to mix drives of different sizes and scalability; in addition, most enclosures allow for hot swapping. Although it does not provide automated redundancy like certain *RAID* (redundant array of *independent* disks) configurations, it is a reliable and flexible storage solution.

JPEG, JPG (Joint Photographic Experts Group) A standard created by the Joint Photographic Experts Group (a joint committee of the ISO and IEC—International Electroctechnical Commission) for the compression of photographic or photo realistic images and the accompanying file format. It employs a *lossy compression* algorithm that can significantly reduce file size but at the expense of image quality and detail. It is not well suited to nonphotographic images due to compression artifacts that become readily apparent in line drawings or artwork and text with straight lines or sharp contrasting edges. Caution should be exercised when using JEPG to re-save original JEPG files because of the cumulative effect of compression artifacts that can significantly degrade the image quality.

JPEG 2000 (JP2, JPX) A standard created by the Joint Photographic Experts Group for a wavelet-based, image compression algorithm and the accompanying file format. It uses a sliding scale of lossy to lossless compression that can significantly reduce file size without artifacts or image degradation.

Keyword An element of descriptive IPTC *metadata* used to add value to a digital image or file by making it more discoverable to searches. Keywords can be individual words or short phrases employing either a flat or hierarchical structure. The use of a *controlled vocabulary* is highly recommended when developing keyword lists or catalogs to ensure a consistent and structured approach. Keywords can be both public and private depending on the nature of the term and how the photographer uses it to organize or reference the image.

Kilobyte (KB) A binary unit of computer data or storage that consists of 1024 *bytes*. It is typically expressed as 1000 bytes when referring to hard drive storage.

LCD (Liquid Crystal Display) A display technology used in computer monitors (also called flat panels) that has largely replaced *CRT* devices. Typically, LCDs use a cold cathode fluorescent (CCFL) backlight to illuminate the screen, which is made up of a layer of liquid crystal, further layered with positive and negative electrodes, polarizing film, and protective glass.

LCD computer monitors can range from consumer-grade displays with reduced contrast, sharpness, and color gamut to high-bit, wide-gamut, TFT (thin-film transistors) active matrix displays designed for digital photography and graphics applications. LCDs are also used on the back of digital cameras to provide an image preview.

LED (Light-Emitting Diode) LED technology is coming into wider use in computer monitors, replacing the cold cathode fluorescent (CCFL) backlights that have until recently (2009) been standard. Providing higher brightness levels, LEDs are also considered more environmentally friendly because they do not contain mercury (as CCFL does) along with reduced energy consumption. OLED (organic light-emitting diode) is an emerging, next-generation display technology that shows great promise and could replace LCD/LED backlit computer monitors in the future.

Linear Capture Digital sensors see and record light in a linear fashion, which is very different from the nonlinear nature of human vision. Sensors are effectively counting the photons that strike the pixels or sensor elements. This luminance information is recorded in a linear format and requires a significant amount of image processing to turn it into a recognizable image. Color information is added in during the *demosiacing* process, along with compression and tone mapping, rendering a final image that we would interpret as a photograph. Also see *ETTR* (expose to the right) for an explanation of the exposure implications of linear capture.

Linear Data Raw files contain the linear data recorded by a digital camera's image sensor. This data is logarithmic in nature, and the tonal values are either doubled or halved as they relate to each f-stop of exposure. For example, if a camera has a dynamic range of 8 f-stops and records 12 bits per pixel, the capture has a maximum of 4096 (2^{12}) possible tonal levels spread out over the 8 stops. Because the distribution from one stop to another is linear, the first (brightest) stop would contain fully half of all the tonal information or levels (if the full dynamic range of the sensor was used). Following this rule, we see that the progression would be 2048 (1st stop), 1024 (2nd), 512 (3rd), and so forth until reaching the 8th stop with only 16 levels available.

Lossless Compression Software algorithms (and accompanying file formats) used for reducing files sizes where data is not discarded during compression and can be fully restored when decompressed. Lossless compression usually results in larger file sizes when compared to lossy. RLE (run-length encoding) and LZW (Lempel–Zif–Welch) are commonly used algorithms along with ZIP, which also has several file format variants. JEPG 2000, GIF, PNG, TIFF, and DNG are all examples of file formats that employ lossless compression.

Lossy Compression Software algorithms (and accompanying file formats) used for reducing files sizes where data (often targeting redundant data) is discarded during compression and is not fully restored when decompressed. High amounts or repeated re-saving with lossy compression can introduce artifacts and degrade image quality. But lossy compression can provide significant savings in file sizes and is especially useful for images intended for web display or digital camera applications where storage capacity may be limited. JPEG and MP3 are examples of file formats that use lossy compression.

LPI (Lines per Inch) A measurement unit of print resolution that relates to the frequency of the halftone

screening. Common LPI numbers are 85 for newsprint, 133 for magazines, and 150, 175, or 200 for high-quality reproduction. It is not to be confused with *dots per inch (DPI)*.

Luminance The intensity of light as emitted or reflected by an object/surface. This is usually expressed in candelas per square meter (cd/m2). It is a measurement of the brightness of an object or light source.

Mask In image processing or publishing applications, a mask is a defined area used to limit the effect of editing/processing operations. There are a number of different types and techniques, including channel, clipping, layer, raster, and vector masks. A wide variety of selection tools can be employed in software such as Photoshop to aid in the creation of masks. Also dedicated applications and plug-ins are available for the express purpose of masking.

Master File Commonly defined as a high-value duplicate of the original source or capture file that has been permanently renamed, had basic metadata, capture sharpening, dust-busting, and basic image/color corrections applied. Depending on the workflow, this could be a DNG (unrendered) or rendered file (with layers) such as a TIFF. This file can be both archived and held in a "working" location. All subsequent derivative files are created from the master.

Megabyte (MB) A binary unit of computer data or storage that consists of 1024 *kilobytes*. Hard drive manufacturers have standardized 1 megabyte at 1000 kilobytes of storage.

Megapixel A term commonly used in reference to digital camera resolution; 1 megapixel equals one million pixels or sensor elements. To calculate the megapixel value for a camera, multiply the horizontal by the vertical pixel counts. In general, a higher megapixel number indicates increased resolution but is not an absolute measurement of image quality. Other factors such as the size of the individual pixels, the presence of an *anti-aliasing filter*, and the noise characteristics of the sensor, along with image processing all play a role in determining the final perceived resolution or image quality.

Metadata Commonly defined as "data about data." Metadata is embedded or associated information describing a file's contents, both technically and conceptually. There are several metadata container formats such as EXIF, IIM, IPTC Core, Dublin Core, DICOM, and XMP. The way metadata is structured is referred to as a schema, an example being IPTC Core, which is a standardized structure to hold information about a digital image file, such as authorship details, description, keywords, copyright status, and usage. *Parametric image editing (PIE)* instructions saved in the XMP format are another type of metadata, which is comprised of the image-processing parameters from a PIEware application.

Metamerism The phenomenon whereby two spectrally different colors appear to visually match under one light source or condition but differ under another. These two colors would be called a metameric pair. Metamerism can be a problem with certain combinations of ink/pigments and *substrates*.

Monitor Gamma The gamma correction applied to a computer monitor that describes the relationship between input voltage and output luminance. Adjusting the gamma setting is part of the calibration process that normally precedes building a *color profile* used by color management systems. A gamma of 2.2 (or there-

abouts) is often regarded as optimal for smooth repro-
duction of tones and gradients. Higher-end displays
designed for digital photography and graphics applica-
tions will often have a factory calibrated gamma setting
that will be automatically adjusted during the regular
creation and updating of the display profile

Open Standard File Format A *file format* that has
published specifications describing the encoding of
data and intended usage, is royalty-free, and is managed
by a standards organization such as the *ISO* or *ICC*.
Examples include PDF, TIFF, DNG, and ICC
profiles.

Operating System (OS) Software that provides the
interface between computer hardware, applications,
and the user. Current popular, and widely used OSs
include several variants of Windows NT and Vista,
Mac OSX (actually Unix based), Unix, and Linux. In
the context of digital photography workflow, Mac and
Windows are the predominant platforms because of
the large base of software applications that have become
the de facto standards. Important OS level implications
for imaging applications (including plug-ins) are
whether they run in 32- or 64-bit memory space. 32-bit
applications (or OS), though still in wide use, only
allows for approximately 4GB of RAM allocation per
application. This may seem like a large number, but it
can be quickly consumed by editing large image files.
In practical terms, 64 bit allows an almost unlimited
amount of addressability, but in reality it will be limited
by how much physical RAM a computer can hold and
by the associated cost of such amounts.

Opponency A theory of color vision which states that
humans see in terms of opposing values of light-dark,
red-green, and yellow-blue. This theory forms the basis
of the *CIELAB* color model.

Optical Resolution The maximum physical resolution
that a device or system is capable of capturing without
aid of interpolation. Often used to define the native
resolution of scanners.

Optimize In the context of digital photography work-
flow, the process/steps of correcting tone and color,
sharpening, retouching, and other output specific
adjustments. Optimization can take place at the indi-
vidual file level, or it can be done as a batch process for
multiple files and in more than a single pass or round.
Files that have been prepared for specific uses such as
proofing, printing, and web would be considered
optimized.

Out-of-Gamut Colors All output devices have a
fixed amount of color (or *gamut*) that they are able to
reproduce. When moving from one device (or color
space) to another, colors that cannot be exactly repro-
duced between the source and destination are consid-
ered to be out-of-gamut. *Rendering intents* are used to
manage the conversion process.

Output A broad-based term that refers to an end use/
destination for a digital image. This could be print
output using inkjet, press, laser writer devices, film, or
other *substrates*. It could also be screen based for use on
the web, multimedia and interactive applications, or
video.

Output Sharpening A final sharpening step that is
intended to correct for softness introduced by the
output process. It is optimized for a specific combina-
tion of output conditions at the final image size and
resolution. This could include the type of device (i.e.,
inkjet, press, laser) combined with a *DPI* or *LPI* setting
and a particular type of *substrate*. Images intended for
screen display can also benefit from output sharpening.

Typically, output sharpening is the last step performed on derivative images that have been tailored for a specific use. Also see *Sharpening* and *Capture Sharpening*.

Parametric Image Editing (PIE) A nondestructive workflow whereby image edits are made using instructions (parameters) saved as metadata. Depending on the application, the metadata can be saved in a database, directly in the file (typically DNG, TIFF, or JPEG) or as a *sidecar file*. The editing instructions can then be rendered by the software (*PIEware*) into *derivative* versions of the file. The premise of PIE is that underlying image data is never directly edited or changed in the process.

PDF (Portable Document Format) Developed by Adobe Systems, an *open standard file format* for cross-platform document exchange. PDF is highly extensible, preserves the integrity of the original document, is searchable, and provides document security. The Adobe Acrobat family of applications provides a platform for PDF creation and editing, along with the free Acrobat reader to open and view files. Many popular software applications can write PDF files directly, and there is a large base of third-party developers with DPF-compliant editing and workflow solutions.

Perceptual Rendering Intent One of the four rendering intents specified by the *ICC* for handling out-of-gamut colors when converting from one color space to another. Perceptual rendering tries to preserve the overall color appearance or relationships between colors while compressing them to fit within the destination space. Because of this compression, all colors are remapped to some degree, and accuracy is sacrificed to preserve the visual relationships. It is a good choice for images that have a significant amount of out-of-gamut color.

Picture Style Settings available on many digital cameras that provide a variety of alternate renderings for camera-generated JEPGs. Each camera manufacturer has its own terms to describe these styles or looks. They can be used to simulate the look of a particular film emulsion and create more pleasing skin tones for portraits, vivid colors for landscapes, or monochrome (B&W) images. These settings do not affect the underlying raw data, and parametric image editors (other than the camera manufacturer's own software) will ignore any associated metadata.

PIEware A software application that edits image files by using instructions saved as metadata. Examples include Camera Raw, Capture One Pro, and Nikon Capture. Also see *Parametric Image Editing (PIE)*.

Pixel Derived from the term *picture element*, this is the smallest unit of information in a digital image. Also commonly used to describe the individual sensor elements on capture device.

Plan The outline or schema for a project whereby the outcomes and methods are decided upon before starting the process. In a digital photography workflow, planning is an essential element in the efficiency of the process and takes into account such issues as ease of use, repeatability, collaboration, final usages, sustainability, longevity, and preservation of the work.

Plug-In A software application or module that provides extensibility and specific functionality from within a larger host application. Adobe Photoshop is an application with a programming architecture that supports a rich plug-in environment. One of the main advantages of supporting plug-ins is that enhancements or new functionality can be added without having to update the host application. The Adobe

Camera Raw plug-in is an example since it is regularly updated with new camera support that would otherwise have to wait for a major release of Photoshop. Third-party software developers can also offer additional or enhanced features that may either be missing or lacking in the host.

PLUS (Picture Licensing Universal System) A cooperative, multi-industry initiative whose focus is the development and management of a universal language for licensing image rights and the preservation of digital content. The components of the PLUS system include a picture licensing glossary, media matrix, and licensing format.

Posterization A visual defect (also called *banding*) in an image created by insufficient amounts of data to maintain the appearance of continuous tone. Posterization can result from overly aggressive image editing (typically, curves or levels adjustments) that forces adjoining (but different) pixels values to all, assuming the same value. It can also be caused by color transforms and by working with an insufficient bit depth to sustain the subtle gradations within an image. The effect often becomes visible first in shadow detail and large areas of continuous or uniform color (blue skies). Digital noise can also create or contribute to posterization as well as the failure of output devices to render subtle differences in tonality.

PPI (Pixels per Inch) The measurement of image resolution expressed in pixel density (or size) relative to inches. PPI can be used to calculate the final image size by dividing the image dimensions in pixels by the PPI. The resulting numbers would be expressed in inches. Example: 2400 × 300 pixel image at 300 PPI would equal 8 by 10 inches. PPI is not to be confused with *dots per inch (DPI)*.

Preservation As it relates to digital images and data, the process of maintaining information in an error-free state to preserve its accessibility and usefulness. Because of the nonphysical nature of digital information, this requires a constant process of upkeep, including refreshing storage mediums, migrating to new mediums and file formats, verifying and validating existing data, and maintaining redundant backups.

Processing In digital imaging or photography, the steps and procedures that transform images or data through the use of software applications. *PIE* software such as Camera Raw processes raw image data into a recognizable photograph according to the user's input and decisions.

Proprietary File Format File formats that may be protected by patent, copyright, or other licensing agreements and that generally are not publicly documented. Examples include Adobe PSD and the vast majority of camera raw formats. Camera manufacturers and software vendors use proprietary formats to protect intellectual property or trade secrets. Their use is controversial because it raises user concerns of data ownership and longevity.

RAID (Redundant Array of Independent Disks) A number of data storage configurations that provide higher performance, redundancy, or both combined. RAID controllers can be software or hardware based, with hardware solutions typically providing higher levels of performance. There are potentially eight RAID levels, with 0, 1, and 5 being the most widely used. Level 0 uses a technique known as *striping* to spread data over multiple drives that appear as a single volume. It provides high performance but with no redundancy of data. Level 1 writes the same data to multiple drives in a process called *mirroring*. It provides a high degree

of redundancy but at the expense of performance. Level 5 uses multiple drives and provides the benefits of combining both striping and mirroring. The other levels are variations based on different levels of parity. RAID should not be confused as a backup in and of itself, although it can be used as part of a backup process or system.

RAM (random access memory) Chip-based computer memory that stores temporary or dynamic data and instructions that can be accessed in any order. It is also known as volatile memory since the data it holds is lost when the computer is shut down or power is interrupted. RAM is considerably faster than disk-based memory and is an important component in computer performance. Modern *operating systems* can take advantage of large amounts of RAM, which can dramatically improve the performance of software applications that have been designed or optimized accordingly. This allows an imaging editing application such as Photoshop to open large files directly into RAM (versus having to read from disk-based *virtual memory*) and to perform processing at much higher speeds.

Raster Image See *Bitmap*.

Raster Image Editor A software application (also commonly called image editors) that works directly on the pixels of an image, Adobe Photoshop and Apple iPhoto are examples. Unlike *PIEware*, changes (edits) made by a raster application can be destructive in nature, permanently changing the pixel values.

Raw Files (or Camera Raw Files) The unprocessed linear data captured by a digital camera sensor and any associated metadata. It can be likened to the digital equivalent of a latent image but with the ability to be infinitely reprocessed or developed. In most cases, cameras write raw files using a *proprietary file format*. Raw files give the photographer the advantage of managing image processing during postproduction rather than allowing the camera to make the processing decisions, as happens when shooting JPEG. Also see *DNG; Linear Data*.

Relative Colorimetric Rendering Intent One of the four rendering intents specified by the *ICC* for handling out-of-gamut colors when converting from one color space to another. Relative colorimetric rendering maps the white of the source to the white of destination and then reproduces all in-gamut colors exactly. Out-of-gamut colors are *clipped* to the closest reproducible hue. Relative is considered to be a good choice for images when you are trying to achieve accurate reproduction and do not have a significant amount of out-of-gamut colors.

Rendering Intents The four methods (*Perceptual, Saturation, Relative Colorimetric*, and *Absolute Colorimetric*) defined in the ICC profile specification by which out-of-gamut colors are handled when converting from one *color space* to another. Perceptual and Saturation use gamut compression to remap source colors to fit the destination. Relative and Absolute Colorimetric utilize *gamut* clipping to remap to the closest reproducible hue.

Repurposing The process of creating *derivative* files or image components for a variety of alternate uses. Examples could include creating a web version of a file originally intended for CMYK reproduction, making a black and white version of a color image, stitching together several images to build a panorama, or taking elements from different images to create a montage.

Resolution A measurement of the ability of an optical, capture, or output system to record and reproduce detail. It can be defined in a number of different metrics such as Line Pairs, PPI, DPI, SPI, and LPI. Also see *Dots per Inch; Lines per Inch; Optical Resolution; Pixels per Inch.*

RGB A *color model* that uses the three primary (red, green, blue) additive colors, which can be mixed to make all other colors.

Saturation Rendering Intent One of the four rendering intents specified by the *ICC* for handling out-of-gamut colors when converting from one color space to another. Saturation tries to produce vivid colors by mapping fully saturated colors from the source to the destination without regard for accuracy. It is not usually a good choice for photographic images, but it works well for business graphics or illustrations.

Scan-o-Gram The process of using a flatbed scanner to create a photographic image of a three-dimensional object by laying it on the scanner bed (glass).

Sharpening The process of increasing (or emphasizing) contrast around the edges of details (comprised of pixels) in an image. Sharpening is a workflow (pioneered by the late Bruce Fraser) unto itself with several different stages to compensate for softness introduced at various points in the image life cycle. These stages are referred to as *capture sharpening, creative sharpening,* and *output sharpening.* Each uses different parameters and techniques to achieve optimum results tailored to that specific need. A variety of different software tools, dedicated applications, and plug-ins are available for sharpening. Pixel Genius is a software developer that has taken the workflow principles and research developed by Bruce Fraser (he was

a founding member) and produced a product (Photokit Sharpener), along with licensing of technology, to Abobe for use in Lightroom and the Camera Raw plug-in.

Sidecar File A text file that contains metadata associated with a parent file. Sidecars are typically used when the parent is a *proprietary* raw file that does not safely support the use of embedded metadata.

Signal-to-Noise Ratio (SNR) In digital photography, defines the relationship between the incoming signal (light/photons striking the pixels/sensor elements) and the background electronic noise generated by the sensor. SNR is inherent in any electronic system. In relative terms, the higher the SNR, the cleaner the resulting data will be, and in turn, this produces a higher quality image. Low SNR results in reduced separation between the signal and background noise and will increase the amount of visible image noise. This will degrade shadow detail and reduce the overall image quality. Increasing the ISO setting on a camera results in amplification of the signal and creates a corresponding increase in noise.

Spatial Resolution Another term used to describe how fine of a line (and their closeness) a particular imaging system can resolve. Also see *Resolution.*

Spectral Sensitivity As it relates to digital photography, the sensitivity and response of image sensors to the color spectrum and wavelengths of light. An example would be how different types of sensors may be more sensitive to certain wavelengths (colors) of light.

Substrate The term used to describe the material onto which an image (and or text) will be printed. Primarily

this is paper, but it may be a variety of other materials including film, foil, plastic, ceramics, textiles, and fabrics.

Terabyte (TB) A binary unit of computer data or storage that consists of 1024 *gigabytes*. Hard drive manufacturers have standardized 1 terabyte at 1000 gigabytes of storage.

Thumbnail Image A small, low-resolution *image preview* used on the web to link to a high-resolution version of the file. Thumbnails can also be embedded in file formats such as TIFF and PSD. Previews that are generated by PIEware and browser applications are also occasionally described as thumbnails.

TIFF or TIF (Tagged Image File Format) An open standard file format specifically designed for images. Although Adobe Systems owns the copyright for the TIFF specification, they maintain the format as an open standard, currently in revision 6. TIFF can incorporate several types of compression if desired, including LZW, JPEG, and ZIP. The format is particularly well suited for the storage of high-quality archive images. The DNG format is based on TIFF/EP (electronic photography), which is a subset of the main TIFF standard.

Tone Curve Used in image editing software, a graphical representation of the relationship between input and output values for the brightness levels of pixels that can be used to adjust the contrast of the image.

User Interface (UI) A graphical front end for the software or code that controls interaction between the user and the computer or device. These range from the complex GUIs (graphical user interfaces) of operating systems and applications like Photoshop to button-driven interfaces, like those found on the back of digital cameras.

Vector Graphics Images that use mathematically described geometric shapes (arcs, curves, lines) and points rather than bitmapped pixels to create objects. Vector images or objects are compact (since they are a description rather than actual pixels), provide clean and crisp edges, and are infinitely saleable without being subject to the interpolation artifacts seen in bitmaps. Adobe Illustrator is an example of a dedicated vector graphics editor. Photoshop also has the ability to create and use vectors in conjunction with pixel-based images.

Virtual Memory A process whereby the computer operating system (or software application) uses hard disk space to extend memory beyond the addressable RAM (random access memory). Also commonly called a page file or swap file (space), it extends the utility of a process but at the expense of slower access speeds. Depending on the operating system or application, it may be user-assignable, and performance can be improved by locating it on a high-speed drive or *RAID0*.

Visually Lossless Compression A subjective term referring to any compression technique that reduces the file size by removing data of fine enough detail that the eye does not notice. A visual comparison between the original and the compressed file does not show any differences but a comparison of the binary code or actual pixels will. In general, many photographic images can be compressed up to a ratio of 10 : 1 without a visually perceptible loss in image quality.

Web Galleries Also referred to as web proofs; simple web pages built using *HTML* or *Flash* to show and share images. Many DAM and PIEware applications

are able to create web galleries from folders or collections of images.

White Balance (WB) In digital photography, establishes the color balance (and neutrality) of the image in relationship to the color temperature of lighting conditions. Most digital cameras have several built-in white balance presets (tungsten, daylight, cloudy, fluorescent, etc.), along with an auto setting and the ability to set a custom WB. In raw capture, the white balance is recorded as a metadata tag but is not applied to the actual image data. *PIEware* provides tremendous flexibility for postprocessing adjustment of WB in raw files. When shooting JEPG, it is more critical to get the white balance "right" since it will in effect be backed into the pixels of the image and requires destructive image edits to correct.

White Point A term used to describe color temperature as it relates to the luminance of the brightest white that a device can display. It also refers to the reference (or target) white of the illuminant. White point is commonly used to describe the calibration setting on a monitor that literally sets the color temperature (or illuminant) of how white is displayed. Common settings include 5000 or 6500k or the D50 or D65 references. Monitor white point settings are often determined by the viewing environment and color matching requirements of a workflow.

Workflow The processes and sequence of steps through which an image or other piece of work passes from inception to completion.

Working Space (Editing Space) An RGB *color space* designed specifically for editing images. The properties would include being gray-balanced (equal amounts of R, G, and B produce neutrality), having perceptual uniformity (meaning a change in a primary or color will yield a visual change of the same degree), and having a wide enough gamut to contain the colors of the image (or color values) being edited. Examples would include sRGB, Adobe 1998, and ProPhoto.

WORM (Write Once, Read Many) An acronym for optical media such as CD-R and DVD-R that is often recommended for archiving digital image files since it is not subject to accidental erasure, viruses, and overwriting of files.

XML (Extensible Markup Language) A specification for creating self-descriptive markup language for transporting and sharing data. XML has been recommended (the final stage of the ratification process) as an open standard by the W3C (World Wide Web consortium). XMP is an example of an XML-based platform.

XMP (Extensible Metadata Platform) Developed by Adobe Systems; an open standard for processing and safely embedding metadata in a wide range of file formats. Based on *XML*, XMP is extensible, meaning that it can accept existing metadata schemas such as IPTC but can grow to accommodate emerging needs and technologies. XMP also supports parametric image editing instructions along with proprietary metadata.

© Patricia Russotti

Chapter 3

An Overview of Workflow Components and Planning

"A good question is never answered. It is not a bolt to be tightened into place but a seed to be planted and to bear more seed toward the hope of greening the landscape of idea."

—*JOHN CIARDI*

THE BASIC CONCEPTS OF DIGITAL PHOTOGRAPHY WORKFLOW

While things may change within the technology, there are basic digital imaging concepts that will remain somewhat constant. The chart on the next page illustrates these tenets. This section will define the basic concepts. Each subsequent chapter will discuss the details and relationships of each concept.

Planning

Many of us have found that starting work on a project can be very exciting and invigorating. Sometimes, however, this excitement changes to anxiety when we realize that maybe we should have thought about the process in more detail before we started.

Understanding the life cycle of an image has become a critical element. Part of this understanding includes accepting the relationship between each decision in the workflow process. If we do not make informed decisions early on, we may be faced with having to spend an enormous amount of time "cleaning up." This can compromise the quality and vision of the work or require a redo, often at our own expense.

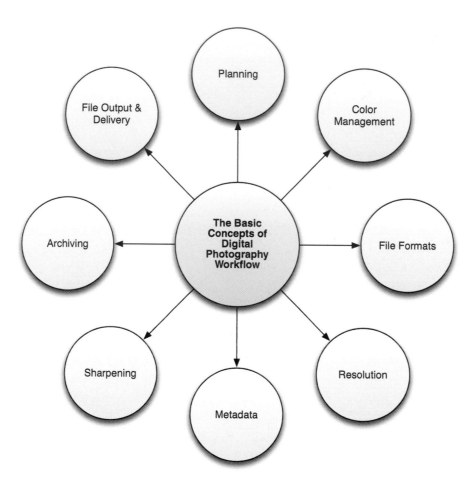

The concept of "paying it forward" is what planning is all about. With the proper amount of planning and decision making, many "could be issues" become non-issues. The goal of planning is to determine what questions to ask and how to proceed with the decision making.

Color Management
A fundamental difference between film and digital photography occurs in how each carries its color information and appearance. A color transparency or an analog print (even one that is black and white) carries its color information in its appearance. Although that color was once dependent on the quality of the viewing light, all good professional printers understood that the majority had professional lightboxes and viewing booths carefully calibrated to ISO graphic arts standards. This generally meant that a transparency (or print) delivered to a commercial printer was unambiguous about its color. Furthermore, the printer had highly skilled scanner operators who were trained to match the film or prints as closely as their technology allowed. When digital cameras and their output replaced film, the printing industry had to adapt, and very few were able to main-

tain the equipment or people who scanned film and prints. The photographer had essentially become the scanner operator, and consequently the keeper of the color, whether ready for that responsibility or not.

For these reasons, a successful digital photography workflow begins with understanding and applying effective color management. The reason is simple: a digital file (even if accompanied by a digital print) can be—and often is—ambiguous in regard to color. Its appearance depends entirely on how different devices from computer monitors to digital projectors and all types of digital printers interpret the 1's (ones) and 0's (zeroes) that make up the digital image file. Even when a digital print accompanies a file, we cannot be sure that the print truly represents the file's 1's and 0's. If it does, will the recipient of the file and the accompanying print view the color print under standard lighting conditions, which describe brightness and color temperature, and view the digital file on a calibrated and profiled monitor?

Digital photography workflow must be designed to remove the possibility that a digital file's color is ambiguous. The file's color description must be carried with (embedded in) the file. This is achieved via International Color Consortium (ICC) profile-based color management. These standardized color definitions (ICC profiles) are required for the proper display and reproduction of images. Profiles are simply look-up tables, sets of recipes that describe the properties of a color space or a device. Ideally, monitors, printers, scanners, and cameras are all profiled. Work and output spaces, such as Adobe RGB, ProPhoto, sRGB, and SWOP CMYK, should be embedded and preserved when opening files. An overview of color management is available on the UPDIG site. Color management information and techniques are explained as we work our way through the dpBestflow workflow steps.

File Formats

One's choice of file formats to be used dictates many of the subsequent workflow decisions. Should you shoot raw, JPEG files, or both? If you have a camera that shoots TIFF, is that a better option than raw for some workflows? What about converting proprietary raw files to Adobe's DNG? If so, when should this be done in the workflow and should any effort be made to also keep the proprietary raw files? File format decisions will determine much about the work order, hardware and software that will prove most effective in your workflow. This decision will also impact the archival value of your work, and what kind of resources will be needed to store it.

Resolution

The need for detail as well as final print or display size can be a deciding factor in choosing a camera for any given photography project. Some projects require a level of detail (and therefore resolution) that is not yet available in a single capture. Other techniques that involve stitching multiple captures together may need to be utilized. At the same time, more resolution is not always better or necessary, so we will discuss how to determine the ideal resolution for any given workflow (or stage in a workflow). Consequently, resolution, whether described by cameras and software as pixels per inch (PPI) or by printing devices as dots per inch (DPI), is an important concept of digital photography and its workflow.

Sharpening

Proper sharpening of digital image files is as important as color management and correct resolution for optimal appearance and reproduction—even for Web use. Sharpening should occur at three distinct points in the workflow:

- **Capture**
- **Creative**
- **Output**

These points may vary depending on factors such as capture format, software used, and who does the final file preparation. Since sharpening is an inherently destructive process, how it is handled in the workflow is a critical issue.

Metadata

> Image files without metadata are just a pile of pixels.
>
> —Bruce Fraser

Although no one called them metadata, captions or labels attached to slide mounts or backs of prints were just that (i.e., information about the image). The difference now is that metadata can be "embedded" into the image file. Convenient as this is, perhaps no other aspect of digital workflow is more confusing. Understanding metadata involves learning such acronyms as IPTC, IPTC Core Schema, PLUS, XMP, and IIM. Additional confusion is caused by the fact that a legacy metadata format known as IIM is gradually (but not universally) being replaced by XMP format.

Often confusion arises over which metadata fields to use and when. See the Ingestion section (chapter 7) for ways to help think about and create metadata templates and address the issue of the most commonly used fields. This section will also show the value of automating this process, depending on which ingestion program you decide to use.

Another issue is that XMP metadata is used to provide processing instructions (parametric image edits) for image files. Concerns about embedding metadata into proprietary raw files have led some software to attach rather than embed XMP metadata. The attached files are referred to as "sidecar" files, and they are essentially a digital version of captions and instructions that were often attached to analog film or prints. Real problems can arise when a file has embedded IPTC (IIM) format, embedded XMP format, and an attached sidecar file. Different software applications may read the metadata in different order or may not recognize XMP data at all. Understanding and avoiding these confusion points and collisions helps keep the workflow efficient and maintains metadata portability for your files.

Some software circumvents the issue of embedding metadata or attaching metadata to raw files by keeping the metadata in a database. When Metadata is locked up in a database, it will not travel with the image file. Your work is not portable to other applications or even (very easily) to other computers.

We say users beware!

File Delivery

File delivery, the handing off of digital image files from person to person and device to device continues to be a challenging aspect of digital photography workflow. It requires understanding and properly applying all the concepts of digital photography—that is, color management, file formats, resolution, sharpening, and metadata. File delivery requires an accurate and consistent workflow and clear communication. The image receiver needs to know the precise status of the image file in terms of its color profile, resolution, sharpening, and applied metadata. Much of this information can (and should) be included in the image file as metadata. The challenge is for the receiver of the image file to know how to find and interpret this information.

During this transition period, additional strategies such as enclosed "readme" files, labels, and direct communication are necessary. We will also discuss the use and inclusion of CMYK Guide Prints and Proofs to ensure that color is preserved or matched for printed output.

Archiving

An effective archive not only preserves images, but also organizes them in a way that makes it searchable and easily available both now and in the future. Archiving digital photography presents a different set of problems than traditional chemical-based photography. Digital photography, like traditional photography, depends on preservation of the media it is on. However, digital image files have the distinct advantage of being easily duplicated. Moreover, this duplication can be lossless—with no degradation of the original. This feature, coupled with the ability to store metadata within the file, makes digital photography archives much easier to organize, search, and retrieve images. Consequently, many photographers, institutions, and businesses are in the process of converting traditional photography to digital files via scanning.

Despite the advantage of a digital archive, we must remember that digital files can be easily deleted, corrupted, or lost due to media failure. In many cases, deletion or media failure means that the image files are gone forever. The vast majority of digital images are stored on computer hard drives. Hard drive storage, though extremely convenient, is definitely not archival. Until a less complex, more sustainable mechanism comes into wide use, developing a plan for constant migration of image files to newer and/or larger hard drives is a necessary component of archiving.

A bigger challenge with regard to the preservation of digital image files is the long-term readability of file formats. This is especially true if they are proprietary, which describes most camera makers; raw formats. Some formats are already unreadable on newer operating systems. One of the more shocking format failures is the Kodak Photo CD format. Although Kodak addressed the issue of media permanence, it was all for naught, as there is no longer any application support for their proprietary format. Many museums and other archiving institutions ended up having to convert thousands of these discs to other formats and storage media before all the contents became unavailable.

PLANNING

(Decisions and the Work to Be Done Prior to Starting a Project)

Digital has often been referred to as instant gratification, or as immediate results without a lot of effort. At first glance, this may seem to be the case because images are immediately visible or available. To the uninitiated, however, these claims do not take into account the value of a consistent and high-quality end result.

We believe that a solid knowledge base along with the development of consistent habits and pragmatic approaches are vital. These approaches become second nature to the craftsman and occur without having to make decisions on a minute-by-minute basis. This allows us to delve into the real work at hand—making images to match your vision, solve a problem, tell a story, or complete the objectives of a job. Planning is one of the essential criteria for having an effective workflow. In its most generic form, one needs to:

Collect Gather all the pertinent information necessary to make smart and appropriate decisions in relation to a specific job or project. Knowing as much as possible about the job or project before starting is critical. Know

all the deliverables and ask questions. Where and how will the work be printed? If printed, will it be done on a traditional press or on a digital press? Inform yourself about the paper stock, weight, coating, and color; is it certified paper (has it been tested on the particular device)? If the work will be going to alternative substrates, what kind of testing is required upfront? Going to the web or screen? What will the other elements on the page be? And of course a critical component of planning is budget, which tends to dictate everything.

Organize Establish a hierarchy for storing the work in process (backup for captures, files, catalogs, PIE work, etc.) as well as for completion. Information related to folder hierarchies is in the Archive section. Take lots of time with this section; develop a plan to make a workable structure for yourself. And make it as bulletproof as possible! There are many ways to approach this, and it requires that you create a system that will fit your individual needs, along with providing scalability for the future. Directly related/connected are Naming Conventions, which are discussed in Chapter 7, Ingestion. (General working conventions are discussed throughout this book.)

These steps should be carefully thought out and tested, ensuring that they will work for you and have longevity (protect your investment). These organizing measures do take time and effort but are well worth the investment. Having clarity on these issues and establishing a fundamental structure with conventions will help you maintain an efficient workflow, save you time, and help you avoid frustration.

Organization and a proper setup of your equipment can also fall into this category. Have you taken the time to test each of the elements and devices that you will need in the imaging loop? Keep records of what you test and of the results so that you can use them again. We will keep stressing this point; don't constantly keep reinventing the wheel!

Process While working, implement best practices for consistency. This along with a pragmatic adherence to a workflow will make your imaging life easier and more efficient, and will allow for more conceptual and creative time. Discipline and consistency are key qualities.

Review and Evaluate Occasionally stop, review the work process and how you are doing it. Determine whether your methods can be adjusted for more efficiency and better results. Again, consistent, pragmatic critical thinking is required.

Document and Communicate Finding the ideal scenario requires keeping a record of what you do. There are many ways to do this while working: you can keep an analog notebook marked by date and project or keep everything in a digital form and then assemble into a document for later use. There are numerous ways to quickly record your processes and experiments (build once and use many times) so that you can free your mind to focus on your work.

Within Photoshop, you can turn on the History Log (found inside General Preferences). This function gives you many options to record work steps which can be stored in the metadata as well as in a text file.

Camera Raw and Lightroom, automatically store your process in the metadata.

Screenshots—we have found that one of the best ways to keep track of what you are doing in an application

is to make screenshots. These can be easily assembled within a variety of programs so you have time stamped, clear records of what you did. Photoshop also has the Annotation or Notes tool that allows you to make little sticky notes anyplace on the image to remind you of details that might be otherwise forgotten. These are non-printing elements that can be stored with the file.

When shooting, we have found that recording info for use later as keywords or image descriptions is very helpful. This can be done by jotting it down into a little notebook or using the voice annotation tools that are on many of today's cameras. And yes, these can be used with Lightroom!

Documentation can also include saving your work in presets, snapshots and templates within your software.

Of equal importance to record keeping is properly communicating that information to the appropriate people during the workflow. There are many levels of knowledge and comfort in the industry. A best practice is to always document and communicate the necessary information during hand-offs. Don't make assumptions!

KNOWLEDGE BASES

Frank Argento, an accomplished artist, designer, educator, and entrepreneur, as well as a colleague and friend, coined the phrase "B.A.T."—Business, Aesthetic, and Technology. The idea for B.A.T. came up many years ago during one of our frequent conversations about how to personally stay current, along with helping staff and colleagues do the same—and of course, dealing with it at the same time as we all do our work and still meet project deadlines! B.A.T. is the careful balance between being able to run a business and stay current

with technology while still keeping your creative and aesthetic edge. There are times during our careers when one of the factors in the equation may be more prominent than another. Recognizing these imbalances and adjusting to meet all three criteria are necessary for ongoing success.

So how do we do that? Our hope is that you develop new thought patterns and perspectives as you work through the process of understanding workflow. Right now, we are talking in holistic terms, getting the big picture down, and yet, dpBestflow and the software we suggest is modular based. This requires understanding each of the elements and its relationship to and impact on the next step. Know the big picture, the entire schema, and then work in varying levels of granularity to ensure you have achieved Frank's theory of "B.A.T."—Business, Aesthetic and Technology.

Artist, Craftsperson, Lifelong Learner

One way to approach the question of what we need to know is to visualize what an ideal curriculum would be. How would our "education" be structured if we had the luxury of going back to school and become a full-time student without the everyday pressures of keeping a business running?

It might be divided as follows:

COMPUTER SKILLS AND DIGITAL FOUNDATIONS
Proficiency in Mac or Windows environment

System configuration and/or a backup

Desktop management

Media types and management

DAM—digital asset management (catalogs (databases), folder hierarchies and structure, naming conventions)

File formats

Understanding of vector and raster

Resolution

PHOTOGRAPHIC SKILL SETS

Genres of imaging

Composition/design

Lighting

Exposure

Understanding of cameras, lenses, focal length, and the
impacts on the image

Color theory, perception, and their relationships

Aesthetics

DIGITAL IMAGING SKILL SETS

Workflow

Software knowledge and proficiency

Life cycle of a digital image file

Sharpening Workflows

Color management

Image archiving and backup

Output

Overview Summary

Skill levels and understanding of all the variables will vary significantly with each reader. Each person may not feel competent in every area, nor have a need to be proficient in all. Depending on your entry point to digital photography, you may be selective about the areas you choose to become highly skilled in. Regardless of that, it is important to have a clear understanding of how each of these knowledge bases interact and become dependent on each other. This understanding will help to minimize the struggle and frustration of pushing and pulling images through an unknown process. Once black holes and nebulous areas are identified, resources can be found to resolve the issues at hand.

© Patricia Russotti

Chapter 4

Workflows and Parameters

"You never change things by fighting the existing reality. To change something, build a new model that makes the existing model obsolete."

—RICHARD BUCKMINSTER FULLER

The goal of this section is to give you the big picture and then break down each of the areas to help you construct the most effective workflow for your needs.

This discussion is divided into several parts:

- Workflow parameter decision points
- Batch or optimized workflow
- Rendered or unrendered workflow
- Capture formats
- Workflow software options
- Working file life cycle order
- The overall dpBestflow workflows
 - Generic—the workflow steps regardless of capture format and software
 - CatalogingPIEware and raw files
 - Conversion to DNG
- Workstation Setup

THE WORKFLOWS

The following flowcharts have been designed with current vocabulary, choices, and variances that might be utilized to maintain best practices and achieve an efficient workflow. Think of these as your general map as you determine the best route for your specific workflow needs. We suggest that you refer to these often as you go thru the subsequent chapters.

- The first chart is a generic overview of the workflow steps regardless of capture format or the type of workflow application(s).

- The second chart illustrates working with CatalogingPIEware and raw files

- The third chart illustrates the workflow for Ingestion and conversion to DNG.

DPBestflow generic workflow

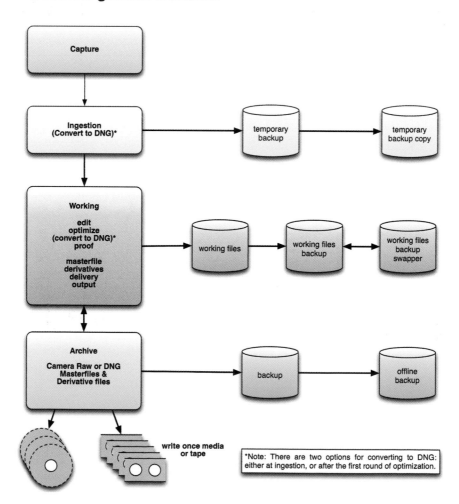

*Note: There are two options for converting to DNG: either at ingestion, or after the first round of optimization.

CatalogingPIEware workflow with proprietary raw files

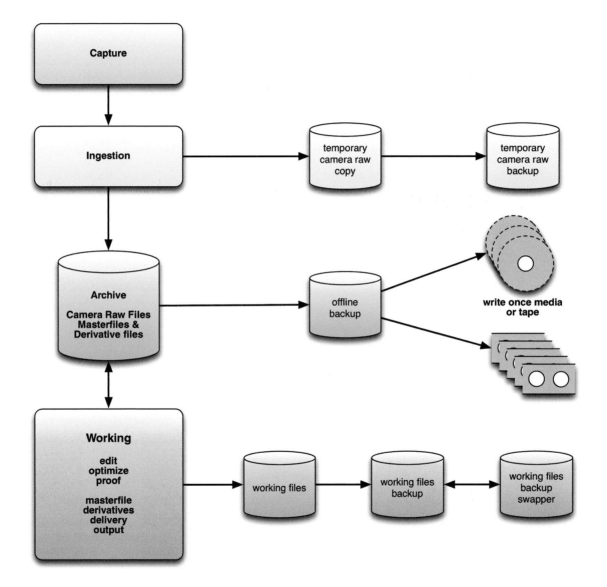

Ingestion and convert to DNG workflow

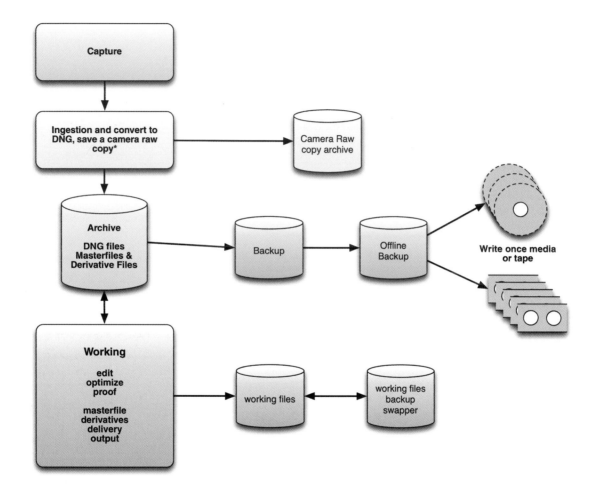

*Notes:
Image Ingester Pro allows the user to keep a copy of the proprietary raw files as well as convert and save a copy in the DNG format. Since Lightroom stores the parametric image edits (PIE) in its catalog database, DNG (or proprietary raw) files can be archived right away. Files selected for further work or for output are the working files. They can be referenced from the archive, which keeps the raw data essentially untouched. It is up to the user whether the PIE information gets written back to the raw or DNG, and also whether the DNG is updated with a new JPEG preview.

QUALITY

Before we dive into all the nitty-gritty details, let's look at the perception of overall technical quality and how that impacts each subsequent decision and workflow. This value judgment is connected to our earlier discussion of proficiency and knowledge bases or the particular needs of the job, client, budget, or project. The least defined workflow parameter is quality. Some people may define quality as something with zero defects, others as something having a high degree of excellence. Photographers are probably most comfortable with defining quality in terms of levels of perfection. This could be described as a sliding scale, or perhaps as a target:

Images from consumer-grade point-and-shoot camera, shooting JPEGs in the sRGB color space, when printed out on a consumer-grade ink jet printer directly from a memory card or displayed on an uncalibrated consumer-grade monitor, would most likely give a result somewhere within the large green circle. No deep knowledge of color management, file types, or sharpening is required to hit somewhere within this large target.

If you use computers with calibrated and profiled monitors that have advanced software for color correction and image manipulation and use high-quality digital printers, you will move into the smaller red circle. If you use high-quality printers with custom profiles, you will move closer to the center. A reasonably complete understanding of color management, file types, sharpening, and postproduction techniques is required.

The use of high-end monitors and custom profiles for printers, along with expert knowledge of color management, file types, sharpening, and postproduction techniques, will put you reliably into the center circle. Museum photographers won't be satisfied until they occupy the space between the words "nearly" and "perfect."

Camera choice figures into the quality equation, though not in a simple or linear way. A digital scan back may take the highest resolution pictures, but a point-and-shoot image from the frontlines of Iraq, or een a camera phone image, may rise to the level of nearly perfect, if content, timing, and artistic intent are considered. It is important to understand that quality has more to do with preserving the artistic intent than with any threshold megapixel number. Certain job types that are based more on the technical ability to accurately document a scene or an object, as needed for most architectural photography, most museum photography, and most catalog or studio

photography, benefit from high-resolution capture—although the differences at the high end are increasingly subtle.

Your decisions and perception of quality will change and evolve as comfort level and type of work pursued expand. We all want to achieve the highest quality results. Knowing your options and making educated decisions can help you stay on budget, keep to your timeline, and achieve the results you want.

WORKFLOW PARAMETER DECISION POINTS

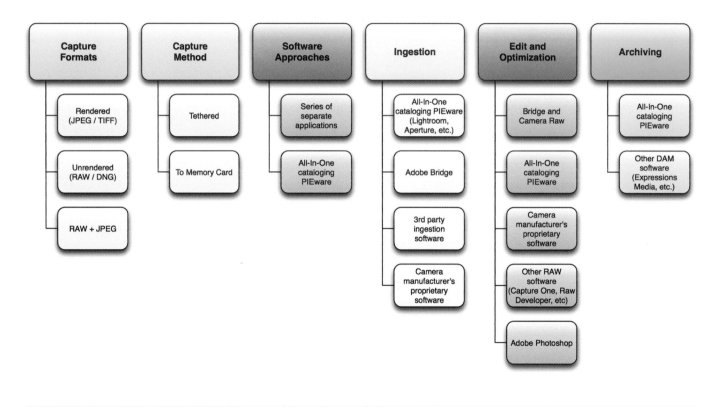

The illustration above shows how many variables and decision points there can be when constructing a workflow.

Capture

Images can be captured as

- rendered files (JPEG/TIFF)
- camera raw files (including DNG) or
- both (raw + JPEG)

Software

The three capture format choices can be used with two distinct software approaches:

1. A series of separate applications (downloader, browser, PIEware, image editing software, and catalog software, or
2. The more recently developed, all-in-one cataloging parametric image editing software (Cataloging-PIEware) such as Aperture, Lightroom, and Bibble 5.

Ingestion

Capture ingestion options:

- All-in-one application (i.e., Lightroom, Aperture)
- Adobe Photoshop / Bridge

- A host of proprietary camera manufacturers' software
- Third-party ingestion applications

Edit/Optimization

Edit and optimization choices:

- Bridge and Camera Raw
- All-in-one Adobe Lightroom, Aperture, and Bibble 5
- Manufacturer's proprietary software
- Capture One, Raw Developer, SILKYPIX . . . the list goes on for alternate options
- Adobe Photoshop or another raster image editor for postproduction

Archiving

Choices include:

- All-in-one cataloging software
- A variety of DAM software choices

CAPTURE FORMATS

Raw Files

Raw capture is sometimes referred to as "the ultimate latent image" since raw files may be processed an infinite number of times in a variety of software applications. Of all the capture format options, raw files can provide the best image quality. The image quality of older files can be improved by reprocessing in newer and better software. These qualities are significant in context to archiving. However, the proprietary and undocumented nature of most raw file formats is problematic because each camera manufacturer places its own secret spin on how the raw file is constructed.

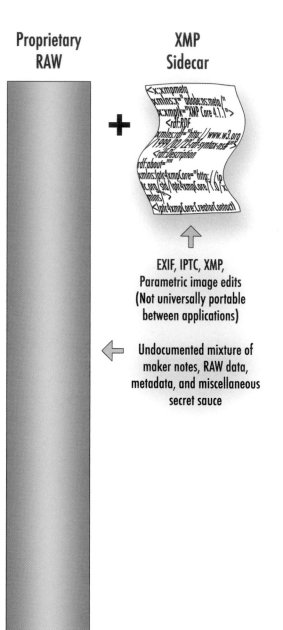

Proprietary RAW

XMP Sidecar

EXIF, IPTC, XMP, Parametric image edits (Not universally portable between applications)

Undocumented mixture of maker notes, RAW data, metadata, and miscellaneous secret sauce

JPEG, JPG (Joint Photographic Experts Group)

JPEGs are fully processed by the camera from the exposed raw data, according to the camera settings you have chosen. Exposure and white balance need to be as accurate as possible (JPEG capture can be compared to exposing for transparency film) because the camera settings are baked into the pixels at capture. Consequently, optimization options and the subsequent image results are more limited when making changes in postproduction.

The primary advantage of JPEG files is that they are cleverly compressed. They are smaller than raw files and much smaller than TIFF files. Another advantage is that JPEG is a standard file format recognized by nearly every software application (web browsers, cell phones, ipods, word docs, and so on) without any additional processing, so they are immediately available for use and distribution.

JPEG

EXIF (Automatically applied metadata:
Exposure info, file dimensions, color profile, etc.)

IPTC IIM format metadata
(User applied info: Copyright, rights usage, etc.)

IPTC4XMP format metadata
(IPTC in XMP format)

XMP (User applied info,
parametric image edits)

Compressed image data

TIFF or TIF (Tagged Image File Format)

TIFF capture has become rare inasmuch as it offers no quality advantage over a high-quality JPEG. Even as a 16-bit file, TIFF offers no processing advantages over raw. Since TIFF is not compressed, it is much larger than JPEG files. TIFF files are also larger than most raw files because raw file image data is monochromatic until the files have been demosaiced (interpolated from black and white to color). Consequently, raw file size is smaller than TIFF. Today, very few cameras offer TIFF as a capture format.

Raw + JPEG capture: Many DSLR cameras can be set to shoot raw files and JPEG files in a single capture. Camera settings, such as white balance, tone curve, color space, picture style, and sharpening, will be reflected in the JPEG. The camera settings will not affect the raw files, and they remain available for processing in PIEware. Shooting raw + JPEG can solve some workflow problems, but at the same time it can create others. For some, it represents the best of both worlds, and for others, the disadvantages of both.

TripWire:

Be sure that you carefully peruse the menu options of your particular camera when you set the camera to shoot in raw, JPEG, or raw and JPEG capture. These settings are a moving target, so always check and be sure you have set up the camera for what you want. Be aware of the different shooting modes—AV, TV, Manual, Auto—and how that might impact your previous menu setup. In the past, we have been unhappily surprised that if a dial is switched to Auto on some camera models, it will override the menu settings and what we thought was set for RAW had been changed to JPEG.

TIFF

EXIF (Automatically applied metadata: Exposure info, file dimensions, color profile, etc.)

IPTC IIM format metadata (User applied info: Copyright, rights usage, etc.)

IPTC4XMP format metadata (IPTC in XMP format)

XMP (User applied info, parametric image edits)

Image data

DNG (Digital Negative)

DNG

A few cameras use the DNG format as their native raw file.

While cameras that have DNG as a capture format inherently have all the benefits (see Chapter 10 DNG Workflow Primer) of DNG, users should be aware of a few things. The file validation that would occur during the DNG conversion process will not occur when shooting with DNG as your capture format. Since corruption is always a possibility during ingestion, be extra vigilant during this step. At the writing of this book, other DNG capture issues are still unknown and cannot be addressed adequately. We suggest that you check www.dpBestflow.org for updates.

Ingestion software will optionally convert camera raw to DNG on ingest or import of images. While the DNG workflow can function exactly like any raw workflow, the DNG file format has some unique features that are advantageous to workflow. There are some TripWires depending on software choices and preference settings that need to be understood to achieve the best DNG-based workflow. We address those issues as we progress through the workflow steps.

File Header: automatically applied metadata (EXIF, file type information), user applied metadata (IPTC4XMP), parametric image edits

DNG-specific tags, camera maker notes (may be private)

Color decoding info: generic Adobe Camera Raw profile, custom DNG profile (optional), 3rd party profile (optional)

Data Verification: MD5 hashes for DNG image data and embedded original file

Optional image preview(s)

DNG image data (can be RAW or linear)

Embedded original proprietary RAW file (optional)

DNG format is essentially a container. In addition to raw or linear image data, DNG can, by design, hold multiple XMP parametric image edits and multiple JPEG previews from multiple applications. No sidecar file is necessary. So far, only Adobe applications make full use of DNG as a "virtual job jacket".

Advantages and Disadvantages of Each Capture Format

Raw

- Requires specialized software to view and use images
- Raw workflow is somewhat slower than JPEG workflow
 - Improvements in hardware and software have reduced this as an impediment
 - Faster CPUs, cheaper RAM, more robust software applications, database-driven raw processors like Lightroom…

JPEG

- All camera settings are permanently embedded in pixels at capture.
 - All additional processing (after ingestion) is destructive, meaning that you are applying all adjustments on top of the pixels
 - Quick turnaround time
 - Universally read by most applications and platforms

TIFF

- All camera settings are permanently embedded in pixels.
 - All additional processing (after ingestion) is destructive, meaning that you are applying all adjustments on top of the pixels, akin to placing filters on a lens
 - Large file size—no compression

RAW + JPEG

- Immediate JPEGs for web, client communication
- May misrepresent how a scene may actually look or may look different than the processed raw file
- May present cataloging and archiving issues, depending on software choices. Some will give you two files with the same name, whereas others will treat them as one file. Having a plan to deal with both file formats of the same image necessitates a clearly defined strategy for tracking

WORKFLOW SOFTWARE OPTIONS

No single workflow suits all photographers or all clients. A good digital workflow is the most efficient automated way to get the job done while collecting and recording the widest range of image information for multiple future uses. Above all, the workflow should satisfy the photographer's needs and/or the client's needs. A good workflow saves time and protects against both the loss of images and the loss of work done to those images. Making appropriate software choices will ensure that these goals are met. Selecting the best software to match particular workflow requirements can feel daunting. There are multiple software applications and few integrated solutions. As users we pay a price for each software choice: in money to purchase new applications, and in the investment of time to learn the new tool and determine the best way to integrate it into digital photography workflow.

An effective workflow requires the following:

Ingest (Ingestion)

We recommend that you use specialized ingestion software to import digital image files from the camera or the camera's memory card (download) after capture. Use of the Finder application to copy, (or worse) moving files from a memory card to the computer, is not recommended since the finder is potentially unreliable. Most ingestion software provides additional efficiency functions—such as browsing and editing capabilities. (See the list comparing ingestion software on page 42.)

Potential issues, if one is using the Finder for capture download, are as follows:

- **If the Finder encounters any problem, including a corrupt file, it will simply stop copying or moving files. Files may be left behind if this happens.**

- **The Finder application's ingestion capabilities are very limited. It cannot add metadata, guard against duplicate file names, rename files, or do other functions necessary for the ingest process.**

Ingestion Software

- **Helps you maintain an organized structure for your ingestion process and can ensure that you repeat Best Practices to maintain the life of your files.**

- **Some applications will keep a script of the ingestion process. This can be useful if you have any problems later in the workflow.**

- **Stores templates for metadata and file-naming conventions. This reinforces the concept of "build it once, edit and use many times," creating time efficiency and consistency**

Browse

Browsing software displays image files and metadata when pointed to a folder. When working with raw files, browsers can optionally display embedded camera preview JPEGs. Browsers that include raw processing can be set up to replace the camera JPEGs, with "thumbnails" built using the raw file parameters and any applied presets. This activity is called *caching*.

Cache

A cache is a block of memory (RAM) used for temporary storage of data that is likely to be used again. The CPU and hard drive frequently use a cache, as do web browsers. In a CPU there can be several caches in order to speed up instructions in loops or to store often accessed data. These caches are small but very fast. Reading data from cache memory is much faster than reading it from RAM or disk.

A browser can feel slow while waiting for the cache to be built or updated as you work. Browsers facilitate many workflow functions such as adding batch and custom metadata, naming/numbering, and editing functions such as rating, labeling, grouping, and moving files. Browsers can also be used to make slideshows and Web galleries either within the application itself or by connecting to a raster program like Adobe Photoshop. The slideshow function can be utilized as a helpful editing tool. Web galleries can be created and used for web proofs. Browsers that include processing functions (parametric image editing) like Camera Raw via Bridge can also be used for batch and individual image processing.

Parametric Image Edit (PIEware)

Edits are made to an image using instruction sets saved in the file's metadata, then rendered by raster software. PIE editing does not affect or change the underlying image data. What exactly is parametric image editing, and how is it different from raster image editing (aka pixel-based image editing, think Photoshop)? Parametric image editing, which we refer to as PIE throughout this book, is true nondestructive image editing. The appearance of digital image files is altered by adjusting parameters (exposure, brightness, color, contrast, saturation, and now many other picture characteristics) by means of instruction sets. These instruction sets can be attached to files, embedded in files that support embedded instruction sets (usually as XMP data), or saved in a database. Whatever method is used to store the PIE, the original raw image data is never changed. The PIE is simply used to interpret the image file according to the instruction set created by the user. This differs from raster image editing where the adjustments are actually applied to the image data and change the pixels. This is why it is referred to as "destructive" image editing; the pixels are altered, rewritten. This comes at a cost. Of course, Photoshop can be used in a nondestructive fashion. But anything done to the pixels changes the pixels, even if you use various kinds of layers. Even the relatively lightweight adjustment layers require considerably more space than PIE instruction sets. Savvy Photoshop users generally use "Save As" and create a new derivative file, maybe two or three of them: one with all the layers and pieces and then a flattened version for delivery or output. This takes more time and storage space. A simple "Save" overwrites the original image data. Each time you do that, you make a copy of a copy. Storage is more efficient, but quality diminishes dramatically. PIE's efficiency becomes evident when you consider that you do not need to create and save a big chunk of image data

when you want to adjust your images. Rather, you merely need to save a very small (usually about 24KB) amount of data, which will effectively create the adjustments on command. In addition, PIE can be easily automated, and large quantities of images can be optimized in a very efficient manner. Since the image data is never rewritten, each time you apply the PIE, it is like a brand new image—aka true nondestructive image editing

PIE has come to mean

- **Higher quality**
- **Efficiency**
- **Less storage space required for PIE master files**

Applications such as Camera Raw, Capture One, Lightroom, Aperture, and Bibble 5, which can adjust image files via instruction sets, are also known as parametric image editors. Some parametric image editors allow you to move directly from editing to image processing within the same application. For example, in Lightroom, you can switch between the Library module and the Develop module without exiting the program. Parametric image editors can also be used to adjust JPEG and TIFF files. It is important to remember that those edit results are more limited than parametric image edits of raw files. JPEG and TIFF files have the camera settings baked into the pixels at the time of capture. Consequently, they do not have as much processing latitude as raw files. This is becoming more widely adopted as a preferred way to process these files.

*Cataloging Parametric Image Edit
(CatalogingPIEware)*

A new variation of parametric image editing software is built on top of a database and provides cataloging

and parametric image editing functions. Two of these functions require cataloging (import files) before allowing parametric image editing (Apple Aperture, Adobe Lightroom). A new arrival (Bibble 5) makes the creation of catalogs an optional feature. We think that making the cataloging function optional is a great workflow-friendly feature.

Raster Image (Pixel) Edit

Raster image editing is also known as postprocessing or postproduction software. The most widely used software application for raster image editing, often referred to as pixel pushing, is Adobe Photoshop. Until recently, this type of software was required for localized corrections on an image file. Recent developments in parametric image editors now include localized correction tools. Photoshop tools are still somewhat quicker and easier to use (especially since we are all used to them) but can be destructive if pixels are edited on the base image. The preferred Best Practice is to do all editing on multiple layers. This will increase the file size and can add complexity. It is important to properly label and group the layers to reduce complexity and avoid confusion for future use. When layers are eventually flattened, the work becomes permanently embedded into the pixels and varying amounts of image degradation occur. By working in 16-bit, the amount of image degradation will be significantly reduced. HDR, panoramic stitching, collage, retouching, and photo-illustration still require Photoshop, Photoshop plug-ins, and other pixel-editing software for the highest level of postproduction work.

Catalog

A catalog, database, library (the term will vary depending on application type) are the key components of digital asset management (DAM) software.

Cataloging software is essential for an effective digital workflow scenario. Unfortunately, the majority of photographers leave this step out of their workflow. A browser application can be a tool to help one build a system that can be converted into a catalog for digital asset management if a strict organizational hierarchy is implemented. Not using cataloging software is the equivalent of cooking a great meal and then leaving all the dishes in the sink. Eventually, somebody will have to clean up after you, or you will be forced to spend time searching for images (or kitchen utensils) within a disorganized pile.

Differences between Browsing Software and Catalog Software

BROWSING SOFTWARE

- **A browser cannot show the file if it is not on the disk or in the folder.**

- **Browsers have to be connected and pointed at drives and folders to return search results.**

- **Browsers require the use of sorting terms such as keywords, labels, or some other embedded metadata written to the file.**

- **Browsers only see what they are pointed, to and the files must be online.**

This requires a very different methodology than is available in cataloging software

CATALOGING SOFTWARE

- **Cataloging software references the original images while keeping track of where the files are located.**

- **Cataloging software is more efficient at searches because it uses a local database.**

- The catalog database contains thumbnails of the original files.

- If a file is missing, has been moved, or renamed, the cataloging software will let you know.

 - This allows for continued image organization even when the original files are in a different location or not connected to your computer.

ADVANTAGES TO CATALOGING SOFTWARE

a. It is easy to back up your organizing work since it only requires backing up the catalog database.

b. Cataloging software allows you to work with offline image files.

In summary, if you don't know exactly where to look for something, a browser is not a big help in finding it. Cataloging software offers a number of different approaches for an automated search, but it still requires you to do the necessary work of populating the catalog to allow for file searches on or offline. Once that work is done, and there are ways to automate this step, the ability to search and retrieve images is much more efficient and easy.

BATCH OR OPTIMIZED WORKFLOW

Despite all the possibilities, there are two basic workflows. One will result in batch-processed image files and the other in optimized image files.

Batch processed describes image files that have been collected and processed simultaneously. The characteristics of a **batch-processed** workflow are as follows:

- **Often used for sports, news, and event photography**

- **Often will be a high volume of images**

- Will often be all, or a substantial portion, of all the images from the shoot

- Often involves a quick turnaround time

- May involve JPEG or raw capture, but is often based on JPEG capture

- May be JPEGs or raw files that have received a round of parametric image edits in PIEware and then processed out to JPEG or TIFF.

- **May be camera JPEGs that have had metadata added and possibly been batched renamed but are otherwise as processed by the camera**

- **May be camera JPEGs that have had metadata added and possibly been batch renamed and then processed through Photoshop with an action or set of actions that applies the same tone or color enhancement to all the image files.**

An **optimized** workflow takes a digital capture beyond batch-processed files. In the optimized workflow, the photographer continues to exercise creative control after the shoot which may involve image compositing, retouching, stitching, high dynamic range tone mapping, and other techniques to produce a finished piece. An optimized workflow involves more work and has more steps, sometimes many more steps than a batch workflow. Although turnaround times can be quick when deadlines dictate speed, there is usually more time built into an optimized workflow. With current PIEware—optimization that used to be done in Photoshop can now occur right in PIE ware. For example; spotting, smoothing skin, dodging and burning all things that a yr or 2 ago were thought of as pixel editing in "post production". In an optimized workflow, the photographer will tend to gather more information about the final uses. This often extends to researching the type of press and paper that will be

used for printed output. Photographers that operate at the highest level in the industry practice an optimized workflow. They are usually known for their postproduction skills and style, which they use to complement their preproduction conceptualization and capture techniques.

An **optimized** workflow has the following characteristics:

- Often used for advertising, corporate, high-end editorial, and portrait photography

- We recommend that the optimized workflow should always start with raw capture.

- If the final desired result is a stitched or high dynamic range (HDR) image, the captured images need to reflect the panoramic sweep or the exposure range optimally.

- The optimized image files will usually be a small portion of the shoot.

- Optimized files will often be selected for optimization from a batch process of the edited and proofed shoot.

- Optimized files will go through a series of steps involving optimization in PIEware and may involve additional optimization in a pixel editing application, usually Photoshop.

- Optimized files are ideally saved as master files, which are usually high-bit TIFF or PSD files normally saved in Adobe RGB (1998) or ProPhoto color space. However they may also be raw files that have been optimized in PIEware. Master files may have capture sharpening applied but never output sharpening.

- Optimized master files are the source files for all other derivative files, which may include files further optimized for print, printing (CMYK), or screen (Web, projection, etc.)

RENDERED OR UNRENDERED WORKFLOW

On the surface, it might appear that the high-level division when describing digital photography workflow is between shooting JPEG (rendered) files and shooting raw (unrendered files). We have found that the workflow decision, based on batch-processed files or optimized files, is actually a higher-level division. We make this claim by positing that an optimized workflow precludes shooting rendered files, especially JPEGs.

We acknowledge that this observation may not apply to museum photography or to fine art photographers, especially when using special cameras and software, which can capture 10 channel color and make profiles on the fly. With the exception of these small-niche workflows, we feel strongly that it is unlikely that the highest quality can be achieved without utilizing the maximum image data as a starting point, and that is precisely what a raw capture provides.

Viewed in this light, we feel that a rendered file (JPEG capture) is only appropriate for a batch workflow, so we will place that workflow as a child of the batch workflow parent. We therefore consider the unrendered (raw capture) workflow to be interchangeable with the optimized workflow.

THE WORKING FILE LIFE CYCLE

If we consider that all workflows can be described as either batch or optimized, it becomes easier to understand the variations that arise by tracking what we call the working file life cycle. The working file life cycle consists of the four essential divisions in the work order: capture, ingestion, working (edit, optimize, proof, delivery, output), and archive.

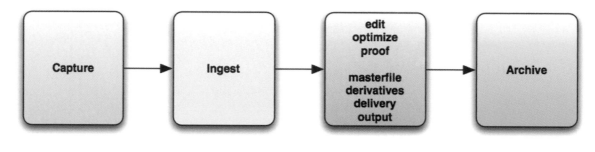

The four essential divisions of the Working File Life Cycle

Batch Workflow

The batch workflow has a short working file life cycle. There are some differences in the batch workflow file life cycle, depending on whether the original capture files are rendered (JPEG) or unrendered (raw).

JPEG Capture Batch Workflow Steps

ONE METHOD

- **Perform a basic edit, addition of basic metadata, and organization of the shoot.**

- **Optionally add a larger number of additional descriptive metadata.**

- **Export JPEG files for output/delivery.**

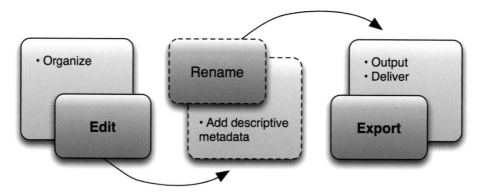

JPEG Capture Batch Workflow Steps

steps with dotted lines represent Alternative method 1

ALTERNATIVE METHOD 1

- Perform a basic edit and organization of the shoot.

- Optionally add a greater number of descriptive metadata.

- Add parametric image edits for tone/color/sharpening, and so on.

- Export JPEG files for output/delivery.

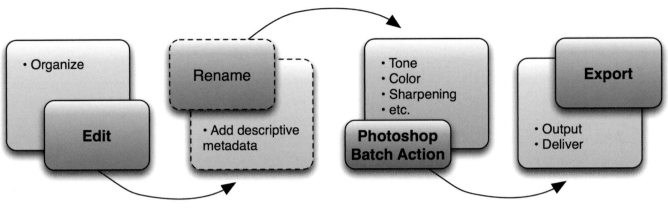

JPEG Capture Batch Workflow Steps

"Alternative Method 2"

ALTERNATIVE METHOD 2

- Add tone/color/sharpening, and so on, via a batch action in Photoshop and then export JPEG files for output/delivery

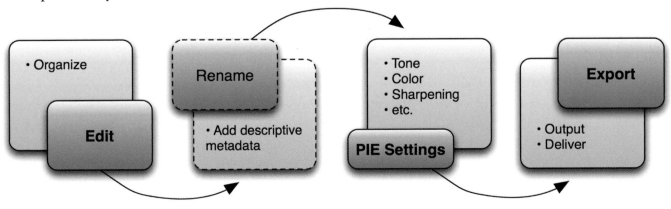

Capture Batch Workflow Steps for RAW or JPEG

RAW CAPTURE BATCH WORKFLOW STEPS

- Perform a basic edit and organization of the shoot.

- Optionally add a larger number of descriptive metadata.

- Add parametric image edits for tone/color/sharpening, and so on, to raw files and then process to JPEG files for output/delivery.

- Add parametric image edits for tone/color/sharpening, and so on, to raw files. Convert to DNG (with the full-size JPEG preview option enabled) through Bridge/ACR, or Lightroom or the standalone DNG converter. Import the DNG files into an application that can copy out the adjusted JPEG preview files, specify the size and quality of the JPEG copies, and process them out for output/delivery.

Optimized Workflow

The optimized workflow has more steps and often a longer time frame.

THE OPTIMIZED WORKFLOW STEPS

- Perform a basic edit and organization of the shoot.

- Rate the images.

- Optionally add a larger number of descriptive metadata.

- Carry out parametric image edits to the raw files with the goal of optimizing well enough for proofing.

- Create a web gallery, online proof, PDF, or other method to create a set of proofs of the shoot. The proofs will be used to determine the "selects" that will become master files.

- Create master files.

- Create derivative files for output/delivery based on the specifications for final use. These files will be sized and sharpened for the final output media, which may be screen, substrate, or both

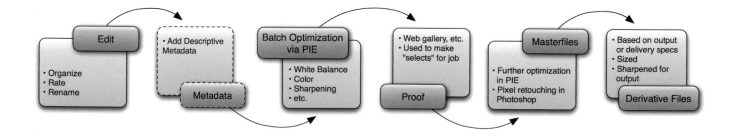

WORKING FILE'S LIFE CYCLE ORDER BASED ON SOFTWARE APPLICATION TYPE

Batch, optimized, rendered, and unrendered workflows can be further distinguished by another division.

A file's working life cycle order and efficiency determined by the type of software chosen.

A series of separate workflow applications, for example, Bridge, Image Ingester Pro, Camera Raw, Photoshop, Portfolio

- Manage workflow through a set of separate workflow applications such as an image ingestion application, followed by a browser application, followed by a cataloging application,

or

- Move your workflow into an all-in-one application such as Lightroom or Aperture.

All-in-One Applications = "CatalogingPIEware".

Let's review terms. When we say all-in-one, we mean applications that can handle most (if not all) the workflow steps including ingest, work in progress, and archiving. Applications like Lightroom and Aperture can also be used for tethered capture, although each has different approaches and procedures. Lightroom and Aperture can be used to download image captures from cards. Both can provide parametric image editing functions for raw files (which are designed for PIE) as well as for JPEG, which can also be parametrically image edited (but not as extensively). Both can be used as a hub to export files to Photoshop (or other raster image editor) for pixel-based image edits. Both applications can then re-import the pixel edited image files to their catalogs.

When we call these applications catalogingPIEware, we are stating that each application is built on a database, which provides a cataloging function. The database saves the previews and allows for virtual organization of the images into collections. The previews and organization are saved into the database (catalog). This is very different from the way browsers or PIEware that do not have a database function. Not having a database requires these applications to build previews on the fly (takes time) or to save them in a small cache. The lack of a database means that they are not considered to be digital asset management (DAM) applications. CatalogingPIEware, on the other hand, can be considered to be a DAM application.

Whether your workflow is based on separate applications, or all-in-one CatalogingPIEware, is an important distinction that will determine the workflow sequence.

The work order when using separate workflow applications looks like this:

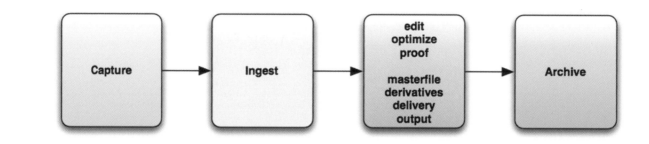

The work order when using an all-in-one application looks like this:

Difference between Separate Applications and an All-in-One Application

A CatalogingPIEware application should allow you to put your original capture files away immediately after the ingestion step. Additional work can be done to the files, which is why the arrow goes both ways. However, the original capture files do not need to be touched except to rename or delete files. They are archived as source files for any additional work. The additional work will be captured by the PIEware application database, although in the case of Lightroom, the additional work, which is represented by XMP instruction sets, can be pushed back into the original capture files at any time.

DPBESTFLOW WORKSTATION SETUP

The main considerations and components necessary for good computer workstation performance for digital imaging involve

- Processor (CPU) speed
- The number of CPUs or the number of cores (multiple CPUs on each chip)
- The speed of the internal and external hard drives and how they are connected to the CPU
- The amount and type of RAM memory
- The capabilities of the graphics card (GPU)

RECOMMENDED WORKSTATION SETUP

Optimize RAM for the application and operating system. More is usually better.

Optimize the video card for the application. Check for firmware updates for existing cards.

video card

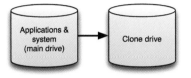

Maintain a bootable clone of the main drive. If the main drive fails, you can boot from the clone and not lose any time. DP Bestflow suggests keeping one for travel and location and one for studio and home use.

Ideally the working files are stored on a separate drive from the main drive as this can speed up the workstation. There should be an automatic daily backup of the working file drive. In addition, having an offsite backup drive is ideal best practice. Swapping out the working backup and the offsite backup on a regular schedule is another smart best practice.

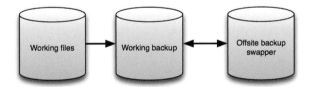

Photoshop uses hard drive space for temporary swap space or virtual memory for any operation that doesn't fit in RAM. History states are an example. You can configure up to four separate hard drives for scratch space. It is best to use a separate drive (or set of drives) for scratch space. Combining drives into a Raid 0 configuration gives the best performance. Having a generous amount of RAM has made exotic Raid 0 scratch disk setups less important for overall performance.

A set of external drives should be set up to hold your digital archives. Maintaining an offsite or offline backup to each archive volume is best practice. Connection speed is not as important as it is for working files unless you routinely access and work from archived files.

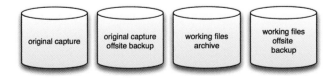

In general, multiple fast processors are useful for a speedy workflow. Digital imaging applications are increasingly designed to make use of multiple processors and multicore processors. Upgrading to a new computer with a faster processor will make the biggest difference in workflow speed.

RAM

Adding RAM (random access memory) is usually cited next as a way to speed up workflow applications. RAM chips themselves come in a variety of speeds, and it is best to use the fastest and highest quality RAM available in your workstation. High-quality RAM chips can have better error correction built in, which is an important feature to prevent file corruption. Since RAM is exponentially faster than disk memory, having more of it allows more image processing to be done in this faster environment. When a program like Photoshop runs out of RAM, it must use much slower disk memory. Parametric image editing applications (like Lightroom) are often very dependent on having a generous amount of RAM to work smoothly.

Graphics Cards

Graphics cards are not usually regarded as important for digital image processing workflow. Most people assume that they are only important for gamers who require fast rendering, but they are being used more and more by applications such as Photoshop, Lightroom, Aperture, and others for image processing tasks.

Hardware Setup

The final piece of the equation is the arrangement of hard drives in the workstation. Hard drive configuration is one of the easiest ways to enhance workstation productivity and is essential for protecting your data. Three characteristics of hard drives need to be kept in mind:

- **Speed**
- **Capacity**
- **Type of connection to the processor**

Speed

Drive speed is a combination of short access time, which is related to how fast the drive spins, and high throughput, which is how fast the drive can read/write data. Modern high-capacity 7200 rpm drives have for all intents and purposes become so fast that the extra speed of 10,000 or 15,000 rpm drives will hardly be noticed. Scratch disks are made faster when two or more drives are combined in a Raid 0 configuration (spreading data evenly over multiple drives, also known as an array) to enhance performance. Because there is no redundancy scheme, it does not provide data protection. However, now that computers and applications can address more RAM, exotic scratch disk setups are not as necessary as they were in the recent past.

Capacity

Large-capacity drives are usually chosen for holding work files and archived files. Large-capacity drives usually have high throughput (density of data on the drive). With today's technology, it makes perfect sense to take advantage of the largest available drives for your digital data.

Connection

How drives are connected to the CPU has evolved over time with desktop computers now using Serial Advanced Technology Attachment (SATA) internal connections. SCSI, always known for speed, has been replaced by SAS drives. Although theoretically faster than SATA, there isn't much real-world performance difference. SAS drives are much more expensive. SAS

and SATA can use the same connections, so you can replace SATA drives with SAS drives if budget is no object.

Connections to external drives vary more in terms of options and speed and need to be chosen carefully. External SATA (eSATA) is currently the fastest practical connection type. Since eSATA is just an external version of internal SATA, it doesn't need to translate data through a bridge, as is necessary for Firewire and USB. As a consequence, eSATA can transfer data up to three times faster than Firewire 800 or USB2. Use of eSATA often requires adding a PCIe host card in a desktop workstation or using an eSATA adapter that fits in the peripheral component interconnect (PCI) slot in a laptop computer.

Since most desktop computers can only hold up to four internal drives, having an external eSATA drive enclosure is a good way to create drive space for clone drives, backup drives, and even scratch disks. We like eSATA enclosures for our archive files since the drives live in hot swappable trays, making them easy to transport, mount, and update. It also speeds up retrieving files that need to go into the working file queue.

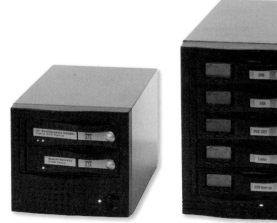

External eSATA drive enclosure

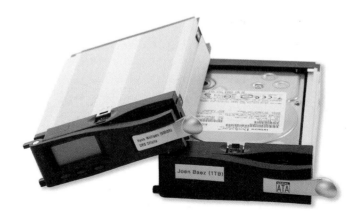

Removable drives

Since eSATA external enclosures use an external version of the internal SATA connection, data transfer is as fast as for internal SATA drives. These enclosures feature removable hot-swap drive trays, making mounting, unmounting, and transporting drives easy.

Other options for external drive connections are Firewire 800 and 400 and USB and USB2. In our testing, we found that Firewire is better supported on the Mac platform, while USB is better supported on the Windows platform. We recommend USB2 over regular USB because it is 40 times faster. Most standalone drive enclosures now feature multiple connectivity and support USB and Firewire 400/800. Some now include eSATA.

travel with one that has a bootable clone of the laptop drive and two that store two copies of the location shoot files.

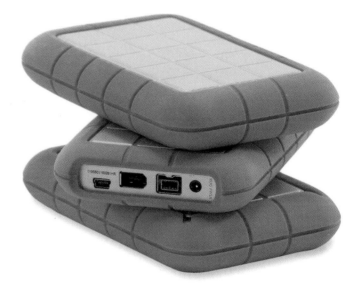

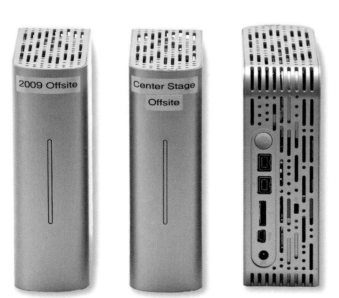

These external drives (above) feature USB, Firewire, and eSATA connectivity. The small pocket drives (below) are great for backing up laptops. We always

Additional Workstation Considerations

Safe computing practice necessitates using battery backups with surge protection to provide clean steady power to the computer and drive enclosures. Another smart safety precaution is to zero out data (write all zeros) to a new drive before formatting and putting it into service.

© Richard Anderson

Chapter 5

The Image Archive

"All changes, even the most longed for, have their melancholy; for what we leave behind us is a part of ourselves; we must die to one life before we can enter another."

—ANATOLE FRANCE

Archive creation and maintenance is often relegated to a chapter in the back of the book or to a series of links that are frustrating to navigate and cull what you need. We believe it is important to deal with creating your archive upfront, even before you do any work. The reality is that most of us already have a collection of image files that have been stored in a method that served the immediate need, with little thought given to a long-term plan. "I was planning on doing that when I have time …" you said? Make the time to create a system. Not everyone has developed a truly thought-out plan for keeping track of their work. Hence, when a client needs to revisit a project or when we want to pull from existing materials or add to an ongoing body of work, we need enormous amounts of time (usually with some help from our buddy, luck) to find exactly what we need. We want to clarify the difference between backup and archive and to give you strategies to build a plan that will work for you, make things more efficient, and protect all of your work and image files.

ARCHIVE VS. BACKUP

There is understandably some confusion between the terms *archive* and *backup*. Using the term *archive* in conjunction with any digital information

can be misleading because archive presumes that something is stored permanently. Currently, no digital media is archival. The most we can hope for is that digital storage is sustainable until we can migrate digital files to a truly archival media.

- Archives are the *primary copy*.
- Backups are *secondary copies* of the same data.

It is the unchanging aspect of this kind of image storage that defines an archive. That's not to say that you will never revisit these files. Depending on your photographic niche, revisiting your archives may happen either rarely or often, particularly if you shoot for stock, art, or personal projects. Commercial photographers who deliver jobs and move on need archives primarily because many of their clients do not have robust DAM systems and are apt to lose delivery files.

ARCHIVE

A collection of images kept in secure storage. There are different kinds of archives that occur at different stages of the workflow:

- Archive original capture files.
- Archive the master files, which contain image optimization.
- We also recommend maintaining an archive of derivative files.

- Migrate all of this to a final archive that is easily searchable and retrievable.

BACKUP

A copy of digital image files whose purpose is to restore the original files in the event of a data loss event. A backup is useful for:

- Disaster recovery due to media failure
 ○ Restore small numbers of files that have been accidentally deleted or corrupted.
 ○ Data loss is very common. Nearly half of all computer users have lost digital files or experienced data corruption.
 ○ Primary working file storage and its backup

We cannot emphasize enough the importance of backing up digital image data throughout the entire workflow process. Think of backups as having an insurance policy, something just in case the unthinkable happens. Eventually, backups become archives. Archives themselves need to be backed up.

Backups are usually:

- Temporary storage
- Created instantly in the case of a mirrored raid
- Created on regular or semiregular intervals either manually or by scheduling software
- Protective of your working files while they are active

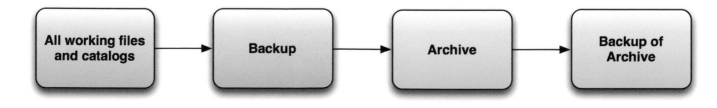

Working files are all files in progress. They are files that are being grouped, rated, image adjusted, and turned into master files, derivative files, delivery files, proof files, and files that will be combined for HDR or panoramic stitching, retouching or composite work. When this work is largely done and you have moved on to newer projects, these working files can be put safely away in a place where they can stay relatively unchanged, the archive.

They can be:

- Camera originals
- Master files
- Derivative files prepared for proofing, printing and delivery

- Files that might be created at any step in the digital workflow, except the final step, the permanent archive

It is important to organize archives so that adding and retrieving images will not affect the integrity of the stored data. The first rule is that both backups and archives should be kept separately from the workstation's main hard drive. This is the drive that has the application and system files. Hard drives or other media, such as CD/DVD/Blu-Ray, or more rarely tape can be used. Hard drives can be either internal but separate, or external drives attached by USB, Firewire, or eSata cables. The use of RAID devices can be considered, although RAID systems (except for mirrored RAID) require their own backups since they are fault-tolerant and not capable of backing themselves up completely.

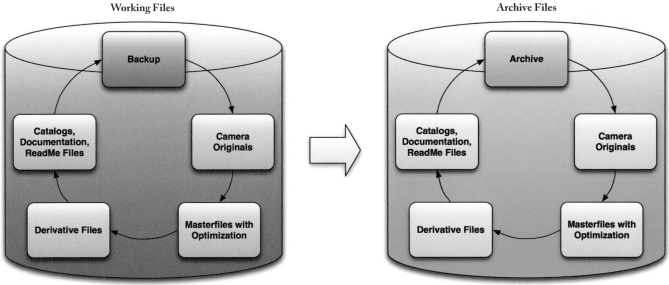

Store Archives and Backups Separately.

DATA INTEGRITY AND FILE TRANSFER

Data integrity is, of course, a core requirement for digital image archives. An important means of preserving data integrity is to use a backup utility to transfer digital image files from the working file drive to the archive.

Use of the Finder application (Mac) or Explorer (Windows) to copy files from the working drive to backup drives and archive drives is potentially unreliable, and there is no verification function. We have found that while using Finder to copy single folders and smaller sets of data is usually reliable, transferring large amounts of data arranged in nested folders is not failsafe. Even the slightest problem with a cable, connection, or power can result in some files not being completely transferred. The Finder application can crash and relaunch undetected during lengthy transfers. Just one corrupt file in a batch of files you are transferring can cause a silent Finder crash, endangering the other files in the process.

Verified Transfer Data

Use of utilities such as Synchronize! Pro X, or Chronosync for the Mac, SyncBack Pro, or Acronis for Windows computers allows verified transfer of image data as well as incremental backups, which are backups that only add new or changed data to the archive. Incremental backups protect against random file corruption by keeping the amount of changed data in an archive to a minimum. Incremental backups are not only safer, but also more efficient since they build on the previously stored data, adding only new or changed data to the archive.

Optical Media

Optical media software has built-in data verification, and we recommend that you always verify burned disks. Disks that have been in storage can be verified against the original data using the burn software, but only if the data has not been changed or if the original burn data or "project" was kept.

Image File Life Cycles—Camera Originals

Image files have different life cycles depending on the photographer's workflow and whether they are camera originals, derivatives of the originals, or delivery files. Camera original JPEG or TIFF files should be archived as soon as they are beyond the editing stage. Since they are written in a standard file format, they

We recommend the use of a verified transfer utility instead of drag and drop

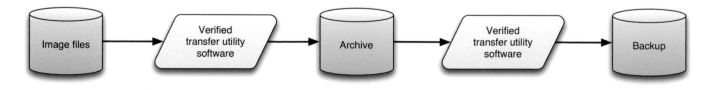

need to be protected from the possibility of being overwritten. Camera original raw files can be archived immediately after ingestion, especially if you do batch renaming and add bulk metadata during ingestion. If that is not your workflow, and you prefer to batch rename and continue to add custom metadata during the edit, you may choose to archive at this point. We have found that it is most useful and efficient to archive after the first round of optimization. This ensures that PIE data is contained in the archived files. Consequently, the camera original raw files (or DNG—digital negative) are backed up and archived after they have been edited and renamed and bulk metadata has been applied along with PIE adjustments. See the illustration below.

While camera original files can be archived immediately after ingestion, waiting until the shoot has been edited, renamed, optimized in PIEware, and optionally converted to DNG will add value to the archive image files.

These adjustments may not be the final adjustments that will ever be made to the files, and we will discuss several strategies for handling PIE updates in archived image files. If you convert to DNG during the ingest step, these files need to be handled similarly to camera raw files. DNG files that are made from edited, renamed, and adjusted camera raw files with metadata applied are ready for archiving. They may be updated just as camera raw files are, although updating DNG files is a safer process for several reasons that we will explain. Master files, derivative files, and delivery files are usually ready for archiving when they are completed. Master files contain the most pertinent data and work, so archiving these is a Best Practice. Although derivative files and delivery files can always be remade from master files, archiving these files is a Best Practice we recommend in case the client loses delivered files. Saving delivered files also provides a record of what was actually delivered and when

What to Archive?

- **Camera originals**
- **Master files**
- **Derivative files**
- **Delivery files**
- **Catalogs**
- **Read Me's—documentation or any materials that will add to the value of the image file**

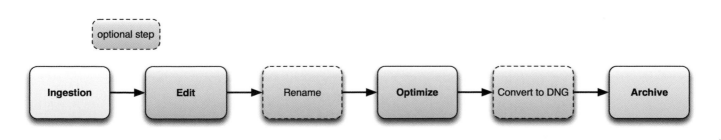

ARCHIVING GOALS

Preserve maximum quality mage data.

- **Store camera originals separate from, or easily distinguished from, copies and derivatives.**

- **Make the archive easy to search.**

- **Have the ability to quickly and easily retrieve images.**

- **Have the ability to quickly and easily migrate images to new media.**

- **Have the ability to quickly and easily migrate image data to new formats.**

- **Build data verification into the archive.**

- **Maintain at a reasonable cost.**

- **Implement the 3-2-1 rule (three copies, two types of media, and one of the copies is offsite/offline) is implemented.**

- **Establish a system that you will consistently use and maintain.**

Digital image files require much more effort to preserve than analog photographic media, and the effort needs to be sustained for the life of the collection. It is believed that with proper storage analog photographic materials can last 500 years or longer. Digital files, captured digital or digitized analog, are much more transient. They are subject to media failure, media obsolescence, computer viruses, corruption, accidental erasure, and format obsolescence. Many are concerned that these challenges to digital preservation may result in a "Digital Dark Age" where the majority of creative output, including digital photography, is lost to posterity. These concerns have driven some photo archives, such as the Historic American Buildings Survey (HABS), to require that archive photographs be produced on large-format black and white film, processed to archival standards, and put into cold storage. The film is scanned to provide working copies, but the film is the archival copy. Digital capture has no such analog backup equivalent unless it is printed or recorded on film. Since only a small percentage of digital photography is ever printed or recorded on film, preserving images requires strategies to ensure long-term, error-free storage, combined with an appropriate method to periodically validate the data and to migrate it to new media and possibly to new formats for as long as someone wishes to preserve it.

Preserving Maximum Quality

Maximum quality for digital image files is achieved by preserving the full extent of the maximum image data. Raw or DNG files currently have the strongest capacity to store image data. The 16-bit TIFF files may be larger, and they certainly can be of very high quality, but undemosaiced raw files actually contain more image data. Since they are undemosaiced, they are typically one-fifth the size of 16-bit uncompressed TIFFs; they therefore go a long way toward making an archive cost effective. Their undemosaiced nature is both a great advantage and a potential disadvantage. It is a great advantage because as PIEware improves over time, so does the potential for increasing image quality from legacy files. Unfortunately, as already mentioned, older raw formats can become unreadable over time. Use of a standardized raw format, such as DNG, can preserve maximum image data, and there is a better chance of avoiding format obsolescence when compared to proprietary undocumented raw formats. Although voluntary documentation of proprietary camera raw formats would be a welcome development, the sheer number and nature of these formats argues against all of them being readable by available standard software as time goes on.

Consequently, to maintain an archive with the highest quality image data, we recommend use of a file format, such as DNG or possibly Phase One's Enhanced Image Package (EIP) format. These formats achieve workflow portability by storing International Press Telecommunications Council (IPTC) metadata and PIE metadata within the file itself. Files that carry this information are a better bet for future readability than file formats that separate the metadata from the raw image data—for example, an image file + XMP side-car file. These formats require maintaining both the file format *and* the interpretation data (XMP) that stores the metadata.

KEEPING TRACK OF CAMERA ORIGINALS, COPIES, AND DERIVATIVES

We recommend separating camera originals, whether they are camera raw or original JPEG, from any copies or derivative files.

Possible exceptions are as follows:

- **Some may choose to either replace proprietary raw with DNG, or**
- **Convert to DNG with the proprietary raw files embedded in them**

Consequently, they may feel secure in eliminating the original proprietary raw files.

Why archive the original captures or converted DNGs, with or without the original raw files?

Maintaining File Integrity and Avoiding Accidental Deletions

It is Best Practice to put camera originals away once and treat that portion of your archive as "read-only."

Write once optical media (CD, DVD, Blu-Ray) fit this criterion. However, it can be more cumbersome and time consuming (storing and properly labeling optical media) compared to hard drives for image retrieval. Hard drives make image retrieval quick and easy, but it is also easy to delete or overwrite image files unless you have procedures and safeguards in place. Keeping original image files separate from derivatives is one such safeguard. A good plan is to determine all the categories of derivative files you normally generate and create a folder structure to accommodate them.

Examples of these categories could be:

- **Camera originals**
- **DNG**
- **Web galleries or proofs**
- **Master files**
- **Derivative files**
- **Delivery files**

There are different schools of thought on the best way to create a workable folder hierarchy. The most important consideration is to build a system that meets your needs and one that you will follow. Folder hierarchy needs to match how your brain works. This requirement is critical so that you will follow your rules and maintain an effective folder structure and system for organizing your work.

Here are two examples of effective, but different, hierarchical systems.

One Method that Richard Utilizes

Although it might seem logical to keep all of these categories in one folder organized by date, job, or project, it is a better and safer plan to put these different

categories of image files in corresponding category folders.

Bottlenecks are inevitable within any workflow, and it can be difficult to eliminate all of them. If you take a pragmatic approach, however, and tackle the very worst first and develop a fix, then the next bottleneck may not be so bad. It may occur in another place, and you will fix that (building on your previous success) and on and on.

Richard found a time-consuming bottleneck in his system. He discovered that when he used the folder structure to the left, he needed to manually import images into his catalog. If he used the automated watched folder option with his folder structure in the left illustration, his catalog would include every file, even those he didn't own, to store in the catalog. The work around was to manually import his chosen files into his catalog = time consuming. Separating files by type, for example, DNG, master files, Richard found that he could fully utilize the automated process of populating the Expressions Media (his chosen DAM application) catalog by means of watched folders. Voila: he eliminated his bottleneck,

and he now has catalogs that contain only the files he wants, with a little up-front work, aka building the folder structure to the right. The problem with putting all file types within a single job folder is that he will have files that he does not want to catalog; for example, html proofs would automatically be added to the catalog.

The directory structure on the right organizes by file type, which is easier to catalog, back up, and migrate. Not only does this method protect camera originals from constant updating of derivative files, but it makes cataloging the archive much easier. The catalog program can auto-update watched folders without adding proofs or other categories to the catalog, and it makes it easier to search for originals, master files, or delivery files separately. Another consideration is that when it comes time to migrate the image data, having the different types of files stored separately can make that process easier. It is likely that proprietary raw files will need to be migrated to another file format on a different schedule from JPEG or TIFF formats. Segregating them from derivative files will make that process easier to automate.

Name
▼ 📁 2008
▼ 📁 08050 Flashes of Hope
▶ 📁 08050 Flashes of Hope delivery files
▶ 📁 08050 Flashes of Hope DNG
▶ 📁 08050 Flashes of Hope proofs
▶ 📁 09050 Flashes of Hope Derivative Files
▶ 📁 09050 Flashes of Hope masterfiles
▶ 📁 08051 Center Stage
▶ 📁 08052 Karen's Garden

Name
▼ 📁 2008
▼ 📁 08050 Flashes of Hope
▶ 📁 08050 Flashes of Hope delivery files
▶ 📁 08050 Flashes of Hope DNG
▶ 📁 08050 Flashes of Hope proofs
▶ 📁 09050 Flashes of Hope Derivative Files
▶ 📁 09050 Flashes of Hope masterfiles
▶ 📁 08051 Center Stage
▶ 📁 08052 Karen's Garden

Another Option that Patti Utilizes

The screen shot above illustrates organizing work by year, with subsequent folders within each year. Notice that the top-level folders to the far left separate the original camera raw files from the masters. The folder hierarchy is by year, then month/day, and it is further identified by location, job, or project. For Patti, this system has proved to be very effective since she revisits work frequently both for her own projects and those of her clients. She is able to locate images based on the folder structure, and at this point in time, she prefers to keep all of the file iterations within a specific job/project folder. The Lightroom catalog is also stored within the folder hierarchy. It is important to note that this folder system does not utilize a dedicated DAM software application. It employs an organizational structure, which she finds to be a natural fit for her personal approach to image management.

Patti's work involves a variety of file types. Image files consist of digital captures, film scans, and two-dimensional reflective materials scans (artwork printed pieces), and a large part of her personal work is using the scanner as a camera. The Scan-o-grams begin as

very large files (up to 1 gig each) before any work is done to the derivatives. These are also stored by year for the original scan captures, PIE work is added, and these become master files. The subsequent derivative files are then stored in separate folders within the year made.

Additional file types include a variety of video and rich media formats, PDF, Word and Pages docs, InDesign files as well as Illustrator and a variety of graphing software formats and Keynote and PowerPoint docs. These documents are also stored by year, subject, and project. Through careful use of metadata and keywording, Patti is able to track and find a wide range of file types over many years.

While a formal DAM would be ideal, like many working artists, Patti has resisted a single-application solution and has adopted a more fluid approach to making it work. It is also important to note that this is an example of a one-person operation. This system does not necessarily make it easy to hand over the archive to another without direction. But in Patti's world, she does not have a need for multiple people searching her archive.

From a hardware point of view, Patti has settled on an external, multidisk, JBOD (just a bunch of disks), eSATA enclosure. This is a highly flexible approach that allows her to hot-swap disks as needed (making it easy to swap drives for backup) and does not write files in a format that ties the drives/files to a particular piece of hardware or RAID. Drives are labeled and dated so that they can be easily tracked for eventual migration.

In summary, we recognize that technology is continuing to evolve, and the needs of users are as diverse as the audience reading this material. Develop a system that will work for you, that will grow as you do, that can be migrated to a possibly more sophisticated system, and above all, create a system that you will use. Whatever system you choose to use, backup is critical and a plan for migration to new media for sustainability is required and must be maintained.

SEARCHING THE ARCHIVE

The value of an archive and its images is dependent on how well the archive is organized and the amount and quality of information contained in the image files.

Images that contain informational metadata, such as descriptive categories, keywords, and IPTC parameters such as date, time, location, and subject are easier to find than images without this information. Images that contain ratings provide more efficiency than those without. Having the ratings in your archive makes it easier to find your most important images and consequently lets you devote more of your time to optimization. Images that contain PIE instruction sets are quicker and easier to process into derivative files than images that do not contain this data.

Organize by cataloging software or by computer directory structure?

Images in archives that are organized with cataloging software are easier to find than images organized only with a computer directory structure of file folders, or images stored on CD or DVD kept on shelves or in binders. When organizing an image archive by means of file folders, either on hard drives or CD/DVD, image files can only reside in one folder. This makes locating images a daunting folder-by-folder task. Duplicating image files so that they can reside in multiple folders creates several logistical problems such as difficulty keeping track of versions as well as increased file storage overhead.

We are waiting (requesting and hoping) for a true cataloging application (DAM) that is also capable of doing PIE work and of exporting standard file formats.

Although setting up a cataloging application is labor intensive, especially if you need to migrate a large volume of legacy image files to it, the enhanced searchability adds value to the archive. If locating image files is important to you or your business, cataloging your archive may well be worth the time and expense.

The popularity of cataloging PIEware such as Lightroom and Aperture is twofold. These applications help users organize their digital images as well as providing tools to manipulate their appearance. Dedicated cataloging software such as Expressions Media, Extensis Portfolio, Canto Cumulus, and others have more robust databases and enhanced feature sets as compared to the current versions of cataloging PIEware, but they share the function of making an archive easily searchable. This is the primary function and reason for using either of these application types.

- can be coaxed into revealing a path by its Manage Referenced Files function, which is intended for reconnecting missing files.

- is able to display a folder tree view when a batch of folders is imported. Once the folders have been imported, the directory becomes virtual, and there is no way to synchronize the directory with the folders on disk.

- does not indicate how many files are contained in a folder.

Folders cannot be moved, and moving files does not change their location on disk.

- is able to display a folder tree view of where an image is kept on disk. By right clicking on a folder in the "folders" pane and choosing "Add Parent Folder" the folder tree view can be expanded to the root level.

- is able to synchronize its contents with the files on disk, though this function automatically removes files that are missing.

Folders that have been cataloged but are missing/not online are grayed out.

Moving files in Lightroom's folder pane moves them on disk, and the number of images contained in each folder and its subfolders is shown.

RETRIEVING IMAGE FILES FROM THE ARCHIVE

If the image archive can be easily searched, image file retrieval also becomes an easy task. Media choice plays a big role in this ability. Hard drive storage is generally quicker to access than optical media. This varies depending on whether the hard drives are constantly connected to a computer workstation, or kept on a shelf to be connected as needed.

The need for random access to the entire archive or just the newest material will vary depending on your business model: assignment photography, stock photography, art photography. Most assignment photographers need to access the newest material intensively and older material only occasionally and, eventually, almost never. Stock photographers, art photographers, and photographers who shoot personal projects may need access

Screen shots of two leading catalog applications, Expressions Media 2 (top) and Extensis Portfolio (bottom). A nice feature of these DAM applications is that they show a file path to the referenced files and an accurate folder tree view of referenced folders. In addition, both programs can warn of missing files and are easily reconnected to folders of files that have been moved. These two features are either missing or more difficult to set up with current versions of cataloging PIEware such as Lightroom and Aperture. Neither Expressions Media 2 nor Extensis Portfolio can perform parametric image editing or convert raw files to standard formats as can Aperture and Lightroom. In summary, none of these applications is yet an "ideal scenario."

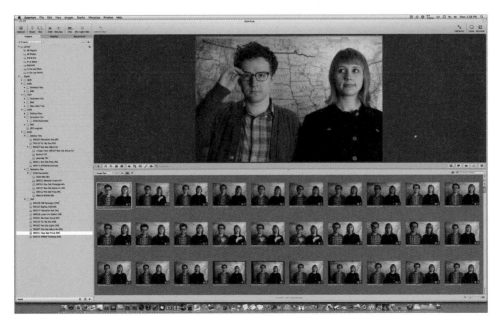

Screen shots of two Cataloging PIEware applications.

These applications create a parallel world to the computer directory structure. Unlike true cataloging applications, they do not show a file path to the referenced files or an accurate folder tree view of referenced folders. Neither Adobe Lightroom nor Apple Aperture will show a simple file path (i.e., ~/User/Desktop/ Cool Images/Stack_0900123_0123.DNG) in its interfaces. Unlike a browser, this view shows only folders that have been cataloged (imported).

to the entire archive more often. If you need quick access to only the newest material, increasing the capacity of the working file backup will make image retrieval most efficient. If the archive is too large to keep efficiently connected to a workstation, then use of a cataloging application is the best way to search, locate, and retrieve image files.

When retrieving archived files, safeguards need to be in place to avoid any possibility of deleting, overwriting, or corrupting files. Use of write-once, read many (WORM) media for archiving image files prevents overwriting or deleting data. However, retrieving files from optical media is not very convenient. Tape drives can be quicker depending on how they are set-up, but they are expensive and few photographers use them. Hard drives are the most cost-effective method of archiving image files. Since they are "live" (you can write to them), they are the most convenient, especially if they are "local" (attached to the workstation). Live and local, though a great attribute for backups, is not the safest scenario for digital image archives. The effects of a power failure, virus, bad RAM, or any variety of computer failures can ripple through a set of attached drives. For this reason, we recommend backing up live, local hard drive setups with at least a second drive or set of offline drives, as well as keeping the files on WORM media. It is ideal to store either the WORM media or the second set of hard drives in an off-site or fire/theft-proof location.

Camera original JPEG files are the most vulnerable and at the highest risk since they can be easily over-written. One should *never* open these archived files from a local attached hard drive. They should either be opened from WORM media or copied temporarily to the workstation hard drive. Thus, if you hit the "Save" button instead of the "Save as" button, you won't be contemplating the loss of the file or going to the backup

media to replace it. Using PIEware to make image adjustments to JPEG camera originals offers another layer of protection since the changes are held within the image files and/or in the PIEware database. When the adjusted files are exported from the PIEware application, there is a warning if you are about to overwrite the original. Lightroom takes this one step further and actually won't allow you to overwrite a camera original, which it calls a "source" file.

Camera raw, DNG, and JPEG and TIFF files adjusted in PIEware present an interesting conundrum for image archives. When stored on live media, there are two options to select from:

- **Keep the archive pristine by copying originals to the workstation before making additional adjustments and then exporting derivatives, or**

- **Push any new adjustments (and/or metadata) back to the archived files by leaving the files in place and working on the originals.**

Lightroom and a "Working" Catalog

One solution for Lightroom users is to maintain a "working image" catalog. This means the archived images are left in place. When it is time to revisit the images, they are imported to the "working image" catalog. New adjustments can be made and derivatives are exported as needed. New image adjustments are not exported back to the archived originals. These images (archived originals) are left untouched in their original location. However, you can push this new XMP data back into those files if and when you choose. The ability to push the XMP data into archived files is a valuable PIEware feature since it allows you to attach newer XMP to older files in the event of an archive drive failure.

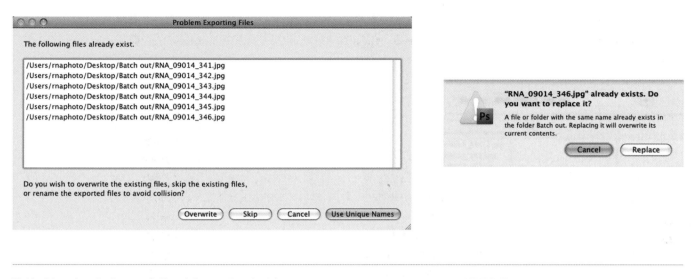

Problem Exporting Files

The following files already exist.

/Users/rnaphoto/Desktop/Batch out/RNA_09014_341.jpg
/Users/rnaphoto/Desktop/Batch out/RNA_09014_342.jpg
/Users/rnaphoto/Desktop/Batch out/RNA_09014_343.jpg
/Users/rnaphoto/Desktop/Batch out/RNA_09014_344.jpg
/Users/rnaphoto/Desktop/Batch out/RNA_09014_345.jpg
/Users/rnaphoto/Desktop/Batch out/RNA_09014_346.jpg

Do you wish to overwrite the existing files, skip the existing files, or rename the exported files to avoid collision?

[Overwrite] [Skip] [Cancel] [Use Unique Names]

"RNA_09014_346.jpg" already exists. Do you want to replace it?

A file or folder with the same name already exists in the folder Batch out. Replacing it will overwrite its current contents.

[Cancel] [Replace]

Unlike Photoshop, Lightroom (left) and Camera Raw (right) protect against overwriting camera original JPEG files.

For many, reworking DNG files and writing the changed XMP and JPEG preview back to the archived DNG is an acceptable risk. This is especially true if the DNG files are kept in a cataloging application such as Expressions Media, which has the ability to update folders automatically. You have verification within a minute or so that the reworked and rebuilt file is okay when the catalog preview is updated. The risk is higher if you are archiving and working from camera raw files. Expressions Media can be set up to build new previews from the raw data, which is a way to verify that the reworked files remain uncorrupted. The risk is lessened when you have a backup copy of the archive, assuming you notice any corrupted files before syncing the primary archive to the backup copy. Having the camera originals on WORM media is your ultimate safety net if the unexpected happens. DNG has an additional capability to store a special data verification tool called a "hash." We will speak more about the usefulness of this tool in the data verification section of this chapter.

MIGRATING THE ARCHIVE

Not much is known about digital longevity on any particular media. What is certain is that digital data deteriorates no matter what media it is stored on. Digital media may also deteriorate and/or fail. For optical media, use the highest quality write-once media since these media use more stable dyes to hold the data. High-quality optical media also has better edge sealing, which guards against the invasion of dye-eating microbes. Keeping the optical media in jewel cases or in CD notebooks (ideally those with archival pages) guards against the three nemeses of optical storage: exposure to sunlight, heat, and scratches.

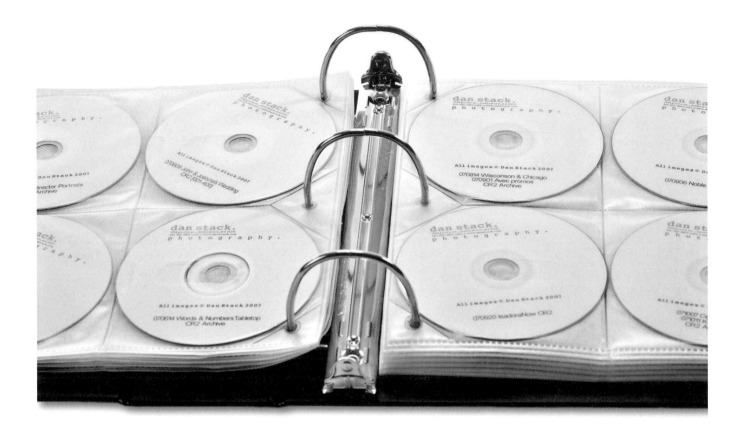

Keeping CD/DVD/Blu-Ray in protected binders with archival pages enhances the longevity of the image data.

To maximize optical media longevity:

- **Never use glued-on labels.**
- **Never write on the disks with solvent-based markers. The glue and ink can eat into the dye layer.**
- **Invest in archival pages or storage boxes.**

We recommend establishing a migration plan for your archive. Rather than worry about whether your CD/

DVD will last longer than the two- to five-year estimates, plan to migrate the data to more current, stable, and potentially larger optical media. Blu-Ray may become a viable option when it becomes cost effective. Current single-layer Blu-Ray disks can replace five DVD disks or over 30 CDs. Blu-Ray has the potential to hold even more data, depending on how many layers are supported.

Hard drives have a useful life span of about five years. The accumulated risk of failure and smaller

size relative to newer, current technology drives make data migration prudent. The rapid increase in drive size has necessitated that the migration of data be done for a more efficient consolidation of the archive before there is a danger of the hard drive failing. The cost per GB of hard drive storage has been cut roughly in half with each advancing year. As of 2009, the average cost is around $0.10. As your archive grows, migrating the image data to larger capacity hard drives can protect against data deterioration and make managing the archive easier. For instance, it is easier to keep track of the well-being of one terabyte drive than a small army of ten 120 GB drives.

Media and file format obsolescence adds to the problem of physical decay or failure of archive and backup media. The only solution is to continually move the data to newer media and periodically convert the image data itself to new formats. Although current storage media may not seem to be in imminent danger of obsolescence, just consider this list of media that now fills landfills, storage trunks in basements, and attics: Bernoulli, Jaz, Clik, Sparq, SyJet, floppy disks of all sizes, 12-inch optical disks, among others. Migrating your archive will ensure that you don't leave viable image data trapped in unreadable media.

Although media obsolescence is a more likely threat than file format obsolescence, there are many examples of data locked in obsolete formats that are unreadable. This is especially true of proprietary formats. Camera makers have already orphaned some proprietary camera raw formats, and we are only a few years into the process. The sheer number of raw formats, many if not most rewritten with every new camera launch, and the fact that they are undocumented, make it unlikely that all of these formats will be readable decades from now.

While converting raw image data to JPEG or TIFF is one strategy for avoiding image format obsolescence, the lossy nature of JPEG and the large size and fixed nature of TIFF are problematic. Converting to a standard raw format is a better choice for image archives. Currently, Adobe DNG format is the only candidate. Still, even DNG files may need to be migrated to a subsequent DNG version or to a replacement format as yet unknown. An important feature of the current DNG specification is that all data is preserved. Even data that is not understood or used by Adobe or third-party software is preserved. Although it is too early to tell how successful it will be, the Phase One EIP format may offer another path. It uses the open ZIP format to wrap up the raw image data with processing instructions and any applicable lens cast correction data. Whatever standard raw solution develops, keeping the raw capture files, proprietary or otherwise, separate from master files and derivative files, as mentioned earlier, will make format migration easier to automate.

DATA VERIFICATION

The primary goal of an image archive is to keep the image data intact. Essentially, all the images stored remain there as uncorrupted files. All digital media is subject to gradual decay, random corruption, and/or total failure. While total failure is a disaster only if there are no other copies, gradual decay or random corruption can be insidious if undetected. It will lead to duplicating bad data when image files are migrated, resulting in image loss.

Data verification begins with checking the media itself. For hard drives, check the mechanics of the drives. Do they spin up and mount? Computer operating systems have built-in utilities to check the integrity of connected hard drives. Checking for bad sectors or other

drive errors and locating the issues is a leading indicator that problems with a drive are developing. A more thorough report can be generated with a SMART (Self-Monitoring Analysis and Reporting Technology) utility. One study concluded that a drive reporting its first scan error was 39 times more likely to fail within 60 days than drives reporting no scan errors. The study also concluded that less than half of drive failures were predicted by SMART error reporting, with 56% of drive failures occurring with no warning. In addition, not all makers of external USB, Firewire, and eSATA drive enclosures support SMART utility reporting, so you may find that it only works on your internal drives.

The next step in image data verification is to check the integrity of the files themselves. Two functions can be used. The first is a utility that can check the structure of the file. This is a standalone operation. It does not need to refer to any previous log for comparison, but looks at the structure of the file and searches for missing headers or data missing from the end of the file (i.e., truncated). Hash checking is the second function that can be used to check file integrity. This verifies a file by comparing a saved hash (typically a 32-digit number that describes in mathematical shorthand what is in a file) with a new hash. The advantage of using a hash check is that it takes less time to run, and a hash can be saved into certain standard formats.

A major advantage of using DNG as an archival format is its ability to contain a hash that describes the raw image data. Periodically checking the hash will verify that the raw image data is unchanged and therefore not corrupted. DNG is uniquely qualified as an archival image format since it has "a firewall" between the underlying raw image data and the XMP metadata and the JPEG preview. Consequently, in practice, a DNG can be reworked; change the XMP data and possibly the JPEG preview, and the hash check will ignore the metadata and preview changes and verify that the raw image data is unchanged. Although several applications can do structural and hash file integrity checks, one that we recommend is Image Verifier. Image Verifier can check JPEG, TIFF, PSD, DNG, and camera raw files for structure and can create hash logs so that files can be checked periodically over time. Image Verifier can also use the hash files built in to newer DNG files made with the 1.2 specifications, released in April 2008.

Current computer operating file systems are based on 20-year-old technologies. The issues we've discussed regarding image file integrity will be moot when the ZFS-based file system is adopted. The Zettabyte File System (ZFS) file system was developed by Sun Microsystems for their Solaris Operating system and could be under development as a supported file system in a new version of Max OS X. The Mac OS X Snow Leopard server operating system has already adopted it.

The ZFS file system features continuous integrity checking and automatic repair of file corruption. It also features snapshots, allowing the user to go back in time and recover a copy of his or her files and directory structure from a previous point in time. This works in a similar fashion to Apple's Time Machine (although Time Machine is not yet based on the ZFS file system).

The ZFS file system would greatly improve and simplify disk storage since it centralizes volume management.

A SMART utility report on the health of a hard drive.

Current file systems reside on single devices (hard drives), which require a volume manager to use more than one drive. This makes formatting, partitioning, and combining drives in various RAID schemes complicated and relatively inflexible. The ZFS file system virtualizes disk storage so that any number of disk drives or disk partitions can be combined and configured in various ways that resemble various RAID setups. The advantage of ZFS is its virtually unlimited capacity. New drives can be added seamlessly, and all data is copy-on-write, which makes snapshot recovery possible. All files are checked end to end for integrity and automatically repaired if an error is detected. The file system maximizes read/write speeds by striping data across all available storage devices, balancing input/output (I/O) so that load and space usage is automatically allocated across the disk drives. Faster drives are used for processes requiring speed, and data is moved from nearly full disks to disks with more available capacity.

The Cost Factor

Digital photography has many hidden costs. Maintaining backups and archives can be one of the most significant costs. Image file storage has a way of sneaking up on you. It seems so easy to shoot digitally, since the cost constraint of buying film and processing is removed, that many of us tend to shoot many more pictures than we did (or do) when shooting film. Other workflow steps have become much more streamlined, computers have become faster, software more capable, and our own familiarity with the workflow process has improved. Consequently, this has led to a greater volume of images and more to archive. The constant increase in native camera file size adds to the burden. Luckily, media storage capacity has kept pace, and the cost of storage has come down.

Storage Capacity

We used to measure capacity in terms of megabytes; now we speak in terms of gigabytes and terabytes, with petabytes soon to come. Hard drives (as we already mentioned) are the most common storage media for photographers, followed by optical media, with a few large studio operations using tape. We predict that tape backup has a very limited future. The future is likely to see a combination of hard disk and solid-state drives (SSDs). Solid-state drives cost more per GB and do not have the capacity of big hard drives, at least for now. Optical media is much cheaper than tape and has reasonable read/write speed but still costs several times more than the equivalent hard drive space. Another cost of optical storage is the time it takes to write, label, and store optical media. This additional time cost leads many photographers to skip optical storage altogether and use it for file delivery or temporary field storage for camera originals. If you do elect to violate the 3-2-1 rule, at least in regard to maintaining WORM media backup, one way to make hard drive storage more like WORM media with its protection against accidental deletion, overwriting, and virus attacks is to make archive volumes "read only." This is easily accomplished by setting volume sharing and permissions on your computer.

The 3-2-1 Rule

The 3-2-1 rule stipulates that you should have a minimum of three copies of all archived image files; a primary copy and two backup copies. One copy should be on a different media from the other two copies. For example, if your primary copy is backed up to another hard drive, there should be a third copy on different media. It is ideal if the second media choice is write once media such as CD/DVD/Blu-Ray. In addition, one of the copies should be offsite. Keeping a set of backup drives offline provides a certain level of protection; keeping them in a separate location protects against many more hazards. A balance needs to be struck so that a weekly backup routine is easy to do but the backups reside at a different address. Many people are able to use an office and a home scenario. If the backup drives are in removable sleds or kept in small cases, the logistics can be fairly easy to manage.

Archive Organization

Part of your archive organization should include a plan to restore either a primary or backup copy of your archive. One method promoted by some DAM experts is to implement a bucket system. A bucket system uses a system of folders the size of the smallest volume of backup media. For example, if DVD is the other media choice, then folders of approximately 4.7 GB are created. These are filled like a series of buckets. This system makes restoration of a hard drive from backup optical media easier and also makes the most efficient use of optical media storage. If you don't like the bucket system, you can use a job, project, or date system. The goal is to create the hard drive media and the second backup media with a mirrored organization. This allows all the data to be restored with confidence that it is all there and in the same order. Having a catalog to refer to during the process is an invaluable aid.

Online Storage

Online storage providers are another option for a digital photography archive. Online services are becoming a popular way to back up laptops, personal files, and other digital data. These services can work well for those purposes but are problematic for large collections of digital image files. Inadequate bandwidth is the fundamental stumbling block. The average broadband speed in the United States is around 1.9 megabits per second (MBS). Theoretical vs. actual speeds can vary widely, depending on the efficiency of the network, time of day, network latency, protocol overhead, driver efficiency, and other technical parameters. In general, you can expect transfer speeds of 40 to 80% of the maximum speed. Also keep in mind that digital images are measured in terms of megabytes (MB), a much larger unit of digital measurement compared to Mbs, the unit in which transfer rates are measured in. Current real-world data transfer times with a fast broadband connection are between 5 and 10 minutes for 50 MB. This translates to 1.5 to 3 hours per GB of data.

While the data transfer times make storage of large archives unrealistic, other impediments exist:

- Cost of storage is high compared to any other method.
- There is no image verification function.
- You are dependent on the online service staying in business
- Liability waivers mean that the service is not ultimately responsible for lost data.
- If you depend on the service for disaster recovery, it could take weeks to download all of your data.
- Internet outage can mean the archive is temporarily unavailable.

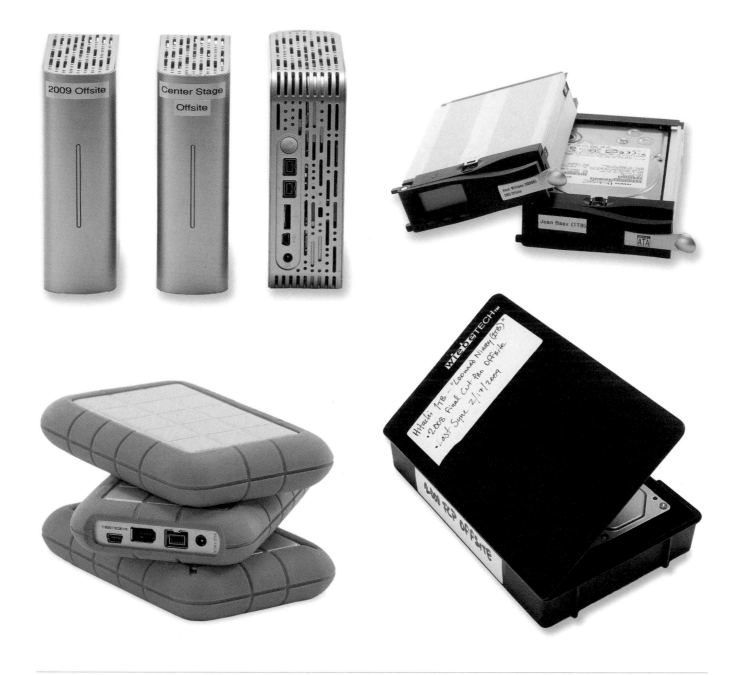

Offsite hard drives can be transported in trays or as bare drives stored in static-protected plastic cases.

An online archive of selected high-value images, or a larger collection of selected JPEG files, however, may be an entirely reasonable solution for someone who cannot easily maintain an offsite backup. If you live in a geologically challenged location subject to earthquakes, floods, or other natural or man-made disasters, then a reasonably sized online archive through one of these services may be a viable option.

ARCHIVE HARDWARE

Since digital imaging workflow is done primarily on hard drive media, it makes sense that hard drive storage is the core archiving choice. Early on we discussed the concept of the workstation (even if that is a laptop) as a process only tool. Additional internal or external drives are used to store the working files and the archived files. There are many options, and all require some thought and planning to determine the best solution for each user.

Internal Drives

Workstations contain a varying number of internal drives. Most laptops only have one drive, so external drives are the only option. Current professional workstations used with any operating system can be configured to take four or more hard drives, and there is also usually an option to install hardware RAID cards. When you consider the need:

- to keep the operating system and applications backed up to a clone,
- for at least one dedicated scratch disk, and
- to have a drive for working files that is also backed up,

it becomes clear that four internal drives may only cover these needs and are not the best choice for even part of an archive. Although more internal drives can be added in some cases by reconfiguring the hardware, we do not think this is a great practice for several reasons:

- It creates a single point of failure with regard to the power supply.
- It taxes the cooling capacity of the enclosure.
- It creates additional risks in the event of fire, theft, flood, earthquake, or other natural disaster.

TripWire

When using external drive enclosures, be careful to distinguish between those designed strictly for maximum throughput using two or more drives in a RAID 0 configuration and those that are single drives. The RAID 0 devices are designed for video editing, which has a high demand on maximum throughput. RAID 0 devices are not good choices for archives because failure of one drive will result in loss of all data on both drives.

External Drives

External drives attached to one or more computers are a safer and more efficient method of hard drive storage configuration than relying on internal drives. When choosing the best type of external drive setup, ask yourself how much of the archive needs to be instantly available? For many, a single 500 GB or 1 TB external drive will cover 90% of what is needed on a daily basis. For others, it might be a much larger amount, much more than can be accommodated on a single drive. When larger amounts of data need to be easily and quickly accessible, the single external drive can be replaced by:

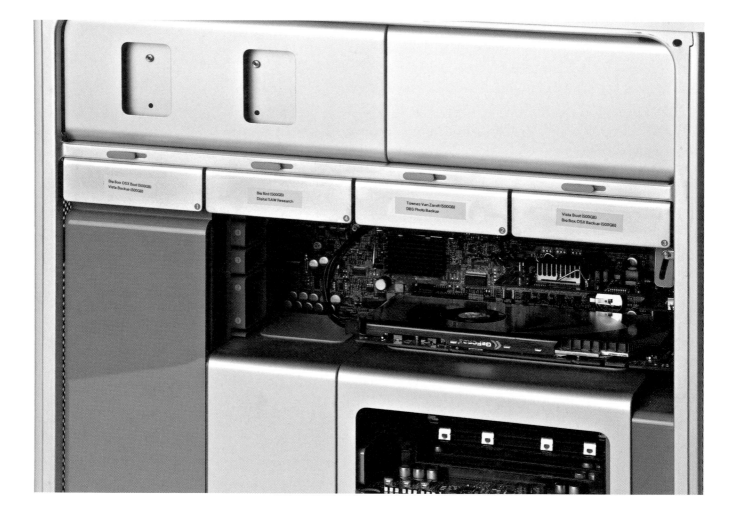

Four internal drives in a Mac Pro Tower. While tempting to use some of this drive space for backup and archive, it is a better choice to use it for scratch disk(s), system boot clone, and working files.

- **multiple drive setups such as RAID volumes, and**
- **JBOD (just a bunch of disks) enclosures.**

When multiple workstations require access to the archive, one workstation can act as a file server, or there can be a computer that is a dedicated file server. When access to the archive is often required from remote locations, an NAS (network attached storage) drive enclosure is an alternative to accessing a file server/workstation. NAS enclosures are limited by the speed of the Ethernet connection, which is currently much slower than USB2, Firewire, or eSata.

The simplest setup is a standard USB or Firewire connection to a single external drive enclosure. Currently, USB2 connections for PC workstations and Firewire 400 or 800 connections for Mac computers offer the best speeds and compatibility. USB3, which is in development, may become the new standard for both platforms. Faster transfer speeds can be obtained with eSata connections, but they often require installation of an eSata host card.

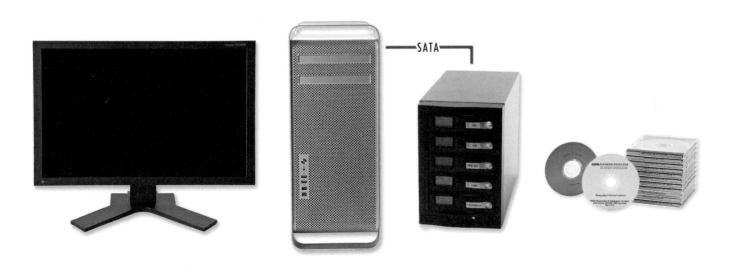

Single workstation with external drive enclosure. Duplicate hard drives are kept offsite. Use of optical media backup completes the 3-2-1 strategy.

The minimum backup/archive setup: A single workstation or laptop with files backed up to an external drive and optical media. This setup is more suited to backing up your work in the field.

If you find that you are daisy chaining several single external drive enclosures, or constantly having to plug and unplug drives to access image files, it may be time to consider a multidrive enclosure. Multidrive enclosures can normally hold between two and eight drives. They come in a large variety of designs, connection types, and configurations. The most flexible designs have built-in hardware RAID controllers and USB2, Firewire, and eSata connectivity. Since eSata is essentially a direct connection to SATA drives, it avoids the slight inefficiency that occurs with USB and Firewire connections. These require "bridge" device to translate the data to the SATA drive. This makes eSata the current fastest connection to external drives or drive enclosures, several times faster than USB2 and Firewire 400/800. eSata also supports hot-swapping of drives.

Single-workstation backup and archive with external USB2 or Firewire drives and optical media.

Recently, inexpensive multidrive enclosures with built-in RAID, such as the Drobo from Data Robotics, have become popular for maintaining digital photo archives. Although they do not provide fast eSata connectivity, they are simple and easy to set up and use. If you are using RAID devices for digital photography archives, understand that with the exception of RAID 1 (mirrored RAID), RAID offers fault tolerance but is not a backup onto itself. If you keep your archive on a RAID device, that device must also have its own backup before the archive can be considered secure and completely protected against loss of data.

THE IMAGE BANK AS
A WORKING ARCHIVE

Before we leave the subject of archives, let's examine the needs of photographers who work in organizations where a group of photography users (clients) need access to pictures, while the integrity of the archive is maintained. This can be accomplished by creating a "working archive," although we think that image bank is a better term. The image bank is a collection of derivative files made from the camera originals. The working archive, or image bank, sits on top of the true archive, the camera originals. It often represents a selection of the best (most highly rated) images culled from the main archive. The difference is that the image bank usually consists of JPEG or TIFF derivative files

that have been processed through PIEware for color, exposure, and tone and may also be capture sharpened. The most useful implementation of an image bank is to organize the image files in a catalog application that has a client/server function. This allows users of the image bank to access the files through client catalogs that they maintain on their desktop. They can use the catalog to search for the images they need, utilizing agreed upon metadata protocols set up by the image bank administrator. The client catalogs are small, lightweight, and quick to use, since they are built with small proxy JPEG previews. When users locate the images they need, they connect to the server containing the original JPEG or TIFF files, and download the high-resolution files to their desktop.

The advantage of this system is that it provides a group of users access to a photography collection in the form they need, which is ready to go high-resolution image files. The archives of camera originals are protected from any danger or from having reworked files saved back to the archive. Properly administrated, it can save users time while maintaining image quality. The camera original (preferably a camera raw or DNG) can always be accessed in the event that a file needs to be produced in a very large size or needs special processing. For this system to be the most effective, having an archive of raw or DNG files saves space and provides a better resource for any additional repurposing of files than an archive of uncompressed TIFF files.

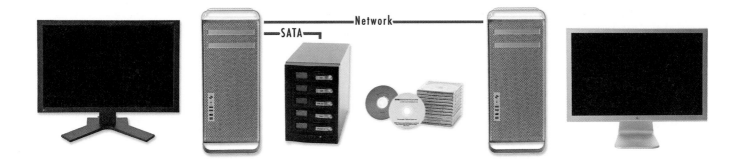

Two workstations can share the external drive enclosure over a network. Transfer of image files over a network can be slower than USB2, Firewire, or eSata, and some PIEware cannot access catalogs over a network. It is best to use a file transfer utility such as Synchronize Pro X for Mac or Chronosync for PC when transferring image files across a network.

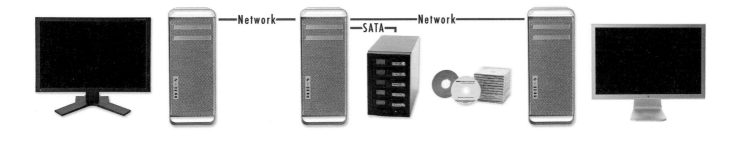

A dedicated file server allows multiple workstations to share the archive over a network. The file server can be replaced by an NAS (network attached server) box, which is a standalone file server. Either system can allow remote access to the archive.

© Patricia Russotti

Chapter 6

Image Capture

"You don't get creative by staying in the same place."

<div align="right">

—*ANDY LAW*

</div>

Digital photography's goal is no different from that of shooting with film: capture and achieve the best translation of the scene (from your vision) to a photographic image. The difference is simply how the "data" captured—now 1's and 0's, not a film negative (or positive)—holds the image. In the realm of professional photography, this requires understanding all the choices and making appropriate decisions as to the best match of image quality to workflow needs.

SHOOT PARAMETERS

Some people shoot a lot to get a lot. Some people shoot a lot to get a little. Some people shoot a little to get a little.

<div align="right">

—Jeff Shewe quoted in a Lightroom video.

</div>

The first step of the workflow is to understand the shoot parameters. Does your assignment require you to shoot a little or a lot? Are you after a few "hero" images, or do you need to create many useful images—perhaps to tell a story through images? What are the light conditions? Do you need to work with ambient light only? If so, is it a consistent color temperature, or will you be working indoors and out, going from strong light to low light—then to almost no light? Will the lighting vary from flat to contrasty and back again? Will you be controlling the light with studio flash, handheld flash, or continuous lighting? How much time and control will you have? Is your style and preference to get it "right" in the camera, or do your style

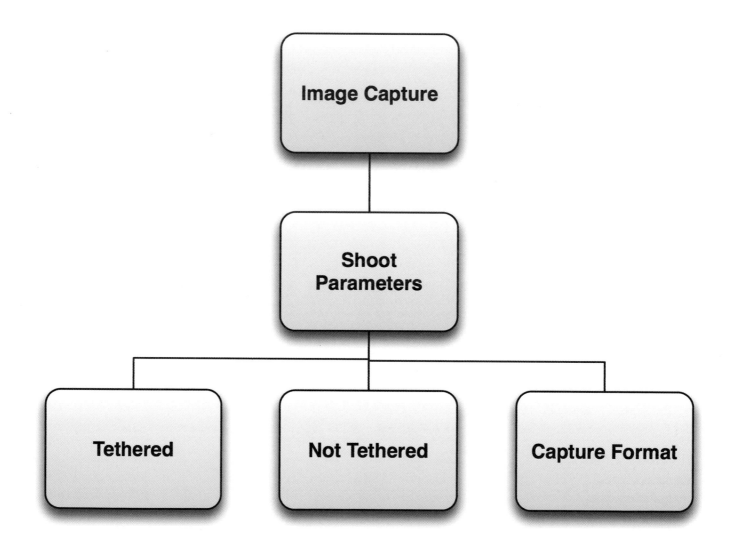

or assignment parameters suggest that artistic vision develop throughout the process from shoot to final image, which may be blended, retouched, composited, combined, stitched, or processed as a high dynamic range (HDR) image? What are the criteria for the final output? Screen or substrate, or both? Traditional offset press or digital press, or both? Big output or little output? What are you to do when you have only a little piece of the delivery image?

The answer is to collect as much information as possible about the final use of the images. You should understand what that means in relation to the kind of file that needs to be delivered and how that dictates image capture.

Tethered Capture

An important parameter concerns whether the shoot will be done with the camera tethered to a computer (or an external monitor). While one advantage of digital is that images are instantly available as thumbnails on the back of the camera, these instant "digital Polaroids" can also be transferred to external monitors or as processed images by using software that imports the images from the camera to the computer. Many types of photo shoots are collaborative. A team approach may include art directors, graphic designers, and clients. Often it is an advantage for a stylist or makeup artist to collaborate during the shoot as well. Even the talent (or portrait subjects) may be easier to direct if they can see the images as they are captured.

Some important considerations for tethered shooting are as follows:

- Does the software application have camera controls?
- Does it have transfer speed?
- Can parametric image presets be applied?
- Can metadata be applied?
- Will the files be written to both memory card, disk?
- What might happen to the images being transferred if the camera connection is interrupted?

When shooting is tethered, there can be a speed difference due to the operating system (OS) and the connection type. The camera manufacturer's software for Mac computers can be slower with USB2 connections than with Firewire. The trend seems to be toward USB2 for newer cameras. This has meant that tether transfer speeds have become significantly slower for cameras with USB2 cables connected to Mac computers. Aware of this change, some have taken advantage of the dual boot capabilities of Intel Macs to run a Windows partition for tethered capture. Others have invested in a Windows laptop for tethered shoots. This is probably a temporary situation, as Apple seems to be withdrawing support for Firewire in favor of USB2. USB3 is in development and, when available, may make this whole discussion moot.

Wireless connections are also possible. Currently, slow transfer speed and finicky setup have resulted in limited adoption. Wireless will undoubtedly become a viable option soon.

Canon has just introduced a wireless file transmitter for the Canon 5D MKII that allows you to wirelessly transfer the photographs from your **Canon** 5D Mark II to a Wireless LAN Access point or straight to your computer. The most interesting aspect of this device is the option to shoot tethered via 1 Gigabit Ethernet, which allows for data transfer speeds of over 150 MB/s. Compare this to Firewire 400's 50 MB/s or Firewire 800's 100 MB/s. Gigabit Ethernet would also break the 30-foot limitation of Firewire cable by allowing tethered shooting at lengths up to 300 feet.

If shooting is tethered, set the software preference to save image data to the camera card as well as transfer it to the computer or hard drive.

If the tethering software doesn't give you the option of simultaneously capturing to card and computer, be aware that you are risking data loss. The best solution is to send the data to a hardware-driven RAID 1 device. Another possible solution is to daisy chain portable drives and use the operating system's software to configure the two drives as a RAID 1 volume. This solution will write data slightly slower than a hardware-driven raid. If that setup seems too complicated, you can simply use a backup utility to sync the two portable drives.

Example: Capturing a hair-swirl took only six digital exposures when the model was able to see each image instantly displayed on a monitor.

Canon EOS Utility preference panel for remote (tethered) shooting indicating that image data will be saved to the camera memory card as well as to computer disk.

CAPTURE FORMAT

Digital cameras can record images as raw data, or they can process raw data into JPEG, or less commonly into TIFF file format. Many cameras can record raw + JPEG, giving you the option of a processed and an unprocessed version of each image. We will explore the features of these format choices, as well as the pros and cons of each choice within workflows for various job types.

Raw Capture

As stated earlier, we like to think of raw capture as the ultimate "latent image." The data can be processed as many times as one chooses from the original capture information. Raw files consist of all the image data recorded by the sensor. They also contain information (metadata) such as EXIF data, camera settings, and arcane data known as "Maker Notes." The vast majority of digital cameras in use today use a Bayer pattern sensor. The exceptions are the Foveon X3, scanning backs, and multishot backs. However, all sensor types require the conversion of what is essentially black and white luminance values to RGB (red, green, and blue) color. We refer to the image data, before this conversion, as raw image data.

There are two types of raw format: proprietary raw files—which we will simply refer to as **raw**—and the standardized nonproprietary raw format **DNG** (digital negative.) At this juncture, both DNG and raw are in use as a capture format, although proprietary raw format is much more common, especially in mainstream camera models such as Canon, Nikon, Sony, Olympus, Phase, and Leaf. Only a few camera models shoot DNG as a capture format.

DNG Capture

One of the primary differences between proprietary raw and DNG is the location of metadata. This is known about DNG and is openly documented. In proprietary raw files, metadata location is not standardized or documented. This is an important difference. Raw capture formats are developed in conjunction with every new camera. Since newly released cameras have new and different raw formats, the quantity of proprietary raw formats is accumulating.

> Adobe alone supports 211 separate raw formats. That number has been growing every year. Consequently, when you buy a new digital camera, you may have to wait several weeks (or longer) before its raw format is supported by your workflow applications. Third-party developers need to get their hands on the new camera before they can reverse engineer its raw format and profile (characterize) its sensor response.

A camera that shoots DNG does not need any reverse engineering; the placement of all metadata, even maker notes, is known. DNG format (unlike raw) supports embedded camera profiles. Native DNG files have the camera maker's profiles already embedded —profiles that will be used by parametric image editors that read DNG. Adobe Camera Raw and other parametric image editors will add their own profiles with software updates. The important point in the interim is that you are able to open and adjust the DNG files.

Two additional advantages of DNG over proprietary raw are image validation and the ability to embed a custom camera profile. Both features are unique to DNG. We will discuss the embedded profile feature in the optimization section and the image validation in the archive section.

Proprietary raw files can be converted to DNG at ingestion or at any other point in the workflow. We will discuss why and when you might want to introduce this step into your workflow.

RAW CAPTURE ADVANTAGES

1. Maximum image quality can be obtained.

2. Image quality of legacy files can be improved over time as parametric image editors improve.

3. White balance can be applied after the fact, alleviating concern for "nailing" white balance on capture.

4. Output can be of 16-bit depth, a major advantage for postprocessing.

5. Good flexibility is possible in adjusting exposure and brightness values.

6. All adjustments are nondestructive, meaning the digital negative can be reprocessed an infinite number of times in a variety of software applications.

RAW CAPTURE DISADVANTAGES

1. Raw format is larger than JPEG (but smaller than TIFF). Storage media fill up faster, as do camera buffers fill, meaning that fewer shots can be taken before the camera will pause.

2. Proprietary raw formats may become unreadable at some point in the future.

3. Processing raw files requires a computer, special software, and time.

4. Raw files require more storage space than JPEG files (but less space than TIFF).

5. Proprietary raw files can take a while to be supported by third-party processors. Buying a new camera may break your workflow for a period of time.

6. Proprietary raw files are not good candidates for storing custom metadata. In fact, most software applications refuse to embed any type of metadata in them, forcing the use of sidecar files or storage of the information in a database or folder.

7. The only standardized raw file format, DNG, is not supported by all raw processing software, limiting the variety of parametric image editors that can be used with it. (The list is growing, however.)

Recommendation

We recommend raw capture for most job types and most workflows. The postprocessing flexibility and image quality usually override the additional time raw requires over JPEG capture. If the original JPEG capture does not have perfect white balance and exposure, then making batch corrections can take as long or longer than with raw, and the results will be inferior.

Raw + JPEG Capture

Many DSLR (Digital Single-Lens Reflex) cameras can be set to shoot raw files and JPEG files in a single capture. Camera settings, such as white balance, tone curve, color space, picture style, and sharpening, will be reflected in the JPEG. The raw files will be available for further processing. Shooting raw + JPEG can solve some workflow problems but create others.

RAW + JPEG CAPTURE ADVANTAGES

1. The JPEG file is immediately available for use.

2. A raw file is available for additional processing.

3. Two files captured for each exposure creates a backup in the rare case of file corruption.

4. Transfer times are reduced during tethered shooting—if only the JPEG file is transferred.

RAW + JPEG CAPTURE DISADVANTAGES

1. Storage media fills up even faster than when shooting raw only.

2. Camera buffers fill faster.

3. Transfer times are longer when both files are transferred during tethered shooting.

4. If a software application is set up to treat raw and JPEG as separate files, it may number them as separate files, which can be confusing.

5. It can be difficult to make raw files match the "look" of camera-created JPEG files, creating color consistency problems when matching camera-created JPEG "proof" files and final files. Clients who approve a shoot based on the camera-created JPEG files may be surprised by the appearance of the processed raw files.

6. Additional storage space is required to archive shoot files.

The decision regarding whether to shoot raw + JPEG will depend entirely on workflow needs. For some,

it represents the best of both worlds, and for others, the disadvantages of both.

JPEG Capture

For many point-and-shoot cameras, JPEG capture is the only option. Some medium-format backs shoot only raw, while others can shoot JPEGs, and raw + JPEG. Most DSLR cameras shoot raw, JPEG, or raw + JPEG.

The essential features of JPEG capture are that the camera shoots a raw file and applies camera settings, such as white balance, sharpening, tone curve (contrast), and saturation (also known as picture styles—vivid, neutral, portrait, etc.). The raw file is then processed out to a JPEG, and the original raw data is deleted. As the raw data is processed, it ends up in a user-determined color space, such as narrow gamut sRGB or wider gamut Adobe RGB (1998). Both of these color spaces will be smaller than the gamut potential of the sensor.

Cameras that shoot JPEG generally have size and/or quality options. Size refers to the pixel dimensions (resolution) of the captured file, and quality refers to the amount of compression applied to the saved JPEG. Most of the time, there is no good reason to shoot at less than the maximum image size. The case for shooting at the highest possible JPEG quality (least compression) is not quite as clear-cut. Increasing JPEG compression will result in more compression artifacts, and these artifacts will become more visible as the compression levels increase. Depending on the camera, there may be only three, poorly defined quality levels available to choose from: fine, normal, and low. If this is the case, it is always best to choose "Fine." More sophisticated cameras may offer a sliding scale (1–10) for example. Unfortunately, there is no defined stan-

dard for these sliding scales. If you wish to test JPEG files for artifacts at different quality settings, the best method is to shoot something with hard edges (like a building) and look carefully in the red channel for artifacts.

Although lossy compression is the main feature (some say benefit) of JPEG capture, there are other factors to consider. One is bit depth. Standard JPEGs provide 8 bits per RGB channel vs. 12-bit, 14-bit, or 16-bit depth per channel for raw capture. This lower bit depth puts more constraints on image edits. Because repeated edits and JPEG saves will degrade images, care must be taken to avoid saving over JPEG originals.

JPEG CAPTURE ADVANTAGES

1. JPEG files are smaller than raw files, so the storage media will hold more images.

2. Most cameras can shoot JPEGs more quickly than raw, and camera buffers do not fill as quickly.

3. JPEG files, being smaller, are quicker to transmit electronically.

4. JPEG files are immediately available for use, not requiring a processing step on a computer.

5. JPEG originals, if shot carefully, can be of very high quality and are sufficient for many applications and job types.

JPEG CAPTURE DISADVANTAGES

1. It is much more important to get the white balance correct when shooting. Accurate white balance requires constantly creating custom white balance settings. This can be time consuming unless the lighting is controlled and consistent.

2. During optimization, adjusting parameters such as white balance, exposure, contrast, and saturation is less easily done as compared to what's needed for raw and can result in a deterioration of image quality.

3. The camera determines image quality. There is less chance that image quality can be improved upon via software updates and improvements as is possible with raw files. All the capture and camera data is embedded (baked) into the pixels when the exposure is made.

4. JPEG camera originals can be easily overwritten if picture edits are made and then saved with the same file name.

5. JPEG files that are edited at the pixel level and re-saved will degrade slightly in quality with each save.

6. Although parametric image editing of JPEG files is possible in parametric editing applications, such as Lightroom/Adobe Camera Raw, Aperture, Bibble, and others, those edits are not as effective as they are for raw files. In addition, the edits are only visible in the program that created them or when they are output to a new JPEG or another standard file format. When PIE work is used for JPEG, it also requires paying close attention to how each of the applications preferences is set.

7. The ultimate quality that the camera can provide is discarded along with the original raw data.

Although we recommend raw capture for most job types and workflows, there are cases where JPEG capture may be appropriate.

TIFF Capture

Although some earlier DSLR cameras offered a TIFF capture option, TIFF capture has largely given way to JPEG or raw/DNG capture. TIFF capture doesn't have the compression and therefore small size advantage of JPEG. Nor does it have the nondestructive adjustability of raw files, since TIFF capture bakes in camera settings the same as JPEG capture. TIFF capture is more unwieldy than raw because it has been processed (demosaiced) by the camera, and so will be approximately three times larger than a raw/DNG file. As the megapixel counts of cameras have grown, the corresponding TIFF size has made TIFF capture largely impracticable from both a speed and a storage standpoint.

Exceptions, but important ones, are digital scan back cameras and multishot cameras. These cameras do not use Bayer pattern filters. They capture RGB channels separately, either as a scan or as three separate shots. While the makers of these cameras sometimes refer to their output as raw data, files are actually three channel TIFF files.

Since these cameras are slow in operation, and the point of using them for image capture is to achieve the ultimate in resolution and quality, TIFF capture is not an impediment.

TripWire

Some cameras shoot raw files with the .tif extension; however, these are actually raw files. To add more confusion, they sometimes have small "preview" TIFF files embedded, which may be confusing when the files seem to open in normal software, but with low (preview) resolution. Fortunately, these manufacturers have stopped using the .tif extension for their raw files

Capture Standards

Although it is difficult to quantify the concept of image quality, there are guidelines to consider when choosing a camera for any given photography project. The table below translates megapixels into final document size at the assumed standard of 300 pixels per inch.

We use the term *guidelines* rather than *standards* in regards to matching sensor size to document size. There are several reasons why calling the information in these tables "standards" would be problematic. A high-quality JPEG will be a fraction of the size of an uncompressed TIFF, and if saved at the minimum compression (12 quality) in Photoshop, it will be visually indistinguishable from a TIFF. Since compressed and uncompressed file formats can provide the same level of quality in print, we cannot say that there is a strict relationship between file size and document size. Additionally, it is the interplay between megapixel rating, sensor size, ISO setting, lens quality, camera technique (focus, lighting, camera stability), and optimization methodology that makes a straight megapixel size to document size chart only a guide, not a standard. If a highly detailed subject is captured under comparable conditions, ISO setting, and lens quality, and aperture, the additional detail provided by a larger sensor (both physically larger and containing more photosites/megapixels) will still be evident even in a small print. In our next section (tools), we will discuss sensor types and sizes that are currently available.

RGB TIFF at 300 ppi
(offset printing default for 150 line screen)

Double Page (A3)	50 MB
Full Page (A4)	25 MB
Half Page (A5)	18 MB
Quarter Page	6 MB
Eighth Page	3 MB
Billboard	48 MB*

*at 600 ppi. 300 ppi is acceptable, i.e. 24 MB

Sensor Size (MP)	Approx. size at 300ppi	Approx. 8-bit TIFF size
3413 x 5120 (17.5MP)	11 x 17 inches	50 MB
2731 x 4096 (11.2MP)	9 x 13 inches	32 MB
2048 x 3072 (6.3MP)	7 x 10 inches	18 MB

Guidelines for Document size to some standard publication uses

Guidelines for the relationship between Sensor Size, Page sizes and 8-bit files

Digital Sensor Native Print Sizes at 300ppi

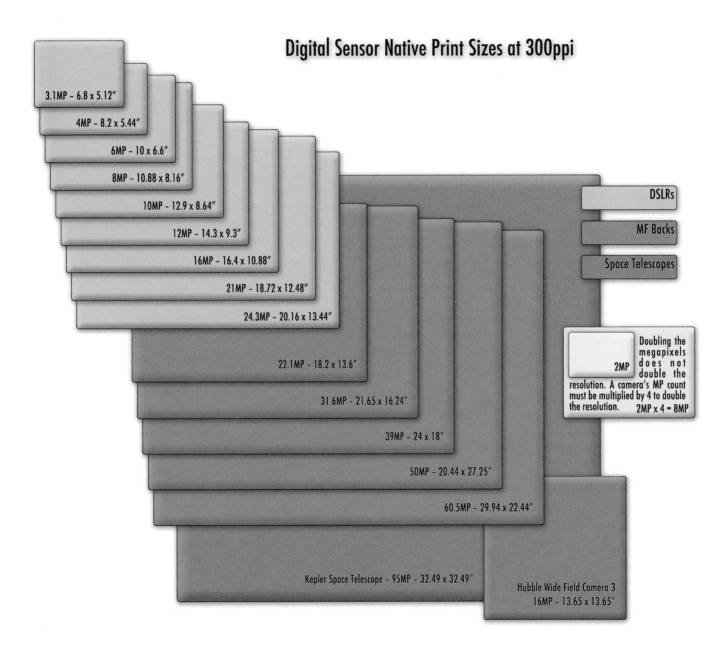

3.1MP – 6.8 x 5.12"

4MP – 8.2 x 5.44"

6MP – 10 x 6.6"

8MP – 10.88 x 8.16"

10MP – 12.9 x 8.64"

12MP – 14.3 x 9.3"

16MP – 16.4 x 10.88"

21MP – 18.72 x 12.48"

24.3MP – 20.16 x 13.44"

22.1MP – 18.2 x 13.6"

31.6MP – 21.65 x 16.24"

39MP – 24 x 18"

50MP – 20.44 x 27.25"

60.5MP – 29.94 x 22.44"

DSLRs

MF Backs

Space Telescopes

2MP

Doubling the megapixels does not double the resolution. A camera's MP count must be multiplied by 4 to double the resolution. 2MP x 4 = 8MP

Kepler Space Telescope – 95MP – 32.49 x 32.49"

Hubble Wide Field Camera 3
16MP – 13.65 x 13.65"

MATCHING CAMERA TECHNOLOGY TO WORKFLOW NEEDS

Despite tension between the race to higher resolution (megapixels) and the overall image quality (IQ), digital camera technology has been advancing at a steady rate. New cameras in every category are generally better than preceding models. Yet higher megapixel counts have sometimes preceded the ability to achieve higher image quality. Manufacturers, however, have been extremely clever in overcoming issues that occur with packing more photosites into the same-size sensor. As a general rule, bigger sensors and bigger photosites on a sensor can achieve higher image quality. This is only a general rule since many other factors enter into the equation.

Sensor Type (CCD, CMOS, Foveon CMOS, Trilinear Array, Multishot)

Although CCD (charge-coupled device) preceded CMOS (complementary metal oxide semiconductor) chips to market, most smaller sensor cameras (up to full-frame 35 mm) use CMOS chips. The larger sensors found in medium-/large-format cameras are currently all CCD technology. At this point, both technologies can achieve the highest image quality. The Foveon CMOS sensor has great potential; unfortunately, that potential has not been fully realized since it is not available in high-end cameras. The trilinear array (digital scan back) cameras and the multishot cameras (the red, green, and blue channels are captured in three separate exposures) are generally reserved for special uses such as museum photography. Some intrepid photographers, such as Stephen Johnson, continue to prove that every rule can be broken by using digital scan backs to create photographs of exceptional quality, even of dynamic landscape subjects.

Sensor Dimensions

Digital sensors come in a wider variety of sizes than we were used to with film formats. They range from the tiny (5.76×4.29 mm) to the large (53.9×40.4 mm).

A few even larger sensors are being made, such as Fairchild Imaging's 81-Mpixel CCD595 3×3 inch sensor, but they are generally floating around in space taking detailed pictures of the Earth. Larger sensors can hold more photosites (or more photosites that are larger). Both are an advantage from the standpoint of resolution and image quality. Another important factor for photographers to consider is whether the sensor is "full frame" or whether it will crop the lens's angle of view. Equally important is the aspect ratio. Some photographers are used to and prefer the 35 mm 1.5 : 1 ratio, while many others are wedded to the 1.33 : 1 ratio of the medium format. The 1.33 : 1 ratio fits normal publication page sizes better and is often preferred for that reason. The so-called crop factor was an impediment for many photographers in the early days of digital capture. Some have grown to like its advantages, whereas others were relieved when full-frame sensors allowed full use of wide-angle lenses. Since digital sensors are not tied to any particular film format, needing only to be compatible with lens coverage, we wonder why there hasn't been more innovation in aspect ratios. Why wouldn't we have a 1.33 : 1 or even a 1.25 : 1 DSLR sensor that uses the full 36-mm width, that is, 36×28 mm or 36×29 mm?

Pixel Pitch (relative size of the photosites/pixels)

Increasing the number of megapixels results in higher resolution, but also in smaller photosites (pixels). Photosite size is referred to as the pixel pitch. Smaller photosites gather less light, so they have less signal strength. Less signal strength, all other things being

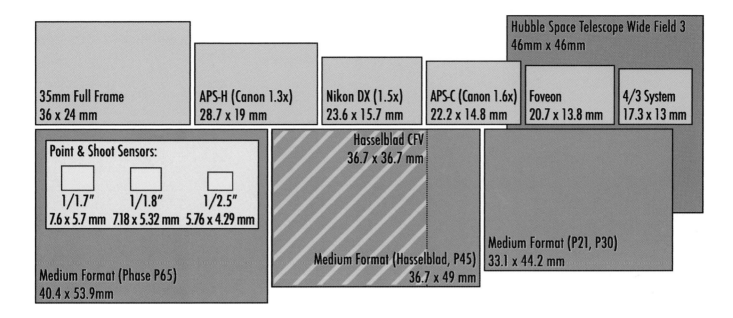

Hubble Space Telescope Wide Field 3
46mm x 46mm

35mm Full Frame
36 x 24 mm

APS-H (Canon 1.3x)
28.7 x 19 mm

Nikon DX (1.5x)
23.6 x 15.7 mm

APS-C (Canon 1.6x)
22.2 x 14.8 mm

Foveon
20.7 x 13.8 mm

4/3 System
17.3 x 13 mm

Point & Shoot Sensors:

1/1.7"
7.6 x 5.7 mm

1/1.8"
7.18 x 5.32 mm

1/2.5"
5.76 x 4.29 mm

Hasselblad CFV
36.7 x 36.7 mm

Medium Format (Hasselblad, P45)
36.7 x 49 mm

Medium Format (P21, P30)
33.1 x 44.2 mm

Medium Format (Phase P65)
40.4 x 53.9mm

equal, results in a less efficient signal-to-noise ratio, and therefore more noise. This effect is much more pronounced at higher ISO settings because increasing the ISO setting requires cranking up the amplification of the signal, which increases the noise level. This is why point-and-shoot cameras produce noisy images at high ISO settings and why the Nikon D3 with its large pixel pitch (8.4 μm) has much lower noise at high ISO settings than a point-and-shoot that might have a pixel pitch as small as 1.7 μm. CCD chips, commonly used for medium and large-format sensors, tend to generate more heat than CMOS sensors. More heat contributes to noise. Some medium-format backs have active cooling to counteract that effect. CCD chips in cameras used by astronomers are cooled with liquid nitrogen to combat noise at the long exposures required for that specialized type of photography.

Pixel Pitch and Diffraction

Smaller photosites can also affect image quality due to an optical effect known as diffraction. Diffraction limits image resolution, nullifying the gains of higher megapixel counts when the lens is stopped down. As photosites get smaller, diffraction occurs at a larger f-stop. For instance, a point-and-shoot camera's resolution can become diffraction limited between f/4.0 and f/5.6, whereas a full-frame DSLR with large photosites will not become diffraction limited until between f/16 and f/22.

Keep in mind that cameras with smaller sensors have a higher depth of field at any given f/stop, so this is not quite as limiting as it might appear. Still, the effect is noticeable enough that a review of the Canon D50 (15.1 megapixels) concluded that it required higher

quality lenses to realize the same image quality as its predecessor, the Canon D40 (10.1 megapixels).

Medium-format sensors are becoming just as crowded as some higher resolution DSLR sensors. Since medium-format lenses are longer for any given angle of view, achieving great depth of field may result in loss of detail at small apertures with high megapixel count sensors. Medium-format camera makers have joined DSLR manufacturers in touting new digital lenses that claim to have higher-resolving power and that have wide-angle lens designs that aim to send light waves at straighter angles back to ever smaller photo sensor sites.

A tutorial on diffraction issues and digital cameras is available at Cambridge Color.com. Another important discussion is available on the Luminous-Landscape site. The bottom line is that at a certain point, increasing resolution by adding more photosites without also increasing total sensor size will not add anything to image quality. In fact, it will decrease image quality, especially at small apertures.

Phase One has acknowledged that packing sensors with ever higher numbers of ever smaller photosites does create limitations in terms of ISO and f/stop settings by introducing a "binning" function in their new Sensor+ camera backs. For instance, the Phase P65+ back has 60 million 6-micron pixels. This gives extremely high resolution but at the expense of image quality if pushed much beyond ISO 200 and stopped down much past f/11. Combining four photosites into one through a proprietary technology results in a 15 MP sensor with relatively large 12-micron pixels. This function completely changes the character of the sensor, allowing faster image capture, higher ISO settings, and likely fewer diffraction issues.

MICROLENSES

Digital sensor photosites have significantly more depth than the relatively flat surface of film. The use of microlenses to focus incoming light from the lens down into the sensor has become a common way to increase sensor efficiency and to avoid problems caused by the angled light path that commonly occurs with wide-angle lenses. Until recently, most medium-format sensors did not have microlenses, which is why medium-format backs did not work as well with wide angles and why the use of shifting lenses often resulted in lens cast (a magenta/green color shift across the image). The use of microlenses has greatly improved the efficiency of digital sensors, helping to nullify the effects of squeezing in ever more resolution without increasing sensor size. In addition, effective microlenses can help to alleviate diffraction limits by capturing the light that would have fallen outside the photosites.

FILTERS IN FRONT OF THE SENSOR (LOW-PASS, ANTI-ALIASING, ANTI-MOIRÉ)

Digital sensors that use Bayer pattern arrays (which is most of them) are subject to aliasing (jaggies) and moiré (a colorful pattern appearing when a scene contains a repetitive pattern that lines up with the Bayer pattern overlaying the sensor).

Moiré can be alleviated by

- **using higher resolution sensors,**
- **moving the camera closer or farther from the subject, or**
- **most reliably, by using a filter that creates a one pixel wide blur over the image.**

Various strategies (http://www.letsgodigital.org/en/news/articles/story_2586.html) can be used to increase the effectiveness of this filter in suppressing aliasing and moiré while minimizing loss of detail due to image

Detail from 21 MP DSLR @ f/11 **Detail from 39 MP MF back @ f/22**

High megapixel digital cameras are becoming diffraction limited at f/stops smaller than f/11

blurring. Use of a filter in front of the sensor is the main reason for the need to apply sharpening to digital images.

Quality of the Analog-to-Digital Converter (ADC) and Its Read Speed

Similar to the race to higher megapixels and the need to keep digital noise at bay, there is tension between the need for higher frame rates and the higher image quality gained by giving the ADC more time to collect data from the sensor. As usual, manufacturers are working toward doing both. The quality available from medium-format sensors is partly due to their slower frame rates (in some cases by a factor of 10). The extent to which your photography requires high frame rates will factor into your speed vs. quality equation. The ADC also determines the sampling bit depth, as it converts the analog voltage to luminance levels. The ADC needs to be matched to the dynamic range of the sensor, thus defining the sensor bit depth for a camera.

SENSOR BIT DEPTH (8-BITS, 12-BITS, 14-BITS, 16-BITS)

The trend has been to increase bit depth from the 8-bits available in JPEG capture to 12-bits, 14-bits, and even 16-bits. Bit depth has an impact on image quality—especially dynamic range. Going from 8-bits to 12-bits results in the greatest gain. At the time of this writing, no 35 mm DSLR cameras that have 14-bit capture ability clearly show an image quality advantage due to the extra bit depth. Some medium-format sensor makers claim an advantage with 16-bit capture. However, we have never seen a study (other than the manufacturer's) that shows that this translates into higher image quality based on 16-bit capture alone. In general, the difference between 14-bit and 16-bit capture would not be visible (to humans anyway) unless a severely steep tone curve

was applied to the image (on the order of 6-7 stops).

IMPROVEMENTS IN RAW FILE PROCESSING

While significant improvements have been made in sensor hardware, allowing improved image quality—even as pixel pitch has been reduced, an even greater amount of improvement has come from improvements in raw-processing algorithms. This fact has several implications. Image quality from older raw files continues to improve, lending weight to the concept of archiving raw files. Another implication is that image quality will inevitably be a blend of camera capabilities and raw file processing. This factor will not be limited to improved demosaicing, but will include improved control over noise and improved lens performance via software. Although Photoshop filters and Photoshop plug-ins, such as PTLens, have been available for some time, similar corrections are now being included in parametric image editors. DxO Optics has been a leader in this arena. An example of how symbiotic hardware and software have become, the Panasonic LX3 camera depends on lens correction algorithms to produce an undistorted picture.

CONCLUSIONS

The camera test conducted at the Rochester Institute of Technology studios confirm that larger sensors provide higher image quality, although packing them with smaller photosites to increase resolution can roll back some of those gains, especially with regard to diffraction limits. While diffraction limits seem, for now, to be an intractable problem, we see that image noise characteristics continue to improve. Manufacturers are employing a variety of technologies such as better micro lenses, higher quality signal amplification, smaller gaps between photosites, shallower photosite well depth, and better analog to digital conversion to overcome the decrease in signal to noise efficiency of

smaller photosites. In addition, improvements in raw file processing have provided even greater gains in extracting detail while leaving noise behind.

The bleeding edge for squeezing high image quality out of small sensors and densely packed photosites is evident in the latest high-end point-and-shoot cameras. Some of them are achieving image quality that surpasses DSLR cameras of just a few years ago. The introduction of the Canon 1Ds full frame (35mm) DSLR did the same to the 11-16 megapixel medium-format backs of the time (2003), and medium-format manufacturers have had to use the same technologies to hold an edge over DSLR advancement.

The competition continues, with our tests showing that 21 megapixel DSLR cameras can produce printed output that is at least as good, and in some respects better, than older 16/22-megapixel medium-format backs. Medium-format has once again jumped ahead with the introduction of 39, 50, and now 60 megapixel sensors. DSLR prices have tended to come down, even as megapixel counts have gone up, while medium-format back prices have remained high and megapixel counts have gone up. Slower operation and less sophisticated auto focus are characteristics of medium-format digital cameras that carry over from film days, while DSLR quality relative to medium-format digital makes image quality between the two camera types much closer than it was in film days. Unfortunately, both DSLR and medium-format camera manufacturers have reduced pixel pitch to a point where stopping down beyond f/11 will result in less image detail. Our tests show that a $2700.00 21 megapixel DSLR at f/11 will produce a more detailed image than a $34,000.00 39 megapixel camera at F/22. If you are considering a camera with a pixel pitch of less than 8 microns, be sure to test it at f/11, f/16, and f/22. If you routinely need small apertures for your work, you should con-

sider a camera with larger photosites (pixels). Consider as well, that larger sensors require smaller apertures to generate the same depth of field as cameras with smaller sensors.

In the processing, optimizing, and archiving sections, we continue to weigh costs and benefits of the different camera systems with regard to job types and shooting styles.

Camera Set-Up

EXPOSURE

Correct exposure for digital capture is complicated by several factors, including whether you are shooting raw or JPEG, (or raw + JPEG), and whether your camera has an exposure bias. Determining exposure bias is a required first step on which all other exposure decisions are based.

Exposure bias occurs two ways: the in-camera meter can have a bias, and the sensor response, relative to the ISO setting, can have a bias. To tell which might be occurring, you'll need to photograph an 18% gray card with a continuous light source using the camera's meter. Set the camera to raw + JPEG and shoot 1/3 stop brackets from -1 to +1. Next use a trusted incident light meter to determine the correct exposure and shoot the same brackets. If the in-camera JPEG looks correct for the incident-metered "0" exposure, but the camera-metered "0" exposure looks lighter or darker, there is an in-camera meter bias. If the histogram of the incident meter "0" setting is not exactly in the middle, then the sensor is not calibrated to the correct ISO.

If the camera metering results in JPEG files that are overexposed or underexposed, as judged by the histogram, then the camera meter should be adjusted until the histogram of the gray card is exactly centered. If the camera sensor is biased in relation to the incident

meter, then the incident meter will need to be adjusted to compensate for the sensor bias in relation to the ISO setting. In our camera testing, we noticed that different manufacturers have different philosophies toward matching the metering and sensors response to ISO values. Figuring out what your camera actually does in this regard is crucial to achieving optimal exposure. Achieving optimal exposure in digital capture is crucial in achieving the best possible image quality.

Once you have determined whether you need to apply exposure compensation, the next step is to determine how the raw processor you use interprets your camera's files. Different manufactures define raw saturation (basically when the sensor reads "full") differently. Consequently, the middle-gray exposure point can vary by as much as 1 stop. An example of this effect can be seen in files from Phase One cameras when opened in Adobe Camera Raw where they appear to be one stop underexposed as compared to the same files opened in Phase One's own software, Capture One. Despite this appearance, the Phase One files are not underexposed. The solution is to move the exposure slider to the right until the image looks correct. In the case of the Phase files, this should be approximately plus one stop. You can then save this as a preset for Phase files. To see if you need to create an exposure offset in your processor of choice, test your camera's files by comparing the in-camera JPEGs to the default exposure settings in the raw processor.

EXPOSING TO THE RIGHT

Exposing to the right is not a foreign concept if you have had any experience shooting negative film. Negative film gives better results when it is exposed for the shadows instead of for the highlights. Color transparency film results are most successful when exposed for the highlights. Raw files are more like negative film. Exposing to the right, just below raw

saturation (highlight clipping point), will reduce noise and posterization—especially in the shadow areas.

NOT GOOD FOR JPEGs

The earlier (especially CCD) digital cameras had a tendency to lose highlight detail or experience blooming when overexposed, so the prevailing recommendation was to slightly underexpose. Newer cameras have mechanisms to drain off light overflow, preventing blooming; however, overexposing when shooting JPEG files still results in loss of highlight detail due to the film-like tone curves that the in-camera processing applies before it discards the raw data. JPEG exposure needs to be as precise as an possible to ensure you get what you need.

GOOD FOR RAW FILES

Raw files, on the other hand, can give optimum quality when slightly overexposed—often up to one stop. Once we have determined the camera's real ISO values, additional testing will determine what the optimal amount of overexposure compensation might be. One caveat with this technique is that the JPEG preview on the back of the camera will look too bright, and raw files loaded into a browser or cataloging program may also look too bright. If the files are loaded into a browser/processor, i.e., (Adobe Bridge, Adobe Lightroom, Aperture, or Capture One) that allows you to apply a preset that adjusts the exposure, then the files will look correct and you can achieve the highest image quality.

Trip Wire

If your workflow involves shooting raw + jpeg, keep in mind that you may have to sacrifice ultimate image quality of your RAW files to avoid having the jpeg files appear overexposed. Another conundrum for shooting RAW + JPEG!

Metering

MATCHING MEERING TO THE SUBJECT

We all know that exposure is critical to image quality. While this is more of a basic shooting technique, we do feel it is important to mention (and remind you) that sometimes matching the metering area to the point of focus (especially in spot metering mode) is a good idea. It is especially important for photographing anything on stage, as the subject is often in a bright spot of light while the background is often dark. This also holds true for many landscape situations where there are many shadows and highlights and a large range between them …

KEEPING THE EXPOSURE CONSTANT FOR PANORAMAS AND STITCHING

When photographing for a panoramic view that will involve stitching multiple exposures, select an exposure that is a compromise between the dark and light side of the panorama, making exposures the same for all the frames to be stitched. This is especially important if there is a lot of sky involved. Matching the density of a stitched skyline can be challenging if you let the camera autoexpose.

METERING FOR HDR

High dynamic range stitching requires an opposite technique from panorama stitching. For the best HDR results, it is necessary to meter the very darkest area of the scene (either with a spot or an incident meter), and then meter the brightest area of the scene. The difference will often be nine or ten stops (or more). To get the best possible HDR rendering, you will need to bracket that entire range. It is important to remember that the bracketing needs to be done by varying the shutter speed and not the f/stop. Changing the f/stop can introduce depth of field or focus changes throughout the bracket.

Trip Wire

If using raw files for HDR blending, do NOT set the raw processor to automatically adjust the exposure settings!

WHITE BALANCE SETTINGS IN THE CAMERA

We know that in-camera white-balance settings are crucial with JPEG capture. White balance is also crucial for raw capture. An accurate white balance is best achieved by including a spectrally neutral gray patch placed in the scene's lighting as a reference frame. Raw software lets the user click on this light gray reference patch to achieve accurate white balance. If this procedure is followed, the white-balance setting in the camera is not of as much concern when shooting raw files. Digital cameras have auto white-balance settings as well as a short list of likely white-balance conditions, such as daylight, cloudy, shade, fluorescent, and tungsten. Many have a defined color temperature in a range from around 2,500K to 10,000K. More sophisticated cameras can even bracket color temperature, going more blue/ amber or more green/magenta on either side of a chosen color temperature. Most people who want to get an accurate color temperature in the camera, however, use the custom color temperature option. This requires measuring the color temperature of the scene lighting, using a white card, shooting a test shot, and letting the camera determine the white balance that will neutralize the white card. The color temperature can be fine-tuned by shooting a warmer or cooler card and using that setting as the basis for the custom color calibration. Other methods involve using a diffusion filter over the lens in place of shooting a card. If you shoot JPEGs, you must rely on auto white-

balance, a color temperature meter, or constant creation and use of custom white balance settings. Failure to get good white balance in-camera when shooting JPEGs will slow down your workflow and will inevitably result in lower image quality. The only instance where white balance would not require extra work when shooting JPEGs is with controlled, unchanging lighting—such as a studio set up.

Recommendation

Although a prime advantage of raw capture is the ability to fine-tune white balance in PIEware, there are times when it makes smart workflow sense to create and use a custom in-camera white balance. One example is a portrait series where a person in a red shirt is followed by one in a green shirt—the white balance will change and will affect skin tone. The goal is to keep the tone neutral and not have to adjust each set of images. The solution is to generate a custom in-camera white balance for the lighting set-up using a white card as the target. Now we can do 20 portraits and get the same consistent skin tone or background color. If a color temperature tweak in PIEware is needed, one global shift is all that is necessary. Using this technique will usually position the frames within +/– 50K of perfect white balance and tint.

We always use this technique for portrait shoots—whether lit or available light—since it simplifies optimization, even for raw files. It is also great for shooting under flourescent light since auto white balance can shift alot and again, its easier to make one global correction later during optimization.

Careful workers will often use custom white balance (or a preset white balance) even when shooting raw files under controlled lighting. This is because auto white balance will result in white balance variations whenever there are scene color changes. Imagine that you are shooting a series of portraits, and the person in the red shirt is followed by a one in a green shirt- the white balance will change and will affect skin tone. Although this is much more challenging to correct when shooting Jpegs, it does require slightly more work in the raw file processor to adjust the white balance for each set of pictures, instead of being able to make one global white balance adjustment for the entire series of portraits.

USING GRAY CARDS OR COLOR CHECKERS WHEN SHOOTING RAW

Even when a custom white balance is set in the camera, it is a good plan to include spectrally neutral gray card designed for the purpose, or a ColorChecker chart in at least one frame of a scene. When the scene or the lighting changes, a new reference shot should be taken. The second gray patch on the ColorChecker will provide a spectrally neutral white balance tool that will be used in the raw processor to achieve an accurate white balance starting point. Without this tool, achieving white balance in the raw processor will involve guess-work.

TONE CURVES AND PICTURE "LOOKS"

These settings are most relevant to JPEG shooters. JPEGs are raw files that are processed in the camera. The raw data is then discarded, and applies a "preset" to the pictures. Camera makers have names such as: "standard", "portrait", "landscape", "neutral", and "faithful" for these presets. Each "look" is a combination of tone curves and saturation settings applied (baked-in) to the JPEGs. To alter these "looks" later is problematic,

just like adjusting white balance. Raw shooters may apply such "looks" (and many others) during optimization or in post-production. Furthermore, "looks" are applied to raw files is non-destructive and can be changed or kept as "versions."

COLOR SPACE

Color space is another setting that applies only to in-camera JPEGs and does not affect raw files. Color space choices for JPEG capture are usually sRGB, a narrow gamut space for use on the Web, and Adobe RGB (1998), a larger gamut space often used for prints or printing. However, not even the wider gamut Adobe RGB (1998) color space comes close to the potential color gamut of the digital camera's sensor.

The camera menu setting for color space will not affect the raw files. Raw capture allows the user to select an appropriate color space in post-processing. By selecting a very large color space in PIEware such as ProPhoto RGB, more of the camera's potential color gamut can be realized (depending of course on the actual color gamut of the scene).

IN-CAMERA SHARPENING

As discussed, Bayer pattern sensors, especially those equipped with low-pass filters, give a slightly blurry or soft image unless an algorithm is applied to define and sharpen the edges of the pixels that make up the image. Most DSLR cameras give us control over a sharpening setting that is applied to JPEG files. When shooting raw, this setting is applied only to the JPEG preview (the image that you see on the back of the camera), letting you control the sharpening of the final image (from a RAW capture) in post-production. In-camera sharpening settings can make a difference for raw + jpeg shooters and how the preview jpegs look in browsers. It's a matter of taste and convenience. Some cameras

do display a fairly blurry preview on the LCD with sharpening off.

Some people prefer to apply at least a small amount of sharpening, if only to see a sharper picture on the camera's LCD. When shooting JPEGs, this sharpening will be baked in, and since sharpening is inherently destructive, over-sharpening in the camera can degrade image quality, especially the ability to enlarge (up-res) the files through interpolation.

It is important to note, however, that when shooting JPEGs, in-camera sharpening before JPEG compression may give superior results compared to sharpening after JPEG compression which is what occurs if you sharpen JPEGs in post-production. As always, this will depend on your workflow and image content and ultimate use of the image.

For more information do check:

http://www.dpreview.com/learn/?key=sharpening, for one perspective and take the time to read "Real World Image Sharpening with Adobe Photoshop, Camera Raw and Lightroom" by Bruce Fraser and Jeff Schewe. Page 48 of this seminal read addresses in-camera sharpening.

When shooting raw files, a high amount of sharpening can be applied so that the images on the camera's LCD, and the images downloaded and viewed in browsers that use the preview JPEG, appear sharper. Since the raw file sharpening will be handled in optimization, there is no danger of unnecessary file degradation due to sharpening settings.

BACKING UP DURING CAPTURE WHEN SHOOTING TO CARDS

Although solid state CF and SD cards and the equivalent are extremely reliable, bear this in mind:

JPEG preview with no in camera sharpening

JPEG preview with maximum in camera sharpening:

when not shooting tethered, your images will be in one place only. Beginning a few years ago, professional grade DSLR cameras began offering the option to write captured images to a second card. For extremely critical assignments, that might be worthwhile. Consider, also, how inexpensive flash memory cards have become in comparison to the cost of a re-shoot.

Another consideration when shooting to cards is deciding on card capacity. How many images are you willing to risk on one card? Make sure you have a good system for handling memory cards. By this, we mean your strategy for identifying shot and un-shot cards. We recommend that you make it a rule to only format cards after they have been downloaded (and checked) and safely backed up.

BACKING UP DURING TETHERED SHOOTING

Some software used for tethered shoots allows you to write to the camera memory card as well as to the computer hard drive. Unfortunately, some software applications write only to the computer hard drive and bypass the camera's installed memory card. While the chance that your computer hard drive will fail during a tethered shoot is small, it is not zero. Consider that many tethered shoots involve laptop computers with hard drives more prone to failure than desktop computer hard drives. Consider, to, that if the laptop is dropped (or pulled off a table by the tether cable) the chance of hard drive failure becomes very high. When using software that only writes to a computer, it may be a good idea to have the files write to a rugged external pocket drive or, even better, a mirrored raid (raid1) set-up.

© Patricia Russotti

Chapter 7

Getting To Work—Image Ingestion

"It is not the strongest of the species that survive, nor the most intelligent, but the one most responsive to change."

—CHARLES DARWIN

DATA PRESERVATION AND DATA BACKUP

The primary goal of image ingestion is to preserve image data and create backups. Image ingestion from memory card(s), tethered cable, or wireless require similar steps. In the capture section, we referred to the ideal setup of using a backup card when shooting if your camera model supports that function. If you do not use two cards for capture, you should:

- Regularly download your single cards to a disk or storage device.
- Not format cards until the downloaded images can be reviewed and backed up to a second drive.
- Not connect the camera directly to the computer to ingest images (unless shooting tethered).
- Always use download software as opposed to using the Finder application to copy the image files.

Using the Finder to copy files is potentially unreliable, sometimes resulting in skipped or missing files. Never use the Finder to *move* files from the memory card. If you move (not copy) files or folders between the memory card and computer disk and some glitch happens to the destination volume, or your connection with it, all your files vanish—both on the memory card

and on the destination hard drive. There are many other good reasons to use dedicated ingestion software, but image preservation is the most important one.

DPBESTFLOW FILE-NAMING CONVENTIONS

Naming (or renaming) digital image files is a key organizational task in digital image workflow because it is the most basic element of your file system structure. Digital cameras do not currently have very sophisticated naming options, and the default names are confusing and lack one of the most important criteria for digital image file naming—each file name must be unique.

The first criterion for file naming is that it must follow these basic computer system rules:

- Letters in the name should only be the letters of the Latin alphabet (A–Z, a–z).

- Numbers should only be the numerals 0–9.

- Only hyphens and underscores should be used. Avoid any other punctuation marks, accented letters, non-Latin letters, and other nonstandard characters such as forward and back slashes, colons, semicolons, asterisks, angle brackets, or brackets.

- File names should end in a three-letter file extension preceded by a period, such as .CR2, .JPG, >TIFF.

The next important criterion is that each digital image file should have a unique file name. Having multiple files with the same name is confusing to photographer and clients alike. There is the danger that a file might automatically overwrite another file with the same name. How you arrive at unique file names will require some thought. Once you have developed a system, it is important to standardize and adhere to it. Some parameters that can be used to develop unique names can incorporate:

- **Your name or initials as the beginning of the string.** Keep in mind that you are limited to 31 characters, so short names or initials work best.

- **The date of the photography session.** This works best if you use year, month, and day to keep files lined up in chronological order.

- **A job sequence number.** The first project of the year might have a date/job string such as 09001, and so on. This will cause files to line up in job number order.

- **A sequence number.** This number can begin at 0001 and go until the end of the job (make sure to have enough digits to contain the total number of files, or your files won't line up correctly!). Many photographers like this model because they tell at a glance if the total number of files matches the final file number. Another reason to use this system is that the order that files line up (and are likely viewed and proofed) can be controlled easily by organizing the files in a desired order and then renaming them. Another approach is to use the automatically generated numbers from the camera. One problem with that approach is that this cannot guarantee unique job names if you use more than one camera when you shoot.

- Avoid incorporating a job name or description in the file name. Although you can do this, it is hard to avoid running into an overlong file name using this approach. Another consideration is that if you do a lot of shoots for a particular client or at a particular location, you'll have to use some other naming string to differentiate the shoots from one another, so the descriptive component of the name is not particularly helpful.

One final criterion is to have a file-naming system that allows you to easily tell whether a file is an original file, master file, or derivative file. Any number of variants are possible, such as a black and white version, a CMYK version, or a standard file format version from a raw original, such as JPEG or TIFF. Plan for this and incorporate enough headroom into your file-naming schema to add a descriptor for these variations. For instance, a master file could have the letter M or MF or Master added at the end of the file name, but just in front of the three-letter extension. A CMYK version could have CMYK added, or a black and white version could have BW added and so on.

Once you have created a file-naming system, use it consistently for all files. Just as with the optional workflow step of converting proprietary raw files to DNG, there can be early-binding file naming, or late-binding file naming. While many prefer to implement a file-naming schema upon ingestion, those who use multiple cameras when they shoot, or those who want to organize image files in a particular order and have the file names preserve that bit of organizational effort, prefer to rename image files after the editing workflow step. The File naming chart on page 126 shows an example of how we do it.

TripWire

One of the very worst things you can do with file naming is to create a situation in which the same image file has two different names. This can occur if you make an immediate duplicate copy of the ingested files, put away a copy, and go on to edit and rename the other copy. A workflow like that will be doubly confusing because not only will the file names not match up, but the total number of files may be different as well. Although there are workarounds such as matching up image files by capture time, or putting the original file name into a metadata field and matching files up that way, it creates more work and wastes time. However, putting the file name into a metadata field, such as the "Title Field," is useful for delivery files. This allows you to easily recover from situations where the files' recipient renames them and then needs another version of the same image. You can direct the person to where the original file name is stored, and your search time becomes much shorter! In addition, keeping the original file name in the metadata can be useful when you need to rename a file for use on your Web page. This will make it more discoverable by search engines.

ADD METADATA

The second goal of the ingest step is to advance the workflow by adding

- Metadata
- Image adjustment presets
- Applications like Image Ingester Pro software, which can even add cataloging information as the files come into the computer

For the cost of a little setup time, batch metadata can be added to the image files via metadata templates. This will save lots of time later in the workflow and doesn't add significantly to the download time. Adding basic metadata at this stage helps to insure that all derivative files will have the same base metadata as the originals. We recommend that your basic metadata template should consist of:

File Naming

DP Bestflow Recommends appending short descriptors for different versions of an image file as part of your naming schema

Original	RNA_08002_001.CR2
DNG Version	RNA_08002_001.DNG
Masterfile	RNA_08002_001_M.PSD
Layered Masterfile	RNA_08002_001_LM.PSD
Flattened Masterfile	RNA_08002_001_FM.PSD
Web version	RNA_08002_001_web.JPG
Offset printing	RNA_08002_001_cmyk.tif
Desktop or Lab print	RNA_08002_001_print.tif

- File Name (in the Document Title Field)
- Name of the Creator/Author
- Address
- Phone
- E-mail
- Copyright Status
- Copyright Notice
- Generic Rights Usage

This basic set of metadata can be built on to provide more specific custom metadata as the image files go through the editing process. This additional metadata might include:

- Description and/or Headline
- Specific Rights Usage (possibly PLUS code or usage description)
- Client Name
- Location
- Keywords
- Star Ratings
- Special Instructions

INGESTION TOOLS

Card Readers

Card readers come in many configurations to accommodate different computer connections (USB, USB2, Firewire 400/800) and several types of memory cards (Compact Flash, Secure Digital, Memory Sticks, etc.). If you have a collection of cameras, from point-and-shoot to high-end digital, you may need an all-in-one card reader to accept a wide variety of card sizes. This type card reader is usually a USB device. You may also need a higher speed Firewire 400 or 800 compact flash (CF) card reader. If you photograph events or sports

and have a need for speed, you may want to have a set of Firewire 800 card readers. These stackable units can download from multiple cards at the same time. The gold standard for information on flash memory cards and card readers is available on the Rob Galbraith site. (http://www.robgalbraith.com/bins/reader_report_multi_page.asp?cid=6007-9392) As with most other things digital, plan to periodically replace older memory cards with newer ones that have greater storage capacity as well as increased read and write speed. Luckily, they have gone down in price.

Download/Ingest Software

Many software applications used for image ingestion are multifunction: they can be used as a browser, parametric image editor, cataloging application, or all of the above, as is the case for such all-in-one programs as Adobe Lightroom and Apple Aperture. One software stands out as purely dedicated to image ingestion, the aptly named ImageIngester. Another widely used application, PhotoMechanic, adds a browsing function as well. Camera manufacturers make downloading utilities and browsers, although their metadata support varies. Adobe Lightroom, Apple Aperture Adobe Bridge, and PhotoMechanic 4.6 include image ingestion along with tethered shooting (Aperture directly, and Lightroom, Bridge, and PhotoMechanic indirectly by means of auto import from a watched folder fed by the manufacturer's capture utility). Some Cataloging Software, such as Expressions Media have import functions, although few use it for that purpose as it jumps ahead too many steps in the workflow. Phase One's Capture One software is widely used for tethered ingestion, although its metadata support is extremely minimal. Bibble Labs's Bibble software also offers tethered shooting. However, its metadata support is only slightly better than Capture One, although like Capture One, it offers advanced parametric image editing capabilities.

IPTC Stationery Pad

☑ Caption:		☑ City:
☑ Caption Writers:		☑ Location:
☑ Headline:		☑ State:
☑ Keywords:		☑ Country: USA · ☑ Code: USA
☑ Object Name: {filenamebase}		☑ Date: 6/29/2009 · Today
☑ Transmission Ref:		☑ Photographer: Richard Anderson
☑ Edit Status:		☑ Title: photographer
☑ Category:		☑ Credit: ©2009 Richard Anderson Photography
☑ Supp Cat 1:		☑ Source: http://www.rnaphoto.com
☑ Supp Cat 2:		☑ Copyright: ©2009 Richard Anderson

Caption
Caption Writers:
Headline:
Keywords:
Object Name: {filenamebase}
Transmission Ref:
Edit Status:
Category:
Supp Cat 1:
Supp Cat 2:
Supp Cat 3:
*IPTC Scene:
*IPTC Subject Code:
*Intellectual Genre:
*Rights Usage Terms: All Rights Reserved
Special Instructions: please credit Richard Anderson Photography
Urgency: Undefined

City:
Location:
State:
Country: USA Code: USA
Date: 6/29/2009 Today
Photographer: Richard Anderson
Title: photographer
Credit: ©2009 Richard Anderson Photography
Source: http://www.rnaphoto.com
Copyright: ©2009 Richard Anderson
*Copyright URL: http://www.rnaphoto.com
*Contact Address: 10 Saint Michaels Way, Baltimore, MD 21212
*Contact City: Baltimore
*Contact State: Maryland
*Contact Zip: 21212
*Contact Country: USA
*Contact Email(s): richard@rnaphoto.com
*Contact Phone(s): 410-532-7470
*Contact Web URL(s): http://www.rnaphoto.com

*These fields are only saved in the XMP data format.

[⚡] [Clear] [Load...] [Save...] [Variables...] [Apply Stationery to Selected] [Close Stationery]

Shown here is a metadata template with a basic set of metadata from PhotoMechanic, an image ingestion/browser software that is popular with photojournalists. Most ingest software allows you to build, save, and apply metadata templates. We believe that you should have an organized plan for storing and retrieving metadata templates.

IPTC Stationery Pad

☑ Caption: Tis Pity She's a Whore, by John Ford, The Pearlstone Theater, Tom Bloom (Donado)

☑ Caption Writers: Richard Anderson

☑ Headline: Tom Bloom (Donado)

☑ Keywords: Tom Bloom (Donado)

☑ Object Name: RNA_09014_341

☑ Transmission Ref: 014

☑ Edit Status: edited

☑ Category: Theater Photography

☑ Supp Cat 1: Location

☑ Supp Cat 2: Stage Performance

☑ Supp Cat 3: Center Stage

☑ *IPTC Scene: THEATER

☑ *IPTC Subject Code:

☑ *Intellectual Genre:

☑ *Rights Usage Terms: Licensed to Center Stage only. No third party u

☑ Special Instructions: Please credit Richard Anderson Photography

☐ Urgency: Undefined

*These fields are only saved in the XMP data format.

☑ City: Baltimore

☑ Location: Center Stage

☑ State: MD

☑ Country: USA ☑ Code: USA

☑ Date: 6/29/2009 Today

☑ Photographer: Richard Anderson

☑ Title: Photographer

☑ Credit: Photo © 2009 Richard Anderson

☑ Source: www.rnaphoto.com

☑ Copyright: © 2009 Richard Anderson

☑ *Copyright URL: www.rnaphoto.com

☑ *Contact Address: 10 Saint Michael's Way

☑ *Contact City: Baltimore

☑ *Contact State: MD

☑ *Contact Zip: 21212

☑ *Contact Country: USA

☑ *Contact Email(s): richard@rnaphoto.com

☑ *Contact Phone(s): 410-532-7470

☑ *Contact Web URL(s): www.rnaphoto.com

Clear Load... Save... Variables... Apply Stationery to Selected Close Stationery

This is what a PhotoMechanic template looks like with a more specific set of metadata added. The template can be added at the ingestion step if all of the images are covered by this enhanced set of information. Or it may need to be done after the editing step for separate batches of image files. For example, some projects may require additional metadata after the first round of edits. The example shown below is from a theater shoot in which each actor's name is added after the files are organized according to the players appearing in each scene.

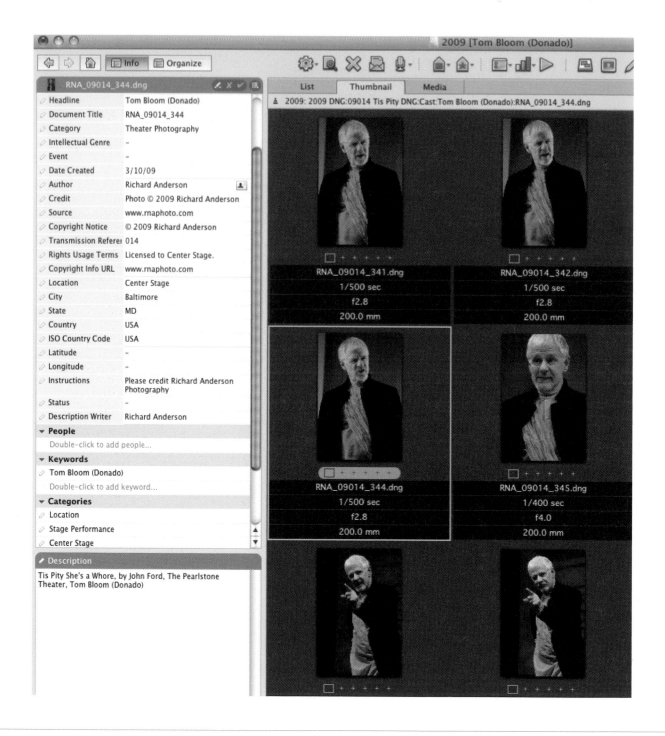

Here is the same set of metadata as viewed in Expressions Media 2.

File Properties

IPTC (IIM, legacy)

Document Title	RNA_09014_341
Headline	Tom Bloom (Donado)
Keywords	Tom Bloom (Donado)
Description	Tis Pity She's a Whore, by John Ford, The Pearlstone Theater, Tom Bloom (Donado)
Description Writer	Richard Anderson
Instructions	Please credit Richard Anderson Photography
Author	Richard Anderson
Author Title	Photographer
Credit	Photo © 2009 Richard Anderson
Source	www.rnaphoto.com
Categories	Theater Photography
Supplemental Categories	Location, Stage Performance, Center Stage
Date Subject Created	3/10/09, 7:42:25 PM
City	Baltimore
State/Province	MD
Country	USA
Transmission Reference	014
Copyright	© 2009 Richard Anderson
Copyright Info URL	www.rnaphoto.com
Urgency	None

IPTC Core

Creator	Richard Anderson
Creator: Job Title	Photographer
Creator: Address	10 Saint Michael's Way
Creator: City	Baltimore
Creator: State/Province	MD
Creator: Postal Code	21212
Creator: Country	USA
Creator: Phone(s)	410-532-7470
Creator: Email(s)	richard@rnaphoto.com
Creator: Website(s)	www.rnaphoto.com
Headline	Tom Bloom (Donado)
Description	Tis Pity She's a Whore, by John Ford, The Pearlstone Theater, Tom Bloom (Donado)
Keywords	Tom Bloom (Donado)
IPTC Subject Code	
Description Writer	Richard Anderson
Date Created	3/10/09, 7:42:25 PM
Intellectual Genre	
IPTC Scene	THEATER
Location	Center Stage
City	Baltimore
State/Province	MD
Country	USA
ISO Country Code	USA
Title	RNA_09014_341
Job Identifier	014
Instructions	Please credit Richard Anderson Photography
Provider	Photo © 2009 Richard Anderson
Source	www.rnaphoto.com
Copyright Notice	© 2009 Richard Anderson
Copyright Status	Copyrighted
Rights Usage Terms	Licensed to Center Stage only. No third party use without permission.

Camera Data (EXIF)

Camera Raw

Here is the metadata template as it appears in Adobe Bridge.

TripWire

Earlier, we said that managing image metadata can be confusing. We face that confusion firsthand in the ingestion step. Some of these applications are as follows:

- (Example: ImageIngester) write only the XMP variety of metadata.

- Others (example: Aperture) write only the legacy IIM IPTC variety.

- Adobe Software writes both varieties.

- PhotoMechanic lets the user decide whether to use XMP or legacy IPTC and where to put it.

PhotoMechanic Issues

One issue is that PhotoMechanic can embed XMP metadata in proprietary raw files (although no longer as a default setting). Not only is this practice potentially dangerous, but it can cause a metadata collision with Adobe Camera Raw where a proprietary raw file can have embedded XMP metadata from PhotoMechanic coexisting with attached XMP (side-car file) from Adobe Camera Raw. This will not apparently be a problem unless the same files are put back into PhotoMechanic and any change is made to the metadata. A change will cause Adobe Camera Raw to read only the newer XMP, which is embedded, and to ignore the older XMP (camera settings in the side-car file). When this happens, all your parametric edits will be lost, and you'll have to start over with your color and tone edits. Our advice is to make sure that the PhotoMechanic preference is to always create a side-car file for the XMP data.

INGESTION SETUP

Card handling

- Have a plan for keeping shot cards separate from unshot cards.

- Make sure that the unshot cards are formatted and ready to go.

- Establish a numbering or coding system for your cards. If you find corrupted files, this will make it easier to track down which card may be creating the problem. It also just helps you keep track of your cards.

Backing Up Downloaded Cards

The ideal plan is to use software that writes files to two separate drive destinations. Use of a RAID1 external drive is highly recommended. But if your software only supports writing to one destination, the second choice is to regularly download to a second drive, although this doubles your download time. The third choice is to regularly copy files from the first download to a second drive. In all cases, memory cards should not be formatted until downloads have been verified. The easiest verification method is to put the downloaded files into a raw processor, and let it build new thumbnails from the raw data.

TripWire

Browsers set to use the embedded camera previews cannot be used to verify raw files. The preview JPEG can appear fine, but the underlying raw data can be corrupt. When using parametric image editors (or browsers set to build previews from the raw data), be aware that you need to let them build their cache and create thumbnails from the raw data before you can judge whether the underlying raw data is good.

Notice in the PhotoMechanic preference example above, that we have not checked the:

"Add embedded IPTC" box, and

"Add embedded IPTC4XMP" box.

You may get away with embedding the IPTC; however, there will be a conflict with Adobe Software if you add embedded XMP. Our advice is to be careful with the settings for handling metadata with raw files. For example, if the software gives you the option of embedding metadata in raw files, our advice is to always attach the metadata with a side-car file—don't embed it.

A useful way to keep track of shot and unshot cards is to use a ThinkTank card wallet. We turn the shot cards over, leaving the unshot cards with the manufacturer's label facing up. This method coupled with a card numbering system helps us stay organized in the field. A card holder also helps minimize any dust and dirt from touching the cards.

Source

Get Photos from:

| EOS_DIGITAL | ⇕ |

44 Files Selected – 513.90MB
05/27/2009

Import Settings

Location: /.../090527 Ergonomics CR2 (Choose...)

Create Subfolder(s): | None | ⇕ |

Rename Files: | Do not rename files | ⇕ |

| | + | |

Example: IMG_9867.CR2

☑ Preserve Current Filename in XMP

☑ Open Adobe Bridge

☐ Convert To DNG (Settings...)

☐ Delete Original Files

☑ Save Copies to:

...7 Ergonomics CR2 (Choose...)

(Advanced Dialog) (Cancel) (Get Photos)

Bridge 2 (CS 4) Photo Downloader in standard mode.

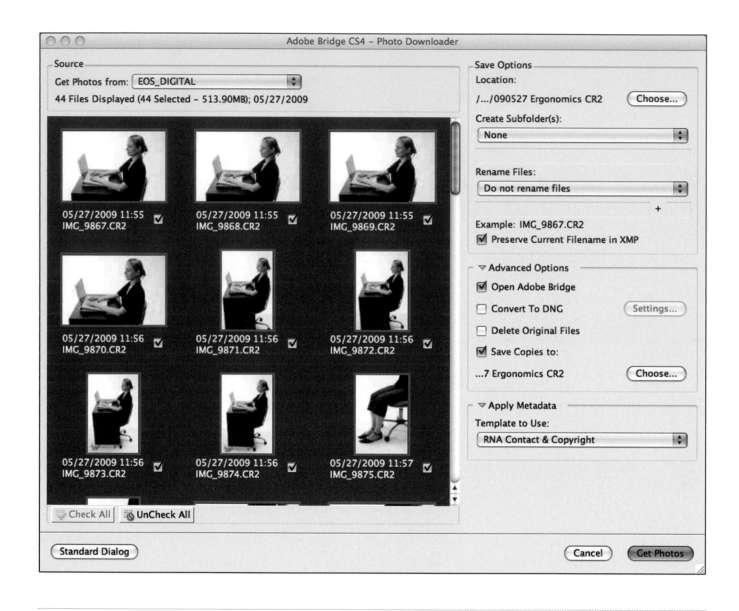

Bridge 2 (CS 4) Photo Downloader in Advanced Mode

ImageIngesterPro

Press Start or Cards to begin

Master Preset [DBS ▾]

Source No image card mounted

[/Volumes/EOS_DIGITAL] (Set...)

(Thumbs...) (Eject) ☐ Auto Ingest ☑ Auto Eject

Metadata

Preset [The Usual ▾] ☑ Enabled

(Start)
(Cards...)

Starting Number
[45]

Photographer Content Rights
[DBS – 414 Lyman ▾] [414 Lyman Ave ▾] [© DBS ▾]

Identification

Client [DPBestflow ▾] Project [Ergonomics ▾]

Card [#001 ▾]

Quick Fields

Caption
[Ergonomics for DPBestflow]

Keywords

Preset [DBS ▾]

| Catalog Sets |
| Keywords |

Destination

Preset [DBS ▾] (Set...)

Primary [/Users/UPDIG/Desktop]

Backup (Pre) [/Volumes/RNA_80 (1) GB]

Backup (Post) [/Users/UPDIG/Pictures/ImageIngesterBackupPost (not used)]

Folder Arr. [{@datetime,3,2}{@datetime,5,2}{@datetime,7,2}{@project.name} CR2]

Number Range [filename numbers]

File Handling

Preset [No Rename, open Bridge ▾] (Set...)

File Name [{@filename}]

Filter [Exclude: [none]]

DNG [Do not run DNG Converter]

JPEG []

ACR/Develop Settings [[none] ▾]

☐ GPS tagging [no data loaded]

Viewer [/Applications/Adobe Bridge CS4/Adobe Bridge CS4.app]

⊞ ⊟

Notes for Next Ingestion
[]

Results

ImageIngesterPro Version 3.2.04

WARRANTY

THIS SOFTWARE IS PROVIDED BY THE COPYRIGHT HOLDER "AS IS" AND ANY EXPRESS OR IMPLIED WARRANTIES, INCLUDING, BUT NOT LIMITED TO, THE IMPLIED WARRANTIES OF MERCHANTABILITY AND FITNESS FOR A PARTICULAR PURPOSE ARE DISCLAIMED. IN NO EVENT SHALL THE COPYRIGHT OWNER OR CONTRIBUTORS BE LIABLE FOR ANY DIRECT, INDIRECT, INCIDENTAL, SPECIAL, EXEMPLARY, OR CONSEQUENTIAL DAMAGES (INCLUDING, BUT NOT LIMITED TO, PROCUREMENT OF SUBSTITUTE GOODS OR SERVICES; LOSS OF USE, DATA, OR PROFITS; OR BUSINESS INTERRUPTION) HOWEVER CAUSED AND ON ANY THEORY OF LIABILITY, WHETHER IN CONTRACT, STRICT LIABILITY, OR TORT (INCLUDING NEGLIGENCE OR OTHERWISE) ARISING IN ANY WAY OUT OF THE USE OF THIS SOFTWARE, EVEN IF

Registered to: rnaphoto@rnaphoto.com

Image Ingetsr Pro

Adobe Lightroom 2

Ingest

Source Paths

○ Ingest Disks ○ Ingest Folders

EOS_DIGITAL (514.8 MB used)

(Rescan) (Unmount)

☐ Incremental Ingest: copy new photos only

Source Directory Structure:

[ignore – copy all photos into same destination ⬍]

Copy Photos:

[into folder with name ⬍]

Folder Name: [090527 Ergonomics CR2]

☐ Use folder sequence: []

Destination Folder Roots

Primary: (Primary Destination...)

/Users/UPDIG/Desktop

☑ Secondary: (Secondary Destination...)

/Volumes/RNA_80 (1) GB

Filter Files:

[Copy Locked and Unlocked Photos ⬍]

[Copy RAW and non–RAW Photos ⬍]

☑ Apply IPTC Stationery Pad To Photos

(IPTC Stationery Pad...)

○ Use Local IPTC Stationery
◉ Use Global IPTC Stationery

☐ Rename Ingested Photos As:

[]

☐ Sequence = (Set {seqn} var...)

[Open contact sheets during ingest ⬍]

☐ Erase Source Disk(s) After Ingest
☑ Unmount Source Disk(s) After Ingest

Primary Destination Path: /Users/UPDIG/Desktop/090527 Ergonomics CR2

Secondary Destination Path: /Volumes/RNA_80 (1) GB/090527 Ergonomics CR2

Maximum Amount To Transfer: no disk(s) selected

⚡ (Variables...) (Job...) (Close) (Cancel) (Ingest)

PhotoMechanic Ingest

COMPARISON CHART OF INGESTION SOFTWARE

	Photo Mechanic	Lightroom	Bridge	Downloader Pro	ImageIngesterPro
Ingests to multiple locations	yes, up to 2	yes, up to 2	yes, up to 2	yes, up to 3	yes, up to 3
Chooses images to be ingested	no	yes	yes	yes	no
Allows automatic ingestion when card is detected	no, but ingest window can pop up	no, but ingest window can pop up	no	yes	yes
Renames files during ingestion	yes	yes	yes	yes	yes
Arranges images into folders by date & time or by name	yes	yes	yes	yes	yes
Converts to DNG during ingestion	no	yes	yes	yes, with plug-in	yes
Image verification during ingestion	no	Only if DNG conversion is being used	Only if DNG conversion is being used	Only if DNG conversion is being used	yes
Embeds metadata during ingest	yes	not in raw files	not in raw files	yes	yes
Side-car metadata during ingest	yes	yes	yes	yes	yes
Metadata variables	yes	no	no	yes	yes
Metadata memory	yes	yes	yes	yes	yes

	Photo Mechanic	Lightroom	Bridge	Downloader Pro	ImageIngesterPro
Renames differently for different cameras	yes	yes	no	yes	yes
Filter files being ingested	yes	no	no	yes	yes
GPS tagging during ingestion	no, but tags can be synced after ingestion	no	no	yes	yes
Ejects card after ingestion	yes	yes	no	yes	yes
Launches external viewer after ingestion	no	no	no	yes	yes
Multiple card downloads at once	no	no	no	no	yes

HANDLING YOUR CAPTURE FORMAT CHOICE

Capturing and downloading JPEGs is simplest and presents the fewest issues. Shooting and downloading Raw + JPEG is trickier. Be sure to test your workflow because weird things can happen. We found that some software gives the raw files and the JPEG files sequential numbers instead of the same number with different extensions. This behavior can vary according to the model of the camera and according to whether ingest is done from cards or is auto-imported when the camera is tethered. Downloading proprietary raw, whether tethered or from cards, takes longer than JPEG but is otherwise straightforward. Some software supports converting files to DNG format on ingestion. This issue has both pros and cons. We discuss them in Chapter 9, Optimization.

© Richard Anderson

Chapter 8

Image Edit

"Change always comes bearing gifts."

—PRICE PRITCHETT

The edit stage is where we get excited about workflow. If you're "vintage" (like us), you remember the excitement of opening boxes of slides and putting them on the light table to edit and sort. With loupe in one hand, trash can at the ready, and a stack of empty plastic slide pages, we would attack the big pile of slide boxes. When finished, rejects were in the trashcan and chosen slides were organized and tucked safely into slide pages. We usually applied some kind of rating. We made checkmarks with china markers (later replaced by sharpies). The more checks on the slide mount, the higher the rating. The photo lab added the metadata by stamping our name, copyright, and phone number on the mount. We used a grease pencil to indicate our choices on black and white contact sheets. We would just have to live with the bad exposures, although sometimes we would simply clip out the bad frames and hope the client wouldn't ask about the missing numbers. We wrote the metadata on the back of the contact sheet, as well as on the envelopes or plastic sleeves that held the negatives. Those retro days are gone. …

While digital photography editing works in the same way, the main difference is that everything (even the images themselves) are virtual. The trashcan is virtual, as is the light box. The choices are tagged with virtual stars and virtual labels. The metadata is virtual and is embedded into the virtual images. Since everything is virtual, we have many more options with regard to sorting, rating, and adding metadata than we ever had with film. However, because the digital images are virtual, we cannot physically touch them, and

our viewing options depend on having a device that can display 1's and 0's as an image. Gone are the days of holding a transparency or negative up to a light box and seeing an image. Despite the difference between virtual and real, the goals for editing digital and analog remain the same:

EDITING CHECKLIST

- Choose the best images.

- Trash the losers. (Be careful here. Sometimes a bad image may have something in it that you may need later when you get to the retouching stage . . . or you just might need that lighter or darker exposure for HDR blending.)

- Rate the images that you feel are worth keeping.

- Organize the keepers using criteria consistent with the needs of the assignment.

- Make sure the images are identified with copyright and contact information.

In the film era, we had to live with the fact that a duplicate could not retain the exact quality of the original. Even 4×5 copies of 35-mm slides or negatives, though extremely good, were never perfect, and cost prohibited copying more than a few images from a shoot.

One major advantage of digital photography over film is the potential to duplicate the originals quickly with an exact copy. Be sure to embed all your metadata during ingestion and editing to give your files maximum portability and longevity

EDITING BEST PRACTICES

When we consider editing workflow Best Practices, they are minimal, but very important, especially for the raw workflow.

- XMP support
- Work portability

The most important standard is that the software used for editing must have full XMP support. The ability to read and write XMP is required for metadata templates, and the 0–5 star ratings system has become an editing standard. XMP support also provides work portability.

Edit Tools and Setup

THE VIRTUAL LIGHTBOX

When we worked with film, setting up for editing involved turning on the lightbox or grabbing the flashlight magnifier and grease pencil. With digital, setup involves choosing a software application that gives us those same tools:

- A virtual lightbox
- A magnifier to check focus and detail
- A way to apply ratings, labels, and metadata
- A way to trash bad images
- A way to organize our images
- Speed and efficiency

The least efficient place to edit images is on the back of the camera. It is also a dangerous practice to delete images off the memory card. A battery-powered, portable image storage device like the Epson P-700 multimedia Photo Viewers is a better device to use in the field. Since these viewers are essentially hard drive devices, when you delete photos from them you do not

risk corruption, as you would if you deleted images from the card in the camera. Do remember that if you haven't kept the captures on the memory cards or duplicated the files to a second drive, deleting images from the portable backup viewer is final. The next choice would be to use a laptop computer. Laptops now have such reliable speed and screen quality that using one is a very viable option—particularly one with a 17-inch screen. Nothing, however, is quite like the experience of editing on a 30-inch monitor connected to a fast desktop workstation.

EDIT SOFTWARE OPTIONS

Five classes of software can be used for editing digital images:

1. Browsers
2. Browsers with a parametric image editing features
3. Parametric image editing software with a browsing feature
4. All-in-one software (Cataloging PIEware)
5. Cataloging Software

As software companies add new features, the lines between these applications become blurred. Many software applications are trending toward the all-in-one software model.

Regardless of software choice, you should apply the editing checklist:

- **Choose the keepers.**
- **Trash or mark as "rejected" the losers.**
- **Use the standard 0–5 star rating system to rate the remaining images.**
- **Incorporate color labels, groups and stacks, collections, and smart collections, depending on which**

software you use. Whichever methods you use, use it consistently.

- **Organize the images according to the needs of the assignment.**
- **Make sure that bulk IPTC metadata is applied to all the images.**
- **Software that allows parametric editing functions (we recommend using this for rendered (JPEG) and unrendered (raw) files) can then be used to apply parametric presets, defaults, or corrections to the images.**

Recommendation

If you use the 0–5 rating system (and we recommend that you do), be sure to review two of our favorite pros' ways of utilizing star ratings.

Peter Krogh, author of *The DAM Book,* suggests making

- 5–star ratings rare, and
- 0 stars (a neutral rating) the most common.

This creates a pyramidal rating scheme and makes it easier to identify high-value images.

Seth Resnick, author of *The Photoshop Lightroom Workbook: Workflow not Workslow in Lightroom,* suggests using:

- 1 star for probable throwaways
- 3 stars for keepers
- 4 stars for the best of day

> Seth also uses color labels in combination with the stars to specify an image's destination, like Portfolio, a particular stock agency, and so on. He finds that using the color labels and star ratings allows him to zero in quickly on what he needs.
>
> Most importantly, use a system that makes sense to you and that you will use consistently.

Browsers

PhotoMechanic is an example of a classic browser. In the case of raw files, it can make thumbnails from either the embedded camera previews or use the computer operating system to create thumbnails. We recommend that you set this preference to enable raw rendering, using the computer's OS, and to "render raw for preview if possible." This will help ensure that you don't have any corrupted raw files. Although PhotoMechanic can do raw rendering for preview purposes, it does not have the capability to process raw files into a standard format.

Its primary functions are to:

- **Quickly edit digital images**

- **Embed or attach IPTC/XMP metadata**

- **Name, number, and organize the files by grouping them into folders**

PhotoMechanic supports both legacy IPTC format and XMP format. Because it supports XMP format, it can create and apply metadata templates. Another feature of PhotoMechanic's XMP support is that its 1–5 star rating system can be seen and used by other software that recognizes XMP. This includes Adobe

Bridge, Lightroom, and Expressions Media. Editing with PhotoMechanic is quick and efficient. Photo-Mechanic reads and writes XMP, allowing the work you do to travel with your files.

Browsers with the Parametric Image Editing (PIE) Feature

Probably the best known software in this category is Adobe Bridge, which pairs with Camera Raw to provide parametric image editing. When editing raw files, Bridge 2 (CS3) builds thumbnails from the raw file data. Bridge 3 (CS4) has added a feature that lets you use the embedded previews from the camera or build new thumbnails from the raw data. The second option provides confirmation that the raw file data is secure and uncorrupted.

This new thumbnail feature, which lets Bridge work from camera-embedded previews, allows a two-step Bridge workflow. The first step is to edit the images, sending the rejects to the trash (or giving them a "rejected" label), and to rate the remainders. CS4 Bridge adds a "review" viewing option, which can be an effective (and entertaining) way to edit: the pictures rotate in and out of view, much like editing slides with a carousel projector. Of course, there is also the slideshow mode, which gives you a full-screen preview of the images. If you are in a rush, choosing to use the embedded previews speeds up the process, but giving Bridge a little extra time to build a cache of thumbnails from the raw data will give you nicer-looking images to review and sets the stage for the parametric image editing.

In addition, you can organize your work by grouping like files or sequences into stacks, collections, and now smart collections. Smart collections allow you to determine a set of parameters for organizing a set of work and automatically add images to the collection based

on the criteria that you set. Again, be very useful and very efficient.

> Many use Bridge because it can be considered a "work hub" when dealing with a variety of file types in addition to images. Bridge can see every file format imaginable and even lets you preview the contents of videos and PDFs. This can be very useful if you are doing desktop publishing or rich media projects.

Parametric Image Editing Software

Although not as full featured as Bridge, applications such as Capture One, Bibble 4, Silkypix, DxO, RAW Developer, and various camera manufacturers' proprietary PIE software put parametric image editing functions first, but they can also be used as editing browsers. If you use these applications for editing, be aware (or beware of) that many do not fully support XMP. Thus, any ratings that you might apply are captured in the application's database and will not travel with the image file. The same goes for IPTC metadata. These applications may embed the legacy IPTC format, but they cannot embed or attach the XMP variety. Consequently, with these applications, metadata templates are not available, and complete image information portability is compromised.

All-in-One Software (Cataloging PIEware)

We refer to Adobe Lightroom, Apple Aperture, and Bibble 5 as all-in-one, or Cataloging PIEware software applications, because they perform nearly all the workflow functions from ingest to output and delivery. In the future, there will undoubtedly be more applications

like them. Having to learn and use just one piece of software is a compelling and attractive feature for many photographers.

Both Lightroom and Aperture require that image files be "imported" into the application. These applications will reference files—that is, leave them where they reside on your computer or hard drive—but they both require that the files (or thumbnails from the files) be added (imported) to the application for the cataloging functions. This will take longer than simply browsing a folder for images, but the upside is that the thumbnail views are persistent (i.e., always instantly available upon reopening the application). There will be a waiting period before you can begin to edit your images. You have to import all the images from a shoot, even if you end up eliminating a large number in the editing process. Although this strikes us as somewhat like the cart coming before the horse, for many, the concept of all-in-one functionality trumps that concern. By contrast, Bibble 5 gives the user the option of creating catalogs, or not. In other words, the database is there if you want to use it, but it is not a requirement. We think this is a superior concept.

> **TripWire**
>
> Although Lightroom and Aperture appear to have much the same functionality, there are some important differences between them in regards to work portability.
>
> Lightroom (along with all Adobe products) has full XMP support, and it can read XMP embedded in or attached to files. Lightroom can write and export XMP, either embedded in standard file formats (JPEG, TIFF, DNG) or attached to proprietary raw.

Aperture, by contrast, cannot read XMP sidecar files. This means that any metadata work you did to raw files in PhotoMechanic, Lightroom, Bridge, Bibble 4, or any other program that attaches XMP, will not be read by Aperture. Aperture is capable of exporting metadata in the form of XMP sidecar files, but some fields such as the important Rights Usage, Creator Contact, and Copyright Status fields are not supported. Aperture will of course embed the other IPTC fields into standard file formats, such as JPEG and TIFF, but not DNG. Hopefully, full support for XMP and DNG may come with a future version of Aperture.

For now, at least, Lightroom is the better choice if work portability is an important criterion.

Cataloging Software

Cataloging Software can be used for editing, rating, labeling, file naming, and applying metadata. If you are working with JPEG, TIFF, or DNG files, this can work well. If you are working with camera raw files, there are a few caveats. The first is that Cataloging Software will display the embedded camera JPEG, which will look the same as a camera-processed JPEG. If your exposure and white balance are reasonably good, this is not much of a problem. The larger issue relates to metadata and to how and where it is written. Will the Cataloging Software embed metadata into raw files, attach it with an XMP sidecar file, or keep it in a database? Embedding metadata risks corrupting raw files. Attaching XMP makes your work portable. Storing the metadata in a database, which is only viewable in the Cataloging Software, prevents your work from being portable.

© Patricia Russotti

Chapter 9

Optimization

"We live in a moment of history where change is so speeded up that we begin to see the present only when it is already disappearing."

—R. D. LAING

We define optimization of digital captures as the translation of sensor data into viewable images. Depending on the photographer's skill and the shoot parameters, these images may be very good "as shot," or they may need additional work before proofing or delivery. JPEG capture is more dependent on establishing correct white balance and other image parameters at time of capture (in camera). When shooting JPEG, the camera itself does the heavy lifting to process the images. Raw capture allows for maximum shooting and optimizing flexibility.

The goal of optimization is to adjust (optimize) the captures to match your vision and workflow needs (and client expectations). This step often includes:

- Match the photographer's vision by adjusting white balance, tone, and color.

- Maximize image quality: capture sharpen, minimize digital noise and lens issues.

- Ensure that your investment in time is protected by properly saving all your PIEwork. This means being careful not to overwrite original files, saving parametric edits within the file if possible, and backing up your work as you proceed through the workflow.

MATCHING THE SCENE

How does one best translate a scene-referred image to an output-referred image? A scene-referred image would be an exact representation of what was actually photographed. Photographers may say that they want to capture the scene faithfully, but if they did, they would not be happy with the dark and toneless result that might initially be viewed on a monitor or a print. This is due to the failure of either monitors or prints to display the full range of brightness and color of the original scene, where the brightness range can be as much as 100,000 : 1 and colors can be very saturated. This points to the issue of achieving accurate versus pleasing or acceptable density, tonality, and color as it appears on screen or substrate. This is why image optimization is required.

Optimization for Density, Tonality, and Color as Viewed on Screen or Substrate

When you shoot JPEGs, the camera renders the scene by compressing the color gamut and dynamic range into a pleasing reproduction of the scene. This is accomplished by compressing the highlights and shadows and adding contrast via a tone curve while adding color and saturation. Various picture looks are often offered as menu choices on digital cameras. They are based on adjusting contrast, color, and saturation in the camera. It is analogous to changing the type and make of film in a film camera to achieve a distinctive "look."

When you shoot raw files, the image rendering is determined by the parametric image editing software. The starting point is based on the "as shot" camera white balance and the default settings provided by the software. These default settings are based on a generic characterization (profile) of the camera sensor. Some parametric image editors give you a choice of profiles. Others will allow you to create your own custom profile and use that as the starting point. Recently, the Adobe DNG Profile editor was introduced, which allows the user to edit the standard profiles. Though not true .icc profiles, these DNG profiles accomplish much the same thing and are quite easy to create and use. We have found that the DNG Profile editor is a superior method of compensating for the slight variations that occur between cameras of the same make and model as compared to the Camera Raw camera calibration tab.

Regardless of the starting point, the rest of the rendering is up to the individual working the controls in the parametric image editing application. The default settings, in conjunction with an appropriate white balance and camera profile, usually result in a reasonably accurate rendition of the scene. When displayed on the monitor and output to print, the image will show an appropriate and pleasing interpretation of the scene.

Achieving accurate white balance for JPEG can be done in the camera via a custom white balance or the auto white balance set. In the case of raw files, white balance can be achieved in the parametric image editor by using the white balance tool and clicking on a spectrally neutral light gray or off-white area of the photograph. We recommend starting each scene with either a Gretag Macbeth color checker or a Whi-Bal card in the frame to reflect the light hitting the scene of the subject. The traditional 18% gray card that you might have used for analog photography to help determine correct exposure may not be spectrally neutral and should not be depended on to give you an accurate white balance.

This portrait rendering is the result of optimizing the file inside Lightroom with the default Camera Raw Profile for the Phase P45 camera back.

This version of the same image has been optimized with the custom profile built with the Adobe DNG Profile Editor for the Phase P45 camera back.

Mini Color Checker in the field

18% Gray Cards and Digital Photography

Our recommendation is to use either a Gretag Macbeth color checker or a Whi-Bal card for determining accurate white balance.

18% Gray Cards were designed to assist in establishing proper exposure for analog photography.

18% Gray Cards do not provide sufficient data to determine an accurate white balance and they may not be spectrally neutral.

MAXIMIZING IMAGE QUALITY

Demosaicing Factoid

Many different demosaicing algorithms are in use. New ones are being developed on a regular basis, although most of the new versions are modified or blended versions of the original algorithms. The fundamental goal of a good demosaicing algorithm is to preserve detail and minimize artifacts. Some algorithms are less complex than others and require less computational power. The trick is to find an algorithm formula that provides high quality but is not overly complex. Most commercially available parametric image editing applications make a calculated trade-off between image quality and computational complexity (speed of processing). It can be interesting to study comparisons (http://www.rawtherapee.com/RAW_Compare/) of the various raw demosaicing methods. Some parametric image editors, such as dcraw, often take much longer to process a raw file because they are expecting that their user base will tolerate slow processing if it means the highest possible quality.

A hot topic these days is how well parametric image editors handle raw files that were shot with extremely high ISO settings. Demosaicing algorithms can be combined with denoising algorithms to combat noise, although this is more often done as a separate antinoise filter step. Third-party plug-ins are often used for the best results, for example, Nik's Dfine, Noise Ninja . . . Since some camera makers control noise more effectively in JPEG file capture (using noise reduction settings) than they do with their raw processor, there is clearly room for improvement. Because noise, sharpening, and saturation are all interrelated, understanding how best to use these functions for high ISO images is critical to achieving the best image quality. Some studies have been done indicating that using one kind of demosaicing algorithm on low ISO images and another one that combines denoise algorithms on high ISO images would be ideal. Obviously, this adds complexity to the software, especially when you consider the number of raw file formats and camera models to support. A sensor can be profiled for noise characteristics just as it can be profiled for color response.

Another area ripe for profiling is lens characteristics, specifically aberrations, vignetting, softness, and distortions. DxO software has specialized in this area for some time, essentially profiling a growing list of commonly used lens and sensor combinations and developing algorithms to correct for these faults.

TripWire

This is a good time to discuss the best way to evaluate image quality, particularly with regard to image noise, aberrations, focus, level of detail, and the like. All of our

testing is done by means of full-size prints. Full size means the image size produced by the camera at the native resolution of the printer and RIP (Raster Image Processor) combined. A common mistake is to look at images on screen at 100% to evaluate their quality. Viewing images this way is very misleading and has little to do with the real world where they either appear in print or appear on the Web where they will be massively scaled down—unless of course they are displayed as 100% crops to prove how noisy/clean, sharp/fuzzy they are.

PRESERVING YOUR WORK

Up to this point, preserving your work has focused on making sure that you had at least two copies of every digital image. Optimization results in the creation of parametric image edit instructions, another kind of work that needs to be preserved. Early on, we referenced the concept of work portability and how that relates to the software we use, image formats, and the way we store this kind of work.

Let's examine the options:

JPEG/TIFF

Although JPEG and TIFF are "baked" or rendered files—that is, processed by the camera—we now have the option of processing both through PIEware. When adjusting JPEG/TIFF files in a parametric image editor, be aware that the results will only be seen inside of that specific PIEware. Even though the PIE instructions are embedded (in the form of XMP or XML data), normal raster image editors, such as Photoshop, will not use that data to render these files unless the preferences for Photoshop are adjusted to tell it to read the PIE work. To see these edits outside of the PIEware,

the JPEG/TIFF files must be exported (rendered), which involves re-saving the optimized files.

Proprietary Raw

There are two ways to save the PIE work with proprietary raw files. One method is to keep the PIE data in the PIEware database. For some, PIEware, such as Aperture and most manufacturers' software, this is the only option. Other PIEware, such as Adobe Lightroom, Camera Raw, and Bibble, provide the option of storing the PIE data in the catalog database or by attaching it to the raw file as a side-car file. The side-car file provides portability since the data can be transferred to another computer or hard drive with the image files.

DNG

DNG is unique in its ability to carry embedded PIE data and to also carry a fully rendered version of the adjusted image file as a medium or full-sized JPEG. Although this feature relies on the software application to parse the PIE data and the embedded JPEG, the design and structure are built into the DNG format.

OPTIMIZATION TOOLS

Monitors

Since optimizing raw files is an inherently visual process that requires computer and monitor, color management of the monitor is paramount. The most important parameters are:

- The monitor's quality (often judged by bit depth and gamut)
- The proper brightness setting (measured in nits or cdm/2)
- The best color temperature (measured in Kelvin units)

Always keep in mind that a perfect match between an emissive device, such as a monitor, and a print viewed with reflected light is not strictly possible. However, with good color management of the monitor and the output device, and accurate soft proofing, the perceived match can be amazingly good.

In the 1990s, high-end CRT (cathode ray tube) monitors were considered to be state of the art. That technology has gradually given way to LCD (liquid crystal display) panels. Up until now, these panels have used CCFL (cold cathode fluorescent lamp), back lights. CCFL technology is in the process of being replaced by LED (light-emitting diode) back-lights. LED backlights have many advantages over CCFL, including requiring half the power consumption, and more importantly, they are free of mercury, a toxic material emitted from electronic equipment. LED backlights have another advantage: since the white light they create is derived from pure red, blue, and green LEDs, the light is purer and brighter and can offer a wider color gamut than CCFL. Some LED panels that are currently available have up to 120% of the Adobe RGB (1998) color gamut, which is 25% more than the very best CCFL panels. Most likely your next LCD will be an LED backlit display.

Regardless of technology, calibration and profiling the display *must* be done before the optimization stage of your workflow. The reason is simple. Optimization requires judging and adjusting the color of your images. Once these adjustments are made and the file is rendered, they will be locked into the image. If your monitor has a colorcast, it is inevitable that your image files will too.

The first step for monitor calibration actually doesn't involve the monitor, but rather involves the workspace and print viewing lighting. The monitor's brightness will be determined by the brightness of your workspace lighting. Ideally, this should match prints viewed with a 5000 K viewing light. The viewing light can be either a commercial light box or a D50 simulated lamp (a filtered tungsten halogen bulb), arranged in a neutral gray box designed to shield the monitor from the light. The color temperature of your print viewing light influences the choice of the monitor color temperature. A reasonably dim working environment may be preferred. Neutral colors for wall, ceiling, and floor are recommended.

The monitor color temperature can range from 5000 K to 6500 K. This is best determined by either measuring the print viewing light color temperature or by comparing the Profile Verification print under the print viewing light to the Profile Verification image file on the monitor.

Try different color temperatures when you profile the monitor, and settle on the color temperature that gives the best match from the monitor to print as viewed under the print viewing light. Note that fine art prints are often viewed under tungsten lighting,which is even warmer than D50.

We routinely use a Profile Verification print (an image file and a certifiably accurate print of the image file) to judge the results of our monitor calibration and profiles. We use a Colorimeter (or Spectrophotometer) to set monitor brightness and to create an accurate profile based on the desired color temperature. The brightness range can be from 80 cd/m2 to 120 cd/m2, depending on the room brightness level. Correct monitor brightness is the most important criterion, followed by monitor color temperature, in achieving as close a match as possible to printed output.

An example of how the viewing light color temperature affects visual interpretation of print output. This can have a significant effect on print/monitor matching. The desk lamp on the left is a typical tungsten light with a color temperature of around 3000 K. The Solux light on the right is very close to the 5000 K ISO specification for print viewing.

What We Use

At our studio we check the monitor and printer profiles with a Profile Verification Kit, which is available from Neil Barstow Consulting (www.neilbarstow.com). The kit comes with

- An accurate Durst Lambda print of a test image
- The CMYK test image from which the Lamda print was made
- The Adobe Photoshop proof setup file, which ensures that the monitor can accurately simulate the test print

The Lambda print includes

- a metamerism checker, which verifies that the print is being viewed under D50 or D65 light conditions, and
- a row of color patches, which can be measured with a spectrophotometer and compared against the actual values in the Photoshop Info Pallette.

The test print is shown above in the light temperature example.

The profiling software may ask you to choose a gamma setting. The normal range is 1.8–2.2 gamma. A few programs support L* gamma, which is a nonlinear tone curve combining 1.8 and 2.2 gamma. Choice of gamma setting 1.8 or 2.2 will not affect work you do on image files. Imaging programs such as Photoshop automatically correct for different gamma settings. The monitor gamma setting will affect noncolor-managed applications (especially Web browsers). If you use 1.8 gamma for your monitor calibration, your Web-viewing experi-

ence may suffer as a result. Most Web content is created for 2.2 gamma correction. Once you have calibrated and profiled your monitors (and verified the profile if you use the Profile Verification method), you are ready to optimize your files into photographs.

Computers

The second part of the parametric image editing equation is the computer. As described earlier, raw files require demosaicing, which is the conversion and interpolation of the red, green, and blue pixels to a full-color image. Demosaicing is processor intensive. When it is done on a computer, more sophisticated (and better) algorithms can be used than can be done in the camera. Better algorithms can result in more detail, less noise, more accurate color, and reduced moiré. Some software addresses lens issues such as aberrations, distortion, and vignetting. If you wish to get your work done quickly, a fast CPU and generous RAM is required. Every new camera model, it seems, ups the ante by creating larger image files; consequently, we never seem to have enough speed or storage space.

File Storage

Processing raw files will result in a doubling or tripling (or more) of your storage requirements as compared to the original captured files.

Field and On Location Work

If you are working in the field with a laptop, a pared-down version of the dpBestflow workstation setup can be put together. It requires at least one, and ideally several, portable drives, and optionally, a supply of blank CD/DVD media. Original raw files can be written to CD/DVD after ingestion, providing an immediate read-only version of the image files as well as freeing up work space on the laptop. Think of the computer as

a work tool, not a storage device. Write the optimized files to one or more external hard drives. Once this is done, the laptop drive can be cleared of files and is ready for the next batch. Though not ideal, a profiled laptop monitor can be used for this step. However, do not expect the color to be as perfect as using a color-managed studio monitor as discussed above.

If you are working in a studio or an office on a computer workstation, the workstation should ideally have several internal drives in addition to the main drive. The main drive works best if kept relatively free of image files. Once again, think of the computer as a work tool only. Few computer workstations are set up for optimal digital photo processing. Additional RAM will need to be added as well as additional hard drives.

While some advocate the partitioning of large hard drives to keep applications and working image files separate, we feel that a better plan is to use additional physical drives. Keep in mind that when a drive fails, you will lose data across all partitions. Whatever configuration is used, it is important that all internal drives are backed up with another drive. For instance, if you have a drive for applications, it should be mirrored with another drive. If you have a second drive for your working image files, it should be backed up as well. The working files should only stay on the computer as long as it takes to process them and move them to a long-term storage drive. The long-term storage drives should be backed up as well. We discuss these strategies in Chapter 5 The Image Archive.

COLOR MANAGEMENT

A prerequisite for optimizing digital image files is to have a good understanding of color management and specifically RGB color spaces. JPEG files will come from the camera in the color space specified in the camera setup menu. Most professional-grade cameras will allow you to embed the appropriate color profile. Many point-and-shoot cameras operate only in sRGB color space, and they may not embed the profile. Open these untagged images and assign the sRGB profile. If the images look okay, then you can assume that sRGB is the capture space.

Raw files do not have an embedded color space until they have been optimized and exported to a standard file format (TIFF, JPEG, or PSD). Some PIEware applications offer just a few possible RGB profiles to output to, whereas others give you the choice of every color profile available on your system. In reality, only a few choices are really needed.

The primary color spaces to consider are the following:

- **sRGB, a narrow gamut lowest common denominator space used on the Web**
- **Adobe RGB (1998), a wider gamut space widely used for print applications**
- **ProPhotoRGB, a wide gamut space that preserves the entire capture of the camera sensor. This allows for later optimal use of the gamut available on wide gamut printers**

All three spaces have their uses and fan base. Unless all of your work ends up on the Web and you do not contemplate any other use, sRGB may work for you. Adobe RGB is the Goldilocks choice, neither too small, nor too large, and may be the best choice if your work is usually destined for publication and offset printing. ProPhotoRGB makes sense when the goal is maximum image gamut. If you use a 16-bit-depth workflow, definitely use Pro-Photo. Although it requires more work and careful handling, ProPhotoRGB is for those who don't want to leave any image gamut behind.

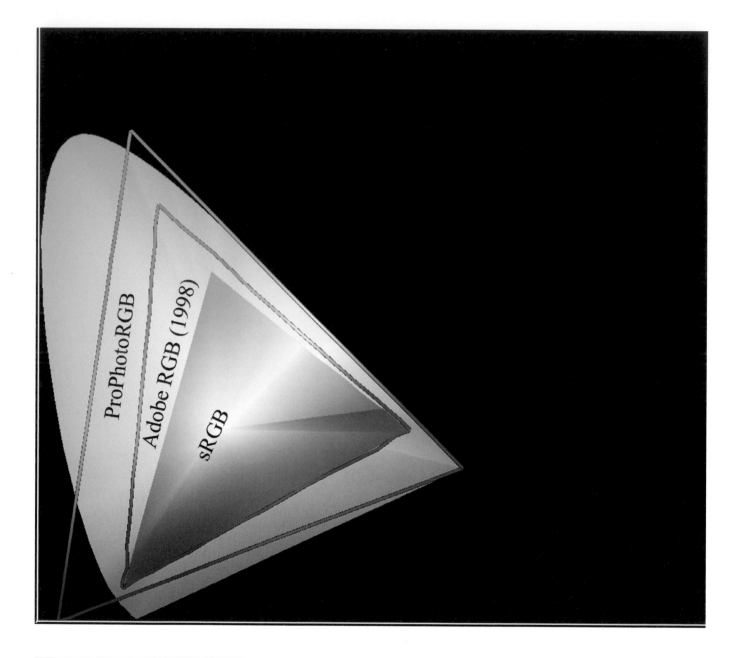

The three primary working spaces: sRGB, Adobe RGB (1998), and ProPhotoRGB.

If you select North American Prepress 2 from the Settings drop-down menu, you will have everything that you need for an Adobe RGB (1998) workflow:

Suite Color Settings

⊕ **Synchronized**

Your Creative Suite applications are synchronized using the same color settings for consistent color management.

 Monitor Color

Preparation of content for video and on-screen presentation. Emulates color behavior of most video applications. This setting is not recommended for documents with CMYK data.

 North America General Purpose 2

General-purpose color settings for screen and print in North America. Profile warnings are disabled.

 North America Prepress 2

Preparation of content for common printing conditions in North America. CMYK values are preserved. Profile warnings are enabled.

 North America Web/Internet

Preparation of content for non-print usage like the World Wide Web (WWW) in North America. RGB content is converted to sRGB.

DPBestflow
DPBestflow for print

☑ **Show Expanded List of Color Settings Files**

(**Show Saved Color Settings Files**) (Apply) (Cancel)

If you use Bridge, as well as other Adobe applications, you can set and apply the color settings to all the applications by going to Edit to Creative Suite Color Settings. In this situation, we select North America Prepress 2 and hit Apply. This will automatically push the settings into all the Adobe applications that you open.

Color Settings

Unsynchronized: Your Creative Suite applications are not synchronized for consistent color.

OK

Cancel

Load...

Save...

Fewer Options

☑ Preview

Settings: DPBestflow-ProPhoto

Working Spaces

RGB: ProPhoto RGB

CMYK: Coated GRACoL 2006 (ISO 12647-2:2004)

Gray: Gray Gamma 2.2

Spot: Dot Gain 20%

Color Management Policies

RGB: Preserve Embedded Profiles

CMYK: Preserve Embedded Profiles

Gray: Preserve Embedded Profiles

Profile Mismatches: ☑ Ask When Opening ☑ Ask When Pasting

Missing Profiles: ☑ Ask When Opening

Conversion Options

Engine: Adobe (ACE)

Intent: Relative Colorimetric

☑ Use Black Point Compensation

☑ Use Dither (8-bit/channel images)

☑ Compensate for Scene-referred Profiles

Advanced Controls

☐ Desaturate Monitor Colors By: 20 %

☐ Blend RGB Colors Using Gamma: 1.00

Description

DPBestflow-ProPhoto:

If you choose to use a 16-bit, ProPhoto Workflow, your color settings **should look like this example.**

The illustration above shows that the three primary color spaces offer progressively larger color gamut for your image files when they are output from the raw processor. Judging by the graph, you might wonder why anyone would choose any space other than the widest, ProPhotoRGB. As the color space gamut becomes wider, more care must be given to making image edits, and it is best to do any pixel-level image editing in 16-bit color. The reason is fairly simple. On a computer, an RGB triplet describes each shade of color. The RGB triplet is derived from the fact that the range of colors in a color space is described on a scale of 0–255. The wider the color gamut described by the color space, the larger the effect will be if you move a color by a few numbers on this scale. If you are working in 8-bit color, there are 16.8 million RGB triplet gradations available for editing. If, on the other hand, you are working in 16-bit color, there are 281 trillion gradations available that allow more precision when editing color in a large gamut color space. This extra precision comes at the price of doubling the file size over 8-bit editing. The extra file size requires more processor power and/or time.

Selecting Color Space and Monitors—Some Things to Be Aware Of

Most computer monitors only display sRGB color gamut. Expensive professional-quality graphics monitors, such as those made by Eizo, can display 97% of Adobe RGB (1998) color gamut. Only a few very expensive LED back light monitors such as those made by LaCie, NEC, and Samsung can display more color gamut than Adobe RGB, but still less than ProPhotoRGB. From a practical standpoint, this means that you may not see some colors in an image file that you are optimizing until you make a print, and only then if the printer has a wide gamut.

Once the color space decision is made, set the Photoshop working space accordingly. Do this by accessing the color settings menu, Edit to Color Settings

Set the RGB working spaces as follows:

- **You can select RGB color spaces from a drop-down menu or load them from the system profile folder.**

- **Choose "Preserve Embedded Profiles" under Color Management Policies.**

- **Place a checkmark next to the Profile Mismatches "Ask When Opening" and "Ask When Pasting," and for Missing Profiles, to "Ask When Opening."**

When the Photoshop Color Settings are configured in this way, you will be kept fully informed when image files have a different color profile from your working space or have no profile. Conversion to another color space will not occur unless you explicitly allow it. This is how it should be for complete color management of your image files, and any image files that pass through your workflow, regardless of origin.

© Patricia Russotti

Chapter 10

Master Files and Derivative Files

"It is a bad plan that admits of no modification."

—*PUBLILIUS SYRUS*

The edit and proof steps funnel image selection down to a set of images to be taken to the next workflow step, optimization for final use. In many cases, there will be multiple final outputs like Web, print, and offset reproduction. Our primary goal at this step is to create master files to provide maximum flexibility when repurposing image files. A master file is defined as a large version of the image (at least as large as the camera's native file size) in a wide gamut color space. Unlike batch-processed capture files, a master file is processed with greater attention to detail, tone, and color. Even if the project specifies Web use only, creating a master file is a necessary first step. Currently, we are in an interesting nexus. File optimization can occur in PIEware as well as in raster image editing software, such as Photoshop. This gives the option of having both a traditional master file created in Photoshop and a virtual master file created in PIEware. The master file is a high-value image file because it is usually highly rated by either the photographer, the client, or both, and also because it usually has a large time investment in either the PIEware, Photoshop, or both. As a high-value file, be sure that these files are backed up as working files and eventually as archived files. The backup strategy will vary depending on whether the master files are virtual, created, and stored in PIEware, or whether they are in a demosaiced standard format such as TIFF, PSD, or more rarely one of the JPEG variants such as JPEG 2000 or JPEG XR.

TOOL OPTIONS

PIEware

Today's technology allows all digital image files, even those in nonraw standard formats, to be adjusted in parametric image editors. We need to explore what can be done, even to JPEG and TIFF files, in PIEware before automatically moving on to the raster image editing application, which we will assume is Photoshop. Of course, PIEware is an even more powerful and necessary first step for raw or DNG files. The first versions of PIEware had a fairly rudimentary set of adjustment parameters. These have been supplemented with an initially confusing array of image adjustment parameters. Initially, the terms and sliders seemed to contradict what we had embraced as absolute ways of working in the earlier days of digital imaging. Today, the power of PIE tools has all but replaced doing optimization in Photoshop. These controls can be broken down into the basic panels that adjust white balance, density, tone, and image presence. Other panels control sharpening, noise, and lens issues such as chromatic aberration, which is often referred to as CA. Other panels can adjust specific hues or colors, either globally or for highlights and shadows separately. Vignetting (both to add it and subtract it) and Adobe software even add a camera calibration tab. The DNG profile editor has largely supplanted the camera calibration tab in Camera Raw. This is a more powerful tool for correcting an individual camera's sensor response. However, once a feature goes into Adobe software, it seldom comes out. Perhaps we could use the camera calibration tab for interesting creative effects rather than its intended purpose.

Newer features of PIEware, which are rapidly developing and improving, are localized image adjustments. These include spot removal, graduated filters, targeted gradient image adjustments, adjustment brushes, red-eye removal, crop, and straighten tools. Use of these tools, coupled with the global color and tone edits, and output sharpening controls, means that many image files never need a trip to Photoshop to be considered master files.

Hybrid Master Files

There is another developing technology in PIEware that has created a completely new master file concept, and that is the hybrid master file, which is one or more PIE edited image files imported into Photoshop as a smart object(s). These special layers can continue to be adjusted with PIEware (so far only with Adobe PIEware), while retouched with normal layers and layer masks.

Setup

PIEWARE SETUP

When creating master files in PIEware, the first step is to make sure that the PIEware preferences have been set up correctly. The most important preferences are to choose the color space, bit depth, image size, sharpening, file size, and file type to be applied to the exported files. The color space should be a wide gamut space. Adobe RGB (1998) is a good choice for master files, where the primary use for the delivered files will be offset printing. Some prefer ProPhoto RGB for this use, although others like to reserve this very wide space for inkjet printing only. Inkjets have a much wider gamut than the CMYK color mode required for offset. Reducing a very wide gamut space to CMYK can be more challenging than employing Adobe RGB (1998) for that purpose. It is recommended that the PIEware output 16-bit files if additional editing is planned in the raster image editing software (Photoshop). Deciding whether to sharpen images in PIEware is a judgment call, although unfortunately some PIEware applications apply an unknown amount of

sharpening even if the sharpen slider is set to zero. Careful comparison testing is required to determine whether your preferred PIEware choice adds sharpening. Careful testing is also required to determine whether sharpening in your particular PIEware creates jaggies or other artifacts than can be avoided by sharpening in Photoshop. Often, the amount of sharpening appropriate for Web proofs will be detrimental for master files, so remember to check the sharpening settings before exporting the file, and either reduce it or take it to zero. We've found that the default sharpening setting in most PIEware is a reasonable amount to use as capture sharpening. Process sharpening is added at the appropriate time as we work on the master file, and output sharpening is only applied to the derivative delivery files based on final use. Some PIEware has interpolation options that allow you to enlarge the image file beyond its native resolution. When available, we often make use of this feature when we are planning elaborate retouching or compositing. We want to have a large version of any file on which we will be spending significant retouching time, and it is always a good idea to do retouches on a larger file that will be reduced in size than the other way around.

Raster Image Editor (Photoshop) Setup

Although at least 70 software titles can do raster (pixel-based) editing, Adobe Photoshop is the largest in terms of features and market share among professional photographers. Photoshop (and Photoshop plug-ins) still play a large role in master file creation, despite the inroads made by PIEware. The first step in setting up Photoshop is to check the color settings. It is advisable to make your Photoshop working space consistent with your choice of export color space in the PIEware. At minimum, make sure that the "Preserve Embedded Profile" box is clicked on to preserve

the color intent of the files coming out of the PIEware.

Master Files and Derivative Files Workflow

The final goal of optimization is to prepare your image files for the next step in your specific workflow. Referring back to the flowcharts, the next step is often to correct tone and color for proofing. If the workflow doesn't require a proofing step, we may want to adjust the tone and color prior to archiving, or perhaps in preparation for exporting selected images to a raster image editor, such as Photoshop, for additional work that can only be done in that kind of application.

If proofing or archiving is the next workflow step, we will want to use the PIE application to make global and then specific image tone and color edits. At this point separating the images by rating may help you focus on the highly rated images and not be distracted (and spend more time on) by the lower rated images. One efficiency strategy is to make only global edits to the low ranking images and to add specific edits only to images with three or more stars, or whatever rating system you have decided to use.

If your shoot volume is high, you'll likely want to work with PIEware that has efficient batch-processing capability.

If you are not planning to convert raw files to DNG, you may wish to use PIEware that can make html Web galleries directly from adjusted raw files. These applications can generate color- and tone-accurate JPEGs sized for use in Web galleries on the fly. Many of these full-featured applications can batch process adjusted raw files to standard file formats in specific sizes and resolutions and save them to folders.

Using Camera Raw or Lightroom for Optimization

The order and sequence is not critical when you are working your way through the raw process engines, but, it is important to be consistent in what you do.

Each manufacturer has developed the sliders and controls for a specific reason and to suggest an order to move through. But, as we all know, the programmers and engineers sometimes do not understand how we work as well as we would like them to. Regardless of when you hit ok, the software will apply the adjustments in a way that is consistent with achieving the best image quality. We acknowledge the wealth of resources already available for specific software versions. We will not be duplicating this effort, but we simply want to share one method that we use.

The Adobe Photoshop Lightroom 2 Book: The Complete Guide for Photographers by Martin Evening

Real World Camera Raw with Adobe Photoshop CS4 by Bruce Fraser and Jeff Schewe

The Photoshop Lightroom Workbook: Workflow not Workslow in Lightroom 2 by Seth Resnick and Jamie Spritzer

Adobe Photoshop CS4 for Photographers: The Ultimate Workshop by Martin Evening and Jeff Schewe

Want to see the pros work through Camera Raw and Lightroom? The following sites give you just about everything you need to get started or to take it up a notch:

www.Jkost.com Julieanne Kost from Adobe has some of the finest step-by-step tutorials for Camera Raw, Photoshop, and Lightroom ,and they are free.

http://www.luminous-landscape.com video tutorials by Michael Reichman, Jeff Schewe,and Seth Resnick are available as well as a slew of articles and additional resources. These video downloads are a great investment, providing unique insight into pros' efficient and speedy workflow.

Our top picks for books that will give you step-by-step information include:

Here is a summary of what we do using an Adobe-centric workflow in either Camera Raw or Lightroom—regardless of the application the concepts are similar: white balance, density, tone, and then color adjustments, followed by capture sharpen and other local and global controls (dodging and burning, spotting, creative sharpening, skin smoothing, all of which can be done using brushes and gradients inside Camera Raw and Lightroom).

CAMERA RAW OR LIGHTROOM

- White balance always come first. Setting an accurate white balance can eliminate many of the image issues immediately.

- Next, we set Exposure and

- Then Blacks.

Think of this as placing stakes in the sand

Here is my white point—here is my black point.

- Markers that establish how everything else shifts.

- Remember to take advantage of seeing the "clipping" to help you determine where these points may

be. Hold down the option or alt key and drag the sliders. You can also click on the clipping warning triangles at the top of the histogram for a full color view.

– Adjust Recovery (especially useful for clipped out highlight detail). This slider will often bring back detail to very bright highlights.

– Adjust the Fill slider (the magic reflector in the raw sky). This slider moves the dark tone pixels toward the right of the histogram.

– Once the end points are established (Exposure and Blacks) and the light tone and dark tone areas are adjusted, then Brightness is used (We think of it as a "dimmer switch slider") to either overall lighten or darken the image.

– Adjust the Contrast slider as needed.

– The Clarity sldier is adjusted to pop the midtones. Adjust your view to 100% so that you can see an accurate build of what is happening. It is also important to slide this in both extremes—like focusing to see what is exactly right.

– Adjust the Vibrance and or Saturation sliders to taste and image content.

– Once you get to here, the next steps are image and style dependent and the order will vary depending on the individual. Typically, what we might do next is to go into

– Tone Curve adjustments based on image

– Capture Sharpen as well as luminance and color noise removal (Detail Panel)

– HSL/Grayscale to tweak any memory color or convert to grayscale

– Lens Correction to correct for any chromatic aberrations and to add vignettes

– And of course save Presets (appropriately labeled for repurposing) wherever possible

– Something often overlooked in Camera Raw (version 5.x and later) is the capability to save snapshots as you progress through the panels. These can be very helpful in providing before and after descriptions of incremental changes for comparisons. Lightroom of course makes it all more transparent and easier. History states and snapshots can be dragged and dropped onto your images and provide a number of ways to track your changes via view options.

We have already said it—but we believe it is important enough to mention again—wrap your head around creating presets and use these for batch processing to free up time to focus on the most important images. Build it once and use many times.

DNG Workflow

If you use a DNG workflow and did not convert to DNG on ingest, your next workflow step is to batch convert the adjusted raw files to DNG. If you plan to archive the proprietary raw files, you can either write the adjusted raw files (with their side-car files) to hard drive, or optical media such as CD/DVD/Blu-Ray, or you can embed the proprietary raw file inside the DNG. We never used to recommend the second option since it results in a doubling of the DNG file size. However, now that the DNG file has image verification built in, it is possible to verify the integrity of all the unchanging image data—including the proprietary raw file data. Remember, the only tool currently available to do this is the Adobe DNG Converter (discussed below). If you simply write the proprietary raw files to a disk, there is currently no way of checking on the integrity of that data as time goes on.

There are several ways to convert proprietary raw files to DNG, although currently in most cases, they require

Adobe software. Perhaps the most efficient tool for DNG conversion is the standalone DNG converter. This simple and efficient application runs in the background to convert adjusted raw files to DNG, leaving your computer free to do other things. It has a short list of preferences, the most important of which specify whether a JPEG preview file will be embedded and, if so, whether it will be medium or full size and whether the proprietary raw file will be embedded. There is another option, which is not well understood. This preference setting asks whether to" preserve raw image" or "convert to linear image." Preserving the raw image specifies that the image data will remain mosaiced. Converting to linear image will bake in the current adjustments and create what is essentially a TIFF file. It will no longer have the ability to be demosaiced, meaning that it is no longer truly raw. It will also assume the file size of a regular TIFF, which is roughly three times larger than it was as a mosaiced file.

Raw files can be converted to DNG via Adobe Bridge and Adobe Lightroom. However, using either of these applications requires the computer to concentrate on that task alone and is time consuming; consequently, we seldom use either for this function.

Once you have converted raw files to DNG, you can move on to proofing, archiving, or additional optimization, the same as you would with raw files (or JPEG/TIFF). The embedded JPEG previews in DNG files will allow you to view your image adjustments in other programs.

DNG WORKFLOW PRIMER

There are some "urban myths" related to converting to DNG, the primary one being: Do you leave something behind when you convert to DNG? NO! Everything is intact, plus a few additional things are included; for example—camera model, sensor type, camera serial number, proprietary raw files spectral characteristics of the sensor, and any lens issues are included within the DNG

DNG Issues
- Third-party software manufacturers do not read DNG or make use of their own proprietary information. They could, but so far do not take advantage of the format's capabilities.
- Third-party software needs to become "smarter" about its ability to take full advantage of the information within a DNG file.

Things You Should Know about DNG
- DNG is a container.
- DNG holds everything that proprietary raw files do.
- DNG also holds additional information that allows any third-party software to understand where the file came from and how it needs to be processed based on the PIE work done.
- DNG can hold a JPEG preview file that accurately reflects the PIE adjustments made to the raw image data. This JPEG preview is controlled by a menu preference in the DNG converter.

A DNG file's ability to hold an accurate JPEG preview (showing updated PIE adjustments) is a unique advantage. Proprietary raw files can only hold the original camera-generated JPEG preview—no matter what PIE adjustments are subsequently made to the image. Having an accurate preview built into the DNG file is an important feature if you use cataloging software and

wish to view your images as you have adjusted them. These ready-made JPEG files can be quickly copied out with certain applications such as PhotoMechanic and Expressions Media Pro. This saves time rather than processing out raw files to JPEG through PIEware.

- The JPEG preview, when it exists, can be updated. When and how that is done has some significant workflow implications. We will discuss those shortly when we talk about points of conversion.

- Of the three JPEG preview options, the full-sized preview option is the best for maximum workflow usefulness. When you select this option, a medium-size preview is also created, which can allow faster preview rendering in browsers or cataloging applications.

Pros for Converting to a DNG Workflow
- It's a standard documented format.

- It's suitable for archiving image data since it is an open-source format.

- DNG contains information about the camera that made the file and how the file needs to be processed (interpreted). This means that if you use a newly released camera with newly released proprietary raw format files that are converted to DNG, these DNGs can be processed in any older software that supports DNG processing.

- DNG can contain a JPEG preview that accurately reflects PIE adjustments.

- The DNG conversion process includes image data verification that tells you whether or not your data is good.

- DNG contains a verification hash that allows for continuing data verification

Cons for Converting to a DNG Workflow
- While this is becoming less true, converting files to DNG tends to lead one to adopt an Adobe-centric workflow (We see this as a reasonable way to live. . . .) For example, some third-party programs do not recognize a DNG since they do not properly parse the file data.

- There is lack of complete support by the industry as a whole.

- The ability to create and update accurate Jpeg previews can slow PIEware. Consequently, it is best done as a batch process.

POINTS OF CONVERSION

Early DNG Binding—Convert on Ingestion
Some choose to convert during ingestion (which we call early DNG binding). This requires awareness of a few issues and making decisions about how to handle these details during the rest of the workflow.

If you use Bridge/Camera Raw, PIEwork is automatically written to the DNG as XMP data. This makes your PIEwork portable because it is now contained within the DNG file. When the DNG is opened on another computer either in Bridge or Lightroom, the PIEwork will follow it there.

Bridge/Camera Raw gives you the option to update the JPEG previews immediately as you do your PIEwork (Camera Raw Preferences: DNG File Handling). Although this ensures that the JPEG previews are rebuilt to reflect your PIE work, this can slow your work progress unless you have a very fast workstation. We recommend that you don't turn on this option, but wait until you have finished adjusting your files.

JPEG previews can be updated within Bridge or with the standalone DNG converter. We recommend that

you run the newly adjusted DNG files back through the DNG converter since it can run in the background. If you open all the files in Camera Raw through Bridge to run the conversion, your workstation will be tied up until that task is finished.

An Important Item to Be Aware of

You will need to save the new DNG files in a new folder; otherwise you will have a second copy of each DNG interleaved with the original files (i.e., the converter will add a _1 just before the file extension). This is true whether you use Bridge/Camera Raw or the DNG converter.

Lightroom

Lightroom gives you the choice (Lightroom: catalog settings) to automatically write PIE XMP to the DNG files or manually update the XMP data (Metadata: Save Metadata to File). We recommend using this command to update the XMP at the end of your PIE session. This ensures that the image adjustments (as well as any metadata additions) are written into the DNG files. A person who only works on one computer may not see the need to write XMP to the DNG, but storing all your PIE work in a catalog will limit your options and make the file less portable. For example, if working in Lightroom and the XMP is not written to the file, the PIE work done in Lightroom will not appear in the file. Consequently, if the file is viewed in Bridge, or in Lightroom on another computer, this means all of your work will not show up.

As with Bridge/Camera Raw, this will tie up your workstation until the task is complete. However, Lightroom conveniently rewrites the DNG files, so you do not have to create a new folder and delete the old folder, as you need to do when using the stand-alone converter or Bridge/Camera Raw. This is the best option, in our opinion because the PIE work will show up in Bridge and Lightroom on any other computer, and since the JPEG preview has also been updated, your image adjustments will show up in other browsers and cataloging applications that don't parse raw files.

LATE DNG BINDING—CONVERT AFTER OPTIMIZATION

Our workflow preference is to convert to DNG after we have gone deeper into the workflow. We edit, rate, rename, and do a good first round (or two) of PIE work so that the image files are at least 90% optimized. More work can always be done, but at this stage, we should feel good enough about how the images look that we can show them. This is the best workflow point to convert to DNG. Here are the options:

Save Options
- **Save Folder**

It's best to save in a new folder. We use the same folder name but indicate that these are DNG files. For example, 09016 TomBloom cr2 becomes 09028 TomBloom DNG. If there are nested folders, we check the option to preserve subfolders. This is a convenient feature only available in the standalone DNG converter.

- **Select name for converted images**

We stick with the default, which is "Document Name." This preserves our original file name and adds the DNG extension. For example; RNA_09028_0123.cr2 becomes RNA_09028_0123.DNG.

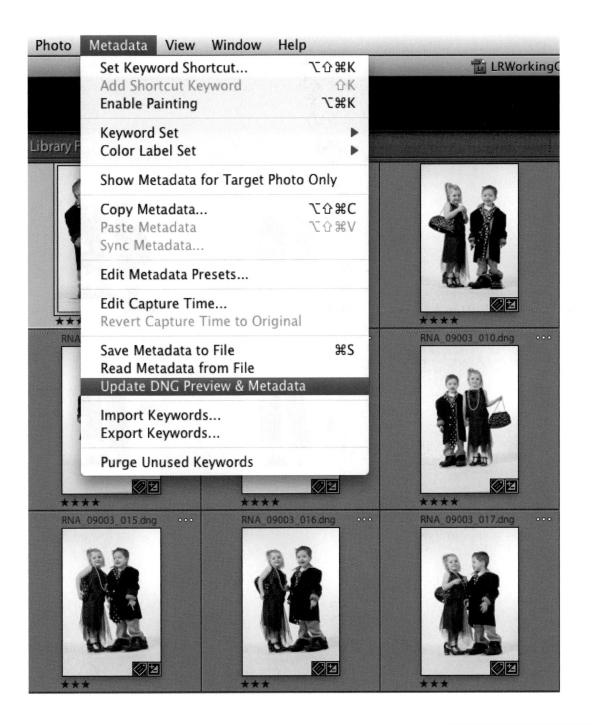

Lightroom has another option to update both the DNG preview (meaning the JPEG preview), and Metadata (meaning the XMP data), with one command found under the Metadata menu (Metadata: Update DNG Preview & Metadata).

DNG Converter

Adobe® Digital Negative Converter

1 Select the images to convert

Select Folder... /Users/rnaphoto/Desktop/09016 Tom Bloom cr2/

☑ Include images contained within subfolders

2 Select location to save converted images

Save in New Location ⬍

Select Folder... /Users/rnaphoto/Desktop/09016 Tom Bloom DNG/

☑ Preserve subfolders

3 Select name for converted images

Name example: MyDocument.dng

Document Name ⬍ + ⬍ +

⬍ + ⬍

Begin numbering:

File extension: .dng ⬍

4 Preferences

Compatibility: Camera Raw 5.4 and later
JPEG Preview: Full Size
Embed original

Change Preferences...

About DNG Converter...　Extract...　Quit　Convert

Preferences

Preview

JPEG Preview: [Full Size ⬍]

Compression

☑ Compressed (lossless)

Image Conversion Method

⦿ Preserve Raw Image

◯ Convert to Linear Image

ⓘ The image data is stored in the original "mosaic" format, if possible, which maximizes the amount of data preserved. Mosaic image data can be converted to linear data, but the reverse is not possible.

Original Raw File

☑ Embed Original Raw File

ⓘ Embeds the entire non–DNG raw file inside the DNG file. This creates a larger DNG file, but it allows the original raw file to be extracted later if needed.

(Cancel) (OK)

Recommended Preference settings for DNG conversion

Preferences

• **JPEG Preview**

We always choose the full-size JPEG preview. This choice will save a medium-size preview as well. The full-size preview will reflect any sharpening applied in Camera Raw or Lightroom (the medium-size JPEG preview is not sharpened). "Full size" means the JPEG will have the file dimensions set in Camera Raw or Lightroom. For instance, if you set Camera Raw to enlarge or reduce the native file, the JPEG preview will reflect that size choice as well as the PPI resolution setting.

• **Compression**

It's lossless; we recommend that you keep this default setting.

• **Image Conversion Method**

We recommend that you choose Preserve Raw Image. The raw image is undemosaiced image data. Once the image data has been processed into mosaiced data, it becomes a linear image, which is another way of saying that it has become similar to a standard raster image like TIFF. There is some confusion about what a linear DNG is, since most people assume that DNG is always a raw file. However, the Adobe DNG specification allows for a demoisaiced (linear) DNG that is essentially just like a TIFF file. Since it is demosaiced, it is three times larger than an undemosaiced (raw) DNG, and it has the PIE work baked in. Creation of a linear DNG is more commonly done by non-Adobe PIEware, such as DxO and Capture One PRO as a means of preserving their rendering of raw files.

• **Embed Original Raw File**

Choosing this preference stores the original proprietary raw file inside the DNG container. This is advantageous since you have preserved the proprietary raw file. You now have the option to extract it and process it in the manufacturer's software, or any other software that doesn't open DNG files. Another advantage is that the proprietary raw file is verified in the conversion process. The hash that allows for continuing verification of the DNG now also extends this extra security to the proprietary image data. The disadvantage is that it essentially doubles the size of the DNG. If you shoot a lot of files, you may find storing all that data to be a challenge, and of course moving files around will take twice as long.

What We Do—
Burn Proprietary Raw Files to Optical Disc

Instead of embedding the original raw files into our DNG, we like the option of burning these optimized, proprietary raw files to DVD or Blu-Ray since it does several things at once.

It saves

• The originals to a different media (one of the 3-2-1 rules)

• The 90% finished PIE work we've done

• The bulk IPTC metadata and file renaming

If we ever had to recover a loss of the DNG files, these archived proprietary raw files would only need to be run through the DNG converter to make us whole again.

Our Conclusions about the DNG Workflow

The DNG files have proven to be significantly more useful than the proprietary raw files in our workflow. We like the fact that:

- The metadata is safely stored in the file, not hanging off it in a side-car file.

- We have a full-size optimized JPEG file available in the DNG container that gives us an accurate view of the image in our DAM applications and offers us the option to quickly copy them out if we, or our clients, need good high-resolution files for general use.

- We have verified our image data by running our files through the DNG converter.

- We can verify these files long into the future, which is currently not possible for the proprietary raw files.

WHERE IS MY PIE STUFF (PARAMETRIC IMAGE EDITS THAT I MADE)?

Capture One

- Contains PIE in a file folder with the images.

- The EIP file format zips the XMP and the image together

Adobe Lightroom

- Three methods to choose from:
 - Store the PIEwork in the catalog database.
 - Push the PIEwork into the images files as you work.

 - Store all the PIE in the catalog database and push the settings into the image files at the end of your PIE work session, or when you export the files.

Bibble

- The existing version of Bibble 4.6 works like Camera Raw and Bridge—the PIE instructions can be attached as XMP side-car files (.bib) or they can be saved in the Bibble database.

- The new, yet to be released, Bibble 5 automatically creates and attaches XMP files with the PIE instructions. Bibble 5 can also function as a cataloging application, similar to Lightroom, by creating and storing high-quality previews. Unlike Lightroom, Bibble 5 allows the user the choice of browsing or cataloging image files. Currently, it is the only software that offers the choice. We think this is a great option.

Camera Raw

- Camera Raw, accessed through Bridge or Photoshop, automatically writes the PIE work as XMP side-car files for proprietary raw files.

- In the case of DNG, Camera Raw is configured by default to automatically update the XMP instructions in the DNG files and build a new JPEG preview. If you have more than a few DNG files to adjust, we recommend that you do not automatically update the DNGs, but rather run these updates as a batch process. Since the standalone DNG converter runs in the background, we think it is the best tool to use when working with a large number of DNG files compared to running the batch update within Bridge.

© Patricia Russotti

Chapter 11

Image Proofing

"I put a dollar in one of those change machines. Nothing changed."

—*GEORGE CARLIN*

The meaning of the term *proofing* has expanded with the digital age. Previously, the term *proof* was reserved for the output or finishing stage of a desktop publishing project. But now with digital photography, the term is more often used to describe image viewing, most commonly on a monitor.

PROOF TYPES THAT WE ARE FAMILIAR WITH

Contact Sheets

The term *contact sheet* is derived from the process of placing a sheet of negatives in direct contact with a photographic piece of paper and exposing the negatives. This creates one sheet with all the images the size of the original negatives. This process is used for viewing the images in a group at a small size so that a decision can be made regarding what images should be printed or used for the final product. A contact sheet has evolved from the traditional negatives on paper to using small thumbnail-size digital images and printing out a grouping on one (or more) sheets of paper. Again, this allows for viewing and selecting images for further use.

Mark-up Proofs

The term *mark-up proof* can be applied to any and all stages of proofing. Basically, a mark-up-proof is any proof that has been "marked" to identify areas that need further optimization. This can include selecting imaging to optimize for a contact sheet; it can also include more specific instructions

such as global or local color adjustment requirements and density adjustments. Or, for example, a graphic design working or artist proof may be "marked" perhaps to suggest a font change or layout alteration.

Work Proof or Artist Proof

A work or artist proof is a proof to ensure that the elements and characteristics are inherent in the image, guideprint, or work print, or example of the finished product, but not the finished product.

Contract Proof

A physical print that serves as a true representation of the anticipated final output. It is a binding object that, once signed off on by all parties, becomes the reference match point for subsequent reproductions.

Bon à Tirer (Pulled from)—Final Proof, Press Proofs

The press proof is the last proof to be checked before approval for printing. It is signed by the customer, or on his or her behalf, and releases the printer from responsibility. See www.proz.com/kudoz/french_to_english/printing_publishing/496223-le_bat.HTML

IMAGE LIFE CYCLE REVIEW

This is a good place to review what we have done so far in the workflow.

- **Capture: Record the photographic information.**
- **Ingestion**
 - **Download, rename, add metadata, back up.**
- **Edit**

Trash the losers, rate the keepers, label via stars and colors and stack, group like images, sequence, create smart collections, and so on.

At this point you may also need to rename the files based on sequence or other criteria.

- **Optimization—Creating Master Files**

Round one is to batch optimize. Apply presets in PIEware to tweak white balance and adjust density, tone, and color, add capture sharpen. This means efficiency - minimal work is needed to turn the images around quickly, and this allows you to concentrate on and devote more time to the highly rated images. This is a good time to archive the original captures, or, depending on the project and your particular workflow, it might be better to do it after the second round of optimization.

- **Proof**
 - **Create Web galleries to show the shoot or select to the client.**
 - **Make contact sheets for reference of sequence or project "visual notes."**
 - **If outputting to a substrate, make a work proof/print on the substrate to be sure you have made the right choice, and/or to check image content that might need to be adjusted based on a particular surface or output device. Or, if you are considering multiple output substrates, you may make work prints on each before you decide on the final substrate.**
 - **Another useful tool is to make ring-arounds for density, contrast, or color so that you can see all possibilities and how each translates as a print.**
 - **This is especially useful when preparing work for exhibitions.**
 - **A great resource for proofing techniques and different ways to think about them is www.**

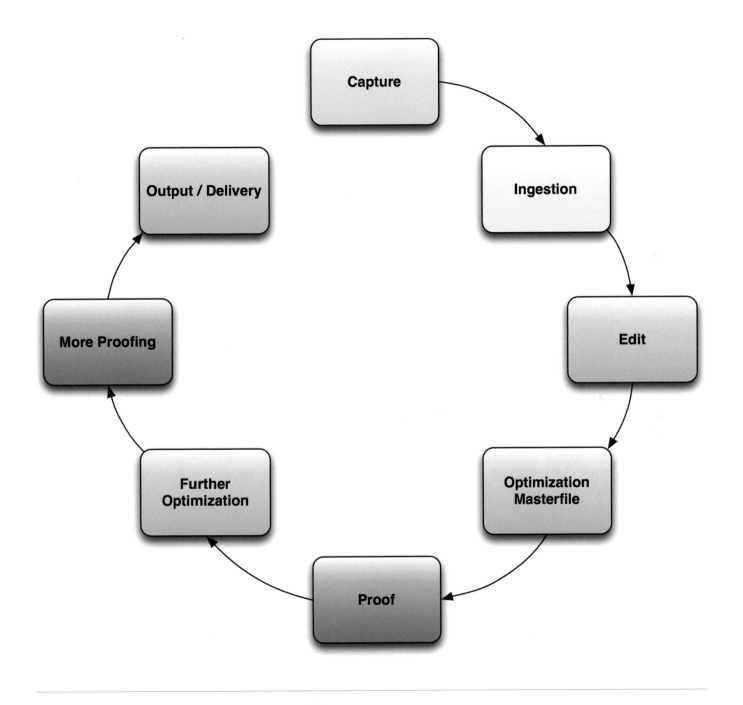

This diagram illustrates where proofing fits into the overall workflow.

johnpaulcaponigro.com. (Go to lessons to techniques to proofing.) John Paul has a long list of PDFs and tutorials that are very insightful and useful.

- **Further optimization:** This may result in an updated existing master file, or it may result in derivative files, depending on the job or project and your unique style or look

 ○ This may involve utilizing more local controls in PIEware that further improve the important images—for example, additional color correction, dodging and burning, basic dust busting.

 ○ This would be the place to take images into Photoshop and do heavy retouching, composites, HDR, image stitching for panoramas, and any other task that requires heavy pixel lifting, although if capture techniques and PIEwork are good, not much heavy lifting should be required. Of course, if you don't know lighting, or available light. ...

- Remember, when you work in a raster program like Photoshop, to use nondestructive techniques. We recommend always working in layers, labeling each of the various flavors and using layer groups to organize the work and using smart objects whenever possible to maximize PIEware and the power of Raw as well as layer comps.

 ○ Consider importing raw files as smart objects to maximize PIEware capabilities.

 ○ Depending on your particular workflow and the project, you may have multiple master files (HDR master file, composite master file, etc.) at this point and/or begin to build derivative files for specific output or delivery.

- More proofing

 ○ If you are preparing the files for final output, this would be the place to make another round of proofs to be sure what you see on screen translates to your specified output. Unfortunately, this extra round of proofing is often skipped, and the consequence may bring some unhappy surprises. We recommend adding this proof phase especially if you are making large prints, exhibition prints, or outputting to a unique substrate. Again, check www.johnpaulcaponigro.com for thoughtful concepts and techniques to consider during the many iterations of the proof portion of the workflow.

 ○ If the final output is for offset press, the RGB-CMYK conversion should be softproofed as part of the conversion process, and a hard proof (CMYK GuidePrint) should be made using a cross-rendered technique with either the printer driver or through the use of RIP software. We give you more information about this part of the workflow in Chapter 12, Image Delivery. An excellent resource on RGB-CMYK workflow is *CMYK 2.0* by Rick McCleary (PeachPit Press).

An image is usually first viewed on either an LCD screen on the back of a camera (mainly useful for checking the histogram for exposure) or on a computer monitor to see what has been captured. After ingestion, we edit and then optimize the files to bring them closer to the original intent, or to push the images in a new or different creative direction. This important part of the workflow can be accomplished using browsers or PIEware. When you feel that the images reflect your intentions, they can be shared with clients or project participants. Many tools can be used, so that sharing proofs can be done efficiently prior to the final image selection.

The proof phase, or file viewing, should occur prior to final output or delivery.

- Soft proofs are used to preview the image in its destination appearance.
- Artist proofs are used to ensure the elements and characteristics in the image and or the design.
- Contract proofs are physical, binding objects, intended to be signed off on by all parties.

Traditionally, proofs had been thought of as an image or images on paper. With today's technology, the majority of proofing phases is done via computer monitors.

WHY PROOF?

At its simplest, the goal of proofing is to see what you have captured. A higher goal may be further optimization to bring the images closer to our original intent, or, seeing potential, push them in a new creative direction. Simple non-PIEware browsers, such as Photo-Mechanic, are good at showing us the images quickly. PIEware browsers and Cataloging PIEware allow us to also adjust the images, without eliminating the original data, and to work efficiently. When we plan to share proofs with clients or other project participants, our goal should be to have the proofs reflect our intentions with the images, even if we aren't aiming for perfection at this stage. If our plan for the images involves HDR, panoramic stitching, compositing or combining, and/or retouching, we may have to do two rounds of proofing—the first to determine the image or set of images that will be blended, combined, or retouched, and the second (or more) rounds to show the work in progress until final sign-off.

The edit phase allows for image selections to be made into groups of images. Once an image or a subset of images has been selected during the edit phase, it is time to optimize them for final use or the next round of optimization.

This may lead to an even further refined selection of images ready for additional optimization. Further optimization can include tasks such as retouching, combining images, stitching, artistic development, creating various looks, and styles.

The goal of optimization is to create a master file that can be repurposed with maximum flexibility and portability for multiple applications such as the Web, print, or offset reproduction.

Unlike the batch optimization phase, some master files may be further optimized with greater attention to detail, tone, and color or additional work in Photoshop.

Master files are of high value because of the amount of time invested in handling these images. It is very important to archive these files in a way that is most suitable to your workflow considerations. Once a master file has been created, it can be repurposed again and again as needed. The repurposed files are now derivative files. Some choose to save derivative files for reuse or simply as documentation, while others discard these files figuring that they can always be quickly generated from the saved master files.

Once all desired optimization has occurred, we can do a variety of different kinds of proofing based on the project need.

The Internet has become the most common and effective way to share images quickly. Online viewing has all but replaced hard copy contact sheets, and it provides almost instantaneous sharing of images through the use of Web galleries built from JPEG images. It is important to note that JPEG images should be

converted to the sRGB color space prior to uploading to a Web gallery to ensure they will be closer to the color space of the average monitor.

When our intention is to share proofs, other goals include

- Making it easy to match the proof image file number with the original image

- Making the proofs available quickly

- Possibly making the proofs available to multiple project participants

- Making the proofs reasonably (or completely) private

- Ensuring the receiver understands that proofs are not good for final use

BEST PRACTICES

The Internet has become the standard for shared proofs. For a brief period, some preferred to make hard copy contact sheets, but online viewing of .HTML Web galleries can be nearly instant, provide higher quality, and be infinitely more flexible. It is, of course, possible to create a contact sheet document, save it as a PDF, and e-mail it, but the quality is poor when compared to HTML galleries. HTML galleries are built from JPEG files for quick loading on the Web. When building Web galleries, it is important to have the applications convert the JPEG files to the sRGB color space. Embedding the sRGB profile is probably a good idea, although currently only a few Web browsers are color managed. Noncolor-managed Web browsers assign the viewer's monitor profile to all image files, even those tagged as sRGB. If your Web galleries are built from sRGB files, they will be closer to the color space of the average monitor than Adobe RGB (1998) files. Adobe RGB (1998) files

will appear dull and lifeless compared to sRGB files in a typical noncolor-managed browser on an average monitor.

Sometimes There Is a Need for the Old Way. ...

Some clients still request hard copy contact sheets and proofs. Hard copies are often used for documentation purposes and sometimes for very large projects. A paper trail can help keep everyone on the same page and honest. We recommend that you utilize as much online delivery as possible for convenience and speed, but sometimes there is just no substitute for physical proofs and test prints. We also want to remind you that sometimes making that extra proof can be worth every penny it costs in time and money if it points to an issue you simply could not have anticipated by viewing the image on a monitor.

Zoomify

Another technique to keep in mind when you are building Web-shared images is to check out the Zoomify function that is available in Photoshop (and as a standalone product) to add a variety of zoom levels to an image. Think on-ine shopping and the ability to zoom into an image to look at its detail. ...

From the Adobe Photoshop Help Menu

Export to Zoomify

You can post high-resolution images on the Web that viewers can pan and zoom to see more detail. The basic-size image downloads at the same time as an equivalent-size JPEG file. Photoshop exports the JPEG files and HTML file that you can upload to your Web server.

1. Choose File > Export > Zoomify and set export options.

 Template Sets the background and navigation for the image viewed in the browser.

 Output Location Specifies the location and name of the file.

 Image Tile Options Specifies the quality of the image.

 Browser Options Sets the pixel width and height for the base image in the viewer's browser.

2. Upload the HTML and image files to your Web server.

For a video on Zoomify, see www.adobe.com/go/vid0003.

PROOFING TOOLS

Most DAM applications, from browsers to PIEware, Cataloging PIEware, and cataloging applications can create HTML Web galleries. Many of them have ready-made templates or can use custom templates. The simplest proofing option is to use an FTP application to transfer HTML Web galleries to an existing Web site. If security is a concern, the Web galleries can be sent to a password-protected area of the site. Password protection can be added if the photographer is Web savvy. One can add a simple Javascript for light protection (if hackers are not an issue), or one can use

server-side commands for more secure password protection. To keep the galleries from being seen by search engines such as Google, simply add ⟨meta name="robots" content="noindex, nofollow"/⟩ to the head portion of the gallery's HTML. A simple low-tech security device is to put a job number at the beginning of the Web gallery name. For instance, if the Web gallery is named 09012_clientA_proofs, it will not come up in a Google search for clientA. Of course, Web galleries can be delivered on CD or delivered via FTP. Either method provides a completely private transaction, although physical delivery on CD seems very last century and slow in today's world!

We have also experienced issues when trying to move large volumes of images through a network. As much as we love dropping images on servers, using ftp, YouSendIt, there are times when it simply is not an effective way to do business. Just recently, Patti experienced the complications of trying to upload gigabytes of files through an ftp site, then YouSendIt. Issues related to file corruption can occur, and these systems just don't work fast enough. After days of trying to move files to a client's server, Patti finally convinced the client that it would be much more expedient if she burned DVDs and sent them overnight delivery. At one point in the process, she even found it more effective to have the client ask a staff member drive to an agreed upon location on the Thruway to deliver the files via a hard drive!

Sometimes, the old-fashioned way works and needs to be considered in the equation for expediency and sanity.

A more elaborate approach to proofing is available by installing software that can be used with an existing

Website to manage photo galleries. The software allows the photographer to create searchable image databases and permits users to comment on images. A few examples are: Zenphoto.org. Jalbum.net, Lightboxphoto.com. The interactive nature of these applications makes collaboration easier than with simple Web galleries. Because the software is only the architecture for the photo galleries, the design is fully customizable and can be fully integrated into an existing site They require some Website management knowledge, an existing URL, and Web hosting. Lightboxphoto.com adds a built-in shopping cart function, which the other applications lack.

There are many online proofing options that don't require maintaining your own URL. Services such as Collages.net, Photoshelter.com, and Smugmug.com add on features such as online archiving, automated fulfillment, and downloads of high-resolution images. Social networking sites, such as Flickr, while perhaps not as professional, do allow showing a collection of images either privately or to the whole world. Flickr features unlimited storage and bandwidth, as well as allows direct downloading of high-resolution files. Galleries can be made private and seen only by those who are given the gallery's URL. Photos can be commented on, although this requires having a Flickr ID.

© Patricia Russotti

Chapter 12

Image Delivery

"If you do not change direction, you may end up where you are heading."

—LAO TZU

Digital image files are usually handed off to the next person in line in the production chain. Some may make their own prints, post images online, or create CMYK files. Whatever the scenario may be, the key goal of image delivery is to hand off or deliver exactly what is needed. Sometimes determining what the next person in line actually needs becomes the biggest challenge, even if it is to yourself.

DELIVERY TYPES

Delivery files break down into two categories: rendered files and unrendered files. We recommend the use of rendered files for delivery. Delivery of unrendered files should only occur in special circumstances. Delivering a rendered file that is "fixed" with all of your intentions for the file's interpretation is critical to ensuring that its reproduction meets your intentions and standards. Files must have all information embedded and, when appropriate, a reference print.

The image file delivery possibilities are:

RENDERED FILES
- **Repro-ready RGB or CMYK image files**
- **Repro-ready, but unsized, RGB or CMYK image files with no output sharpening**

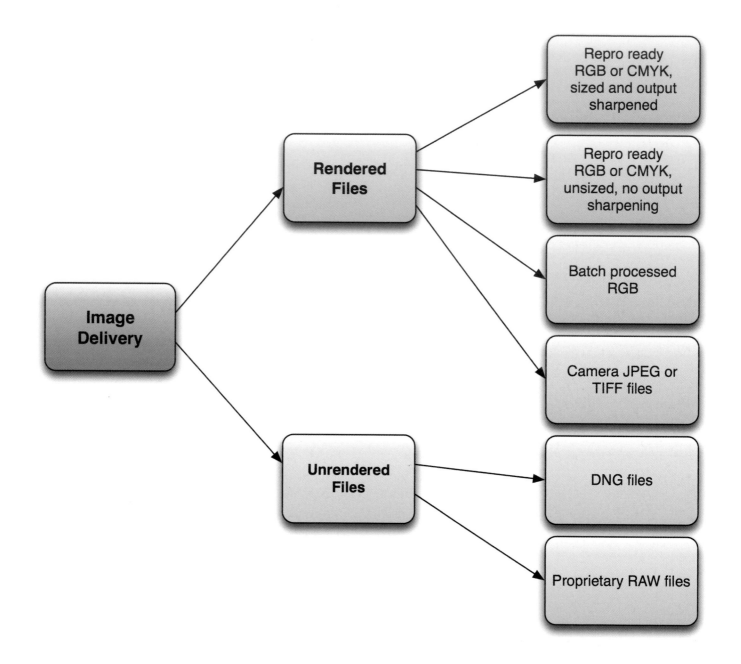

- Batch-processed RGB Image files
- Camera JPEG or TIFF files

UNRENDERED FILES
- DNG files
- Raw files.

Note: When we say repro ready, we mean a file that has been optimized to the specs of the output destination—size, resolution, sharpening, working space.

RENDERED FILES: REPRO-READY RGB OR CMYK IMAGE FILES

Delivering finished RGB or CMYK image files provides the greatest degree of control over how the images will display or be reproduced. Delivering completely finished files requires a high level of communication (precise instructions from the service provider and precise instructions about the file from you) between provider and receiver.

This process usually involves:

- Flattening the master file, no layers, channels, or paths
- Converting it to the delivery color profile, file format
- Almost always 8-bit depth

The image receiver may need images for a variety of uses, including offset reproduction, the Web, digital projection, or for prints. In the case of multiple uses, it's best if the images match visually, despite the different media. The first step for delivery of finished files is to nail down the exact media requirements. Hopefully, the media requirements are determined during the planning step—collect as much information as possible about the deliverables or file requirements from the service provider.

The minimum information required to deliver finished files includes the following:

- The reproduction size
- The media that the file will be output to, that is, print, Web, projection, digital prints
- If it is for print, the type of screening, the line screen, and the general paper specification (if not the exact paper)
- The type of press (offset, Web, gravure, digital, etc.)

In today's fluid and fast-paced production environment, getting answers to these seemingly simple questions is akin to asking your broker if the stock market will go up or down tomorrow. Many times design directors do not determine final sizes until they have the images in hand. It is often impossible to know who will be printing any particular project. Sometimes it is multiple printers—especially in the case of magazine ads that may run in a variety of publications. It is also increasingly common for a set of images to appear in all media. If you can get this information, it is much easier to create appropriately prepared delivery files.

One strategy that works well for some is to deliver files in sets of small, medium, and large, at 300 PPI for print, and small, medium, and large, at pixel dimensions to match for Web or projection. Although this is slightly more work, it does enable output sharpening since the image receiver should be able to adjust the size of the most appropriately sized image without impacting the sharpening very much. It is important for the image files to be sized down and not up, unless the up-res is 10% or less.

PREPARING IMAGE FILES FOR THE WEB

If the Web designer can give you pixel dimensions for the needed image files, your job is fairly easy. Master files should be

- Flattened (no layers, channels or paths)
- Converted to sRGB color space

It is good practice to embed the profile, even if most Web browsers won't see it; a few, such as Safari, do, and color accuracy will be enhanced in those cases.

TripWire

One possible caveat to the rule that says embedding the profile is best practice is when color consistency is more important than color accuracy. In a noncolor-managed browser, untagged images are assigned the viewer's monitor profile. This means that identical RGB triplets, tagged and untagged, display the same. In a color-managed browser such as Safari, tagged and untagged, the RGB triplets do not display the same since the untagged RGB will display in monitor color and the tagged RGB will display in sRGB color.

Image Size

The image files should then be resized to the correct width and height (in pixels). The PPI is irrelevant. But if you want to visualize the final size on screen in terms of inches (or centimeters), set the resolution to 72 PPI and adjust the inches or centimeters to the desired size. Since this usually involves making the image files smaller, there are two resampling choices to consider: bicubic or bicubic sharper. Many prefer bicubic sharper because it sharpens and resizes in one action. For more control, use bicubic resampling, and then sharpen to taste using smart sharpen, unsharp mask, or high-pass sharpening. Since you are sharpening for screen, the effect you see at 100% on your monitor is accurate.

Photoshop CS4 General Preferences

The Image Interpolation choice that is set here is what will be used to calculate any dynamic changes (crop, or any of the functions within the free transform options) in Photoshop.

The Image Size dialogue box in Adobe Photoshop CS 4

SAVING FILES FOR SCREEN USE

The final step is to save the image files to the JPEG, PNG, or, more rarely, GIF format. JPEG is the usual choice because it offers the best quality/size ratio for photographic images. Photoshop offers two conversion choices: "Save as" JPEG, or "Save for Web and Devices." Save for Web and Devices offers more control over compression options as well as letting you see the final compression effects before you convert. Save for Web and Devices strips most metadata from files by default as you save them, which can be desirable if you need the smallest possible file size, but undesirable if you wish to keep your copyright

and other IPTC information in the image file. Photoshop CS3 saves only the image file description and the creator's copyright notice by default. It is possible to save all metadata (XMP format only) in CS3 if the "include XMP" option box is checked. In CS3, this option saves an XMP copy of the EXIF data as well, so stripping EXIF data must be done prior to using this option. Photoshop CS4 has improved the situation considerably with four metadata options (XMP format only):

- **None**

- **Copyright and contact information**

- All metadata except EXIF data

- All metadata

While there is always more than one way to do anything in Photoshop. The following are options we recommend for saving JPEGs within Adobe Photoshop.

Save for Web and Devices

This method allows you to see exactly how the image will look without having to save and reopen the JPEG. File to Save for Web and Devices

Image Processor in Abobe Photoshop CS 4

Image Processor is a script that automates the process and will resize large batches of images automatically, and of course; the work and instructions can be saved and applied to future batches of images.

Preparing Image Files for Digital Projectors and Other Screen Devices

Digital projectors come in a variety of resolutions. You should deliver flattened image files that have the correct pixel dimensions for the projection device. The common resolutions are:

- **VGA (640 × 480)—used primarily on small graphic tablets**
- **SVGA (800 × 600)—only seen now on older projectors**
- **XGA (1024 × 768)—the most common resolution for Power Point presentations and projected video**
- **SXGA (1280 × 1024)**
- **SXGA+ (1400 × 1050)—newer projectors**
- **Widescreen (1920 × 1080)—HDTV**

Images should be cropped to fit the varying aspect ratios. If cropping is undesirable, images can be dropped into a canvass of the correct aspect ratio that is filled with a compatible color (or black). If the image is to be zoomed in on, or panned across, it will need to be sized accordingly. Projected images should be sharpened for screen just as they are for the Web.

Crop tool in Photoshop CS4 set to crop at specific pixel dimensions to match a screen's dimensions.

Although digital projectors can be calibrated and pro-filed using the same or similar tools and software as for computer monitors, they seldom are. For this reason, it is usually a good idea to convert the delivery files to the sRGB color space. Conversion to sRGB is particularly important if the images are to be incorporated into other software, such as Power Point, KeyNote, or MSWord, since these programs vary in their ability to read and use embedded color profiles.

PREPARING RGB FILES FOR DIGITAL PRINTING

Proper Resolution

Digital print devices include inkjet, continuous-tone printers such as those found in digital color labs and commercial digital presses. Files delivered for these uses need to be "high resolution," which may mean 300 PPI at the final printed size in inches or centimeters. In our testing, we discovered that some laser print devices show smoother tonal rendition and better detail if given 400 PPI files.

Files should be

- Flattened, with no channels or paths
- Converted to 8-bit except in cases where 16-bit printing is supported, as is the case with some of the newer printer drivers and RIPs

Inkjet printers can print at very high DPI resolutions such as 720, 1440, and 2880. There has always been some confusion between the terms *dots per inch* and *pixels per inch*, and those who don't understand the distinction might conclude that the best resolution for an 8″ × 10″ Epson inkjet would be 8 × 10 × the native resolution of Epson Photo Stylus printers, which is 1440 PPI. The fact is that this would be a great waste of pixels. Most agree that there is no more detail to be realized beyond 480 PPI, and that 360 PPI is a very practical upper limit. As a rule, large inkjet prints can be made from lower resolution files, although 180 PPI is often mentioned as the practical lower limit—depending on print size and viewing distance.

Continuous-tone printers, such as the Kodak Durst Lamda and Cymbolic Sciences Lightjets, print at much lower PPI resolution than inkjets (either 200 or 400 PPI). These devices expose photographic paper with laser light generated from digital files, and despite their lower native resolution compared to inkjets, they create continuous-tone images. This technology is flexible in terms of input resolution. A one-to-one matching of input to output resolution is ideal, but good results can be had with an input resolution one-half that of the output resolution. This makes this type of printer ideal for very large print sizes.

Commercial Digital Presses are becoming an increasingly common adjunct to offset presses in the commercial print world. Since they are much easier to set up and run than offset presses, they are ideal for short runs and print-on-demand applications. In general, they print with a linescreen equivalent of around 200 DPI. Most printers recommend 300 PPI resolution files for input, although anything above 200 PPI is quite safe. Depending on the image, you may see a smoother tone as a result of resolution up to 400 PPI.

Color Profiles

Inkjets, continuous-tone printers, and commercial digital presses can all be profiled. In addition, they can be used with raster image processors (RIPs), which usually provide a means to calibrate as well as profile the device. Obtaining a specific profile for any of these printers is ideal. Unless you own the device and have the means to profile it, you will need to rely on good communication with the people who run the machine to find out if there is a custom profile available to use, or whether they use a RIP to apply an input profile on the fly. When that is the case, delivering a good RGB file in a standard RGB space such as sRGB or Adobe RGB (1998) will suffice. If the shop running the device shrugs off color management questions, your best bet is to deliver sRGB files and hope for the best. If you have the time and inclination, you can pay to have test targets printed and then create your own profiles. Be aware that the longevity of these profiles depends entirely on the level of process control at the print shop or service bureau.

Preparing Digital Image Files for CMYK Delivery

The majority of photographers shy away from providing CMYK files. Perhaps it's because many of them remember making color separations from the film days as an arcane process requiring $50,000 drum scanners, specialized RIP software, and printers who treat the whole process like it was their own version of the original Coke recipe. Meanwhile, many design directors blithely push the "convert to profile" button without a second thought. The truth is somewhere in between. Good RGB to CMYK conversion is both an art and a science, but it is not rocket science. We highly recommend Rick McCleary's *CMYK 2.0* (Peachpit 2009) as a good guide to this process, as well as the Adobe white papers by Bruce Fraser and Jeff Schewe, www.adobe.com/digitalimag/ps_pro_primers. HTML.

The big difference between preparing image files for RGB output versus CMYK output is that the CMYK color mode has a much smaller gamut (range of possible colors) than the RGB color mode. Consequently, certain colors that appear in RGB simply don't translate into CMYK, which is why vivid blue skies often become dull or take on a magenta hue. It also explains why detail disappears in very saturated colors. For example, the weave in a saturated red fabric may turn into undifferentiated red mush. Various strategies can be employed to adjust the hue and saturation of RGB files to achieve reasonable CMYK rendering. Fancier strategies, such as replacing a weak black (K) channel with one derived from the Cyan or Magenta channel, can be used to bring back detail in out of gamut colors. The truth is that these problems only surface occasionally and the norm is for RGB images to convert fairly easily to CMYK.

You can take certain steps to learn what the issues may be during the CMYK conversion

1. Check the image for any out of gamut pixels by turning on the gamut Warning as shown below
2. Soft Proof in Adobe Photoshop CS4

View of an image with the gamut warning turned on to show where out of gamut pixels live

In Adobe Photoshop CS4, go to **View to Proof setup to Custom**

Dialogue box for selecting output profile

- Be sure to place a checkmark next to Simulate Black Ink.
- Use Simulate Paper Color when outputting to a substrate with a hue or tone. For example, we

might only turn this on if we are going to a fine art paper to be printed on an inkjet device. For press, we would only turn this on if we knew the image was to be printed on a colored stock.

While the general rule of thumb is to use Relative Colorimetric Rendering Intent for most photographic images, sometimes Perceptual will yield a visually better result. If you have an image that is out of gamut, Perceptual may result in a more appropriate print.

How do you know? Try them out, take a look on screen, but for the most accurate information, make some test prints.

One potential stumbling block is the concern that specific CMYK profiles are needed for best results. Offset presses are different from other printing devices in that they have much greater calibration control. Newer presses are controlled by computers that can adjust the mix of inks at many points across the press sheet with a high degree of accuracy. Just as we gray balance monitors and gray balance cameras, good press operators gray balance their presses. The gray balancing methodology outlined in the GRACoL/SWOP speci-

fications has the huge benefit of making specific CMYK profiles largely irrelevant except in the unusual case of nonstandard ink colors. Three profiles, one for sheetfed presses and two for Web presses, cover the range of papers from premium coated #1 sheets to wood pulp-based #5 sheets. Adobe's version of these three profiles shipped with CS4, or the GRACoL/SWOP versions, can be downloaded from the SWOP. org Website. The GRACoL Coated profiles can be used in place of U.S. Sheetfed Coated, and the Web Coated SWOP 2006 Grade 3 or Grade 5 paper profiles can replace the U.S. Web Coated v2 profiles that shipped with earlier versions of Photoshop up to CS3. We have discovered that even non color-managed print shops print better from the new GRACoL or SWOP profiles (as long as they don't assign a different profile to the image files). If you are provided with a specific CMYK profile, by all means use it. However, don't assume that just because the printer is unknown,

you are unable to deliver good CMYK files. An additional benefit of the GRACoL/SWOP methodology and the accompanying CMYK profiles is that they maximize the CMYK gamut, getting the most color out of the press and making conversion from RGB easier, since fewer colors get clipped. Although the new profiles are all formulated for coated stock and have correspondingly high total ink limits, most printers can easily bring those values down for uncoated stock via Photoshop, a device link profile, or by means of the RIP.

CMYK GUIDEPRINTS

CMYK guideprints can be a very useful tool, especially when the printer is unknown. These are easily produced on desktop printers. The main criteria are that you have a good profile for the printer/paper combination and that you make the print from either the CMYK proof space (RGB file with the appropriate CMYK profile set as the destination space) or the CMYK derivative file. Doing either will restrict the colors to the target CMYK color gamut, giving a realistic preview of how the image file will print on the offset press. Using the printer driver will give a good visual match; using a RIP will get you even closer, especially if the RIP has a linearization function. Linearization calibrates the printer and makes the profile even more accurate. RIP-driven inkjets are, in fact, what printers use nowadays for making proofs.

One advantage of delivering CMYK files is that if the image files are reproduced in a variety of media, from Web to print (screen to substrate), it is possible to achieve a visual match across the various media if you create the CMYK files first. Then when you convert them back to RGB for the other uses, they will match since the colors have already been reduced to the CMYK gamut.

Sharpening for Output

All image files, regardless of reproduction method, require output sharpening. This targeted output sharpening occurs when the image is at the final size for the specific display or printing device and substrate. Sometimes the only piece of missing information preventing delivery of a completely finished image file is the exact reproduction size. Although it is possible to sharpen delivery files "generically," any resizing done after this will resample the pixels and result in some loss of sharpness. As mentioned previously, a work around is to deliver sets of files at different sizes, but this does add to the workload. However, use of Photoshop actions can automate and speed up this process.

There are two fundamental ways to sharpen digital images:

- **Sharpening the pixels that make up an image**
- **Edge sharpening, which is sharpening the edges of shapes within an image.**

We conclude that capture sharpening is best done inside Camera Raw or Lightroom and that other pixel sharpening, using Unsharp Mask, Smart Sharpen filters, or sharpening plug-ins such as PhotoKit Sharpener, Nik Sharpener Pro, and Focal Blade, works well for both capture and creative sharpening. When it comes to sharpening for output, we prefer edge sharpening. Edge sharpening avoids emphasizing noise or other artifacts. In addition, edge sharpening holds up better if an image is resized slightly—which is often an unavoidable occurrence when image files are put into page layouts. The best technique for edge sharpening is to use one of the many variations of combining the Photoshop high-pass filter with an overlay, hard light, soft light, or linear light-blending mode. A nice advantage of this method is that it requires a duplicate layer, which makes the process

nondestructive and infinitely adjustable by tweaking the opacity of the high pass layer. This technique also allows for adding a layer mask to prevent some areas from being sharpened or to minimize selective sharpening.

We found one of the most succinct and best explanations of the sharpening tools in Camera Raw and Lightroom in *The Ultimate Workshop* by Schewe and Evening.

When judging sharpening for print, the image should be viewed at 50% or even 25% (if is a very large image), and not at 100%. Viewing at 50% gives a much better approximation of the actual effect of the sharpening, whereas 100% view will be largely misleading. Appropriate sharpness is definitely a subjective decision. Our advice is to try many techniques until you find one that gives good results and is repeatable. Keep a record of what you like best so that you do not have to re-create this part of the wheel each time. Remember that different output devices as well as different substrates may each require very different approaches and levels of output sharpening.

REPRO-READY, BUT UNSIZED, RGB OR CMYK IMAGE FILES WITH NO OUTPUT SHARPENING

When the final size for an image is unknown, it is best practice to submit the file without output sharpening. This is a very common delivery category since information about final size can be hard to come by. All the file preparation outlined above is carried out with the exception of sizing and sharpening. We've outlined the strategy of delivering sets of files at varying sizes, but this requires more work and uses up more delivery bandwidth, so it may not be practical for large numbers of files. In addition, the image

receiver may prefer to resize the files and do the output sharpening. If the delivery format is TIFF or PSD, these files can be delivered with a sharpening layer. The layer should be labeled to indicate that it is a sharpening layer. This method allows the image receiver to flatten the file, retaining the sharpening, as long as the image is not drastically resampled. Alternatively, the reciever can discard the layer and redo the sharpening if the resample requires different sharpening.

The Importance and Need for Documentation

Take the extra time to include a Read Me file explaining the state you have left the file in.

Be as specific as possible about the sharpening and any other parameter that you even think may impact the end result. Include this information as a Read Me file, and if you deliver it in person or by any of the snail mail options, always print it out and include with the job. Regardless of delivery method, also e-mail the Read Me file. Assumptions and guesswork almost always lead to unhappiness, frustration, and greater cost in money and time.

Batch-Processed RGB Files

Shooting raw files and delivering batch-processed RGB, either JPEG or TIFF, is the next best option in terms of controlling image appearance and quality. So much control is now available in PIEware that, for many images, additional work in Photoshop is optional or not needed. As a result, we've expanded our definition of master file to include raw or DNG files that have been adjusted in PIEware. Once the PIEwork

has been done, all that is required is to export the raw or DNG to standard format (TIFF or JPEG), and deliver it. It's even possible to sharpen for output via PIEware.

The Workflow Options dialogue box in Camera Raw now has "Sharpen for Output" options. Output sharpening uses similar algorithms to what is used in the capture sharpen controls in Camera Raw and Lightroom. These are based on PhotoKit Sharpener, with a little more punch from Thomas Knoll.

CMYK conversion is not supported yet, but most photographers prefer to deliver RGB files anyway. If you convert raw to DNG, you can take advantage of the full-size embedded JPEG preview option and copy out the JPEGs with applications such as Expressions Media or PhotoMechanic. These JPEGs are the equiv-

alent of quality 7 Photoshop JPEGs and are tagged with the sRGB profile. Batch-processed image files will likely need to be resized by the image receiver, which means that they will need to provide the output sharpening.

Camera JPEG or TIFF

Since PIEware can be used to adjust JPEG and TIFF (although not with as much latitude as with raw), camera JPEGs or TIFFs can be adjusted and batch optimized. The caveat is that these files will need to be re-saved in order for the adjustments to take effect. This is not a problem for TIFF, but re-saving JPEG files does carry a penalty due to recompression. If the resave is done at the minimum compression (maximum quality in Photoshop terms), it is not usually detectable. Best practice is to save a JPEG file as a TIFF, do any

This is the Workflow Options dialogue box in Camera Raw

image editing necessary, and then resave it (Save As, or Save for Web and Devices) as a JPEG.

This can also be done via Image Processor, as described earlier in this section.

Delivering camera capture JPEG or TIFF is the next step down in terms of control, but not necessarily quality. If the camera has been set up correctly, the exposure and the white balance are accurate, camera-generated JPEGs or TIFFs can be high-quality files. Getting perfect white balance is difficult, however, and while turning camera sharpening off is recommended to keep image destruction to a minimum, it does mean that the images that are made with cameras using low-pass filters will need to be sharpened and re-saved in order to appear sharp when displayed or reproduced.

When delivering capture JPEG or TIFF files, you will need to verify that the correct color profile tag has been embedded in the image files. Progress has been made; particularly since the DCF 2.0 EXIF specification was released in 2003, which added Adobe RGB (1998) to sRGB as supported camera-embedded tags. Newer professional cameras allow the choice of either sRGB or Adobe RGB (1998), and the image files will be appropriately tagged. Older cameras and many point and shoot cameras still require the user to assign the correct profile. This can be done in a variety of software, although in some applications this requires re-saving the file. The best method is to use one of the downloader applications that we mentioned in the Ingestion section that can embed the appropriate profile during ingestion.

RENDERED DELIVERY FILE FORMATS

Rendered file delivery formats are usually JPEG, TIFF, or rarely Photoshop (PSD). PDF format can be used for image files, although its main use is for files that contain both vector and raster data, such as those from page layout programs such as InDesign and QuarkX-Press. One feature of PDF is that it supports password protection, although this feature has limited real-world functionality. Some publishers and service bureaus specify EPS (encapsulated postscript) as a preferred format, but we recommend that you only use this delivery format if it is specifically requested. Some museums have standardized on JPEG 2000 due to its enhanced feature set, which includes improved lossy as well as completely lossless compression. JPEG 2000 is not widely supported by Web browsers and is generally not used in the professional photographic, print, or design community.

Standard JPEG is probably the most common delivery format because it takes up much less space on delivery media and uses less bandwidth for electronic delivery. JPEGs saved at the least compression or maximum quality, however you wish to express it, are visually indistinguishable from uncompressed TIFF files. Standard JPEG format has several important caveats when compared to TIFF. These do not impact their usefulness as a delivery format as long as these features are understood. The fact that JPEG files can be very highly compressed means that it is easy to introduce visual and completely destructive image artifacts if the Photoshop save quality drops below 6 (on a sliding scale of 12). Different applications and even Photoshop Save for Web and Devices use different scales, which can be confusing. The best rule of thumb is to not go below the midpoint of any JPEG save scale if it can be avoided. Quality 8 on a scale of 12 is the minimum that should be used for delivery files. If you think there is any chance that delivery JPEGs will be altered and re-saved as JPEGs, it is best to save at quality 12. It is a good plan to explain in a delivery memo or delivery Read Me file that

JPEGs should be saved as TIFF or PSD files before any additional work is done on them. This will minimize compression artifacts on re-save (and educate the uninformed) and will allow the use of layers and other Photoshop features.

TIFF is probably the second most common delivery format after JPEG. Many design directors and publishers prefer it because it is an uncompressed format and doesn't lose any quality with multiple saves. TIFF also has the advantage of supporting greater bit depth and layers. The disadvantage of TIFF is that it is approximately 10 times larger than JPEG. TIFF can be compressed both lossless (LZW) and lossy (ZIP, JPEG). However, LZW compression doesn't result in much size saving (and may actually increase file size for 16-bit TIFFs). ZIP compression results in a slightly smaller file size than LZW, and JPEG compression comes very close to standard JPEG compression size. However, few TIFF readers, other than Photoshop and InDesign, read ZIP or JPEG compressed TIFF files. JPEG compression offers one advantage over simply saving as a JPEG, and that is layers are preserved. JPEG compressed TIFFs do not support 16-bit depth. We recommend delivering compressed versions of TIFF only if they are specifically requested.

PSD, the native Photoshop file, is used more for the creation of rendered master files than as a delivery file format. It supports the complete range of Photoshop features such as multiple layers, adjustment layers, type layers, layer effects, paths, multiple channels, and screening. It is this extreme functionality that makes PSD a good option for master files. PSD's uniqueness has been somewhat diminished now that TIFF and PDF can save everything that can be saved in a PSD file. PSD files can be much larger than TIFF files if "maximize file compatibility" is turned on since this

causes a flattened composite version of the file to be saved as a file within a file. Turning this feature off prevents some applications, Expressions Media, for instance, from showing a layered PSD file as an image file, which is not too useful if you catalog layered master files. We recommend that if PSD is not specifically requested, and it seldom is, using either TIFF or JPEG for delivery. (see Chapter 5, The Image Archive, for recommended master files file formats).

UNRENDERED FILES

DNG Files

Some organizations, such as DISC, which represents the publishing industry, have recommended DNG as a delivery file format. The attraction of DNG is that it is a standardized raw format and can be opened in all Adobe software (and an increasing number of other PIEware), no matter what camera it came from. In addition, DNG files can contain a rendered JPEG file, which gives a correct preview in Adobe software and in many browsers and cataloging applications, preserving the photographer's intentions for the image. On the other hand, DNG can be reinterpreted in supporting PIEware like any raw file. However, any digital image file can be reinterpreted, and raw data is the best data to work with, even compared to 16-bit rendered files. DNG delivery may work well for photographers who want to shoot raw files but don't have the time, inclination, or facilities to do extensive postproduction work.

Raw Files

We do not recommend delivery of proprietary raw files unless they are being given to a trusted partner in the creative production pipeline. Raw files display differently in every PIEware no matter how the camera is set. This means that the interpretation of the images is entirely up to the choice of PIEware and how the

PIEware is configured. For instance, Camera Raw can be set up to auto adjust the main image controls: exposure, recovery, fill light, blacks, brightness, and contrast. The results may be good, or they may not be so good. The take-away is that the photographer's intentions have clearly gone out the window. Some say that delivering raw files is the equivalent of handing over unprocessed film. We would suggest that understates the problem. Film is processed to a standard at least, whereas there is no standard for how raw files are processed. Delivering raw files is definitely dependent on the kindness of strangers; their knowledge base, their skill set and skill level, and even their taste with regard to how they think images should look.

Metadata

Ideally, the IPTC metadata was embedded in or attached to camera files during ingestion. More metadata may have been added during editing. If nothing has been done to strip metadata during processing or master file creation, it should be intact in the derivative files. If images were copied to a new canvass in the process of making master files, the metadata will have been stripped. In this case, the metadata should be re-embedded. All delivery files should have basic IPTC metadata embedded in them—which is at least copyright and contact information. The copyright status field should indicate that the images are copyrighted. This is the minimum.

PLUS metadata is an emerging standard that describes picture-licensing terms, organizing all rights-related fields into a standardized metadata framework. This is accomplished via the PLUS Media Summary code, an alphanumeric string representing all of the media rights included in an image license. These codes, in combination with an Internet database that is under development (the PLUS registry), will link images to rights holders. This database will contain updated versions of licenses, allowing users to match images to available licensing options. The PLUS glossary of licensing terms allows precise, multilingual communication of the media usage offered. Although gaining some acceptance, there is still no file info panel dedicated to showing PLUS information. For the time being, PLUS codes can be inserted into the instructions or rights usage terms fields.

We recommend that you take the time to drop the delivery file folder into Adobe Bridge, or another file browser that reads metadata, to double check that the IPTC data is intact and complete. It's also a good idea to educate image receivers about metadata: how to view it and how to use it as an organizational tool. Check out www.photometadata.org and controlled vocabulary.com for useful information. Currently, too many users of digital photography depend exclusively on the 31 file name characters to provide information about digital images. Not only does this result in unwieldy filenames, but it also leads to renaming files, a leading cause of miscommunication with regard to file delivery. To counteract this possibility, we recommend putting the file name into the title field of the metadata. This makes it easy to determine the original file name if someone changes it.

Delivery files do not necessarily need to have EXIF data (camera data) in them. Many photographers prefer to strip out the camera data and leave the IPTC metadata. Photographers who are delivering to news organizations, however, may be instructed to keep the camera data intact for verification purposes.

DELIVERY MEDIA

Today's technology provides many ways to deliver image files. The possibilities are as follows:

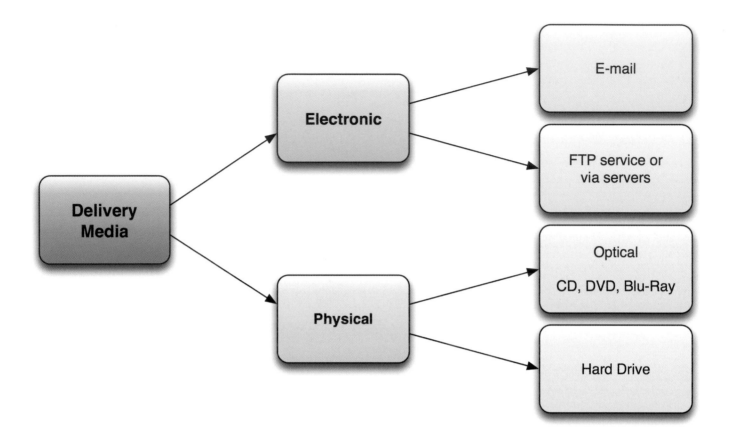

- Electronic delivery
 - E-mail
 - FTP delivery services
 - FTP to and from a file server
- Physical delivery
 - Optical media: CD, DVD, or Blu-ray
 - Hard drive

Electronic Delivery

Electronic delivery is attractive for its speed, low cost, and immediacy. Image files can typically be delivered nearly as quickly as they can be burned to optical media if you have fast broadband upload speeds. The downside is that there are limits on the size of the delivery and it is dependent on good bandwidth on both ends. There is also the slight possibility of file corruption if some of the bits don't get reassembled correctly. Electronic delivery also depends on the image receiver having a reasonable color management setup. Unless they have profiled monitors, they may not see the same color and tone you assume they do.

E-mail delivery has the smallest capacity—often 10 MB or less—so it is only good for a few image files

at a time. Folders of files can be sent by e-mail if they are compressed (zipped) using WinZip or Stuffit utilities. There are many FTP delivery services, such as YouSendIt, that make sending large files or large numbers of files quite easy. They often incorporate lossless ZIP compression, which improves uploa, and download speeds. FTP can also be used to place files on a file server. All that is required is an FTP application such as FileZilla, Fetch, Transmit, and space on a server to park the files. As mentioned earlier in the proofing chapter, Internet services such as Collages.net, Photoshelter.com, and Smugmug.com, among others, can be used as file servers in addition to their other scrviccs.

Electronic delivery of high-volume, large file size can be very time consuming, even with good bandwidth. Do keep in mind that sometimes it is simply more efficient to burn the files to disk and to use any of the mail options available to us.

Physical Delivery

Physical delivery is often preferred because it provides the image receiver with an archive. It is sometimes used as a backup to electronic delivery for that very reason. Physical delivery also allows for the delivery of printed proofs or CMYK guideprints, as well as any Read Me files, instructions printed out as well as burned to disk. This alleviates the concern of purely electronic delivery being totally dependent on profiled monitors on the receiving end.

CDs can hold up to 750 MB of data. We recommend using only CD-R and not CD-RW since CD-R writes faster and cannot be overwritten. DVD-R holds up to 4.7 GB of data, making them more useful for larger file delivery needs. Dual-sided and double-layer DVDs are also available but have the drawbacks of slower write times, are not backwardly compatible with older CD/

DVD reader/writers, are much more expensive, and are more delicate.

A concern for physical delivery is cross-platform compatibility. CDs should be written in a format that allows them to be read on both Mac and PC. This is simply an option to select in the CD burning software. DVDs are compatible with both platforms. Hard drives are usually formatted either for Mac or for PC, since the two platforms have different file systems. If a hard drive needs to be compatible with both platforms, it can be formatted with the Windows FAT32 format since both platforms can read and write to this file system. On the Mac this formatting option is listed as MS-DOS (FAT) in the Disk Utility.

Hard drives used for file delivery should ideally feature Firewire connectivity, although it is increasingly common for portable drives to have multiple connectivity. Another development is that the smaller 2.5-inch drives that are used in laptop computers and the so-called pocket drives are up to, and probably surpassing, 500 GB by the time you read this. These small drives are usually designed to withstand shock better than 3.5-inch drives since they are designed for use in portable devices. They are also smaller and have lighter shipping weight.

Although hard drives are definitely the highest capacity media for file delivery, they are the most expensive option. They can also be overwritten, so they are less secure than write-once optical media.

DELIVERY PAPERWORK: THE READ ME FILE

Just as good transmittal paperwork is required for film delivery, a transmittal Read Me file should accompany every digital file delivery. This can be an

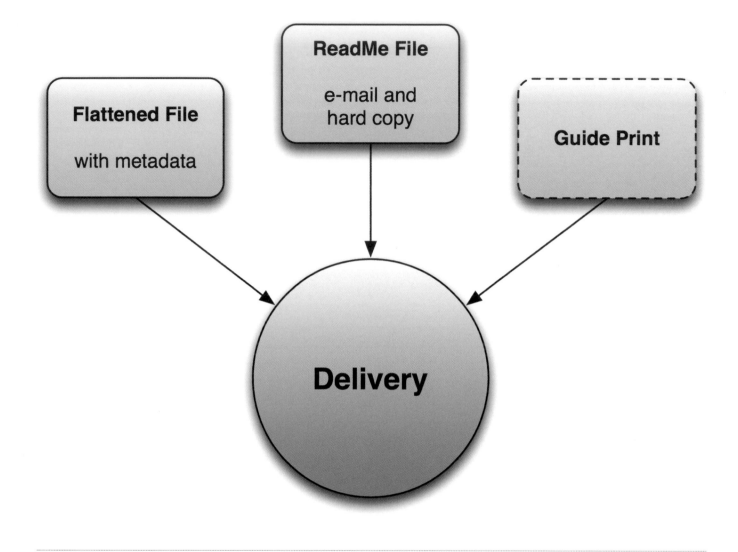

The elements above should be included in every delivery or hand-off. The Guide Print is optional, but we highly encourage you to include one whenever possible.

RTF format or MSWord document that describes the number of files, the file format, color space (and whether or not the profile is embedded), the file characteristics, such as the bit-depth, whether the files are layered, and whether they have been sharp- ened for output. There should be a statement indicat- ing whether the files are copyrighted and to whom, as well as the rights usage and licensing terms. It is best to include this document where it can be easily deciphered on the delivery disc. This information can

Press & Web JPEGs...

There are 2 types of files on this disc:

1. **Press JPEGs** are 300ppi JPEGs in Adobe (1998) colorspace. They have been sharpened for halftone printing.

2. **Web JPEGs** are 100ppi JPEGs in the sRGB colorspace. They have been sharpened for web use.

For accurate color be sure to preserve the embedded profile when opening in Photoshop.

The files may need to be sharpened slightly if they are resized by more than 20%.

For more information about digital file handling visit: www.UPDIG.org

Richard Anderson Photography
410-532-7470
www.rnaphoto.com

This is an example of a Read Me file accompanying delivery files for a theater production. It describes the two types of files on the disk and how they should be handled.

also be printed on inkjet or light-scribe writable CD or DVD media. It is not a good idea to use adhesive labels on CD/DVD media because labels can separate during use, potentially jamming the CD/DVD reader. An adhesive label can be put on delivery hard drives.

We recommend adding Read Me files, printing them whenever possible for delivery with the media. When sending work electronically, these important communication documents should be included with the image files and then sent in a follow-up e-mail.

© Patricia Russotti

It's a Wrap

"Things don't change. You change your way of looking, that's all."

—*CARLOS CASTANEDA*

Okay, we have provided quite a load of information. It's a lot to take in, and you really shouldn't expect to fully wrap your head around all of it with one read. You may want to "chunk it down" (one of Patti's favorite metaphors) into bite-sized and digestible pieces. As you get comfortable with each section of the various workflows, test and stretch them, try to break them, and decide how to use them to your best advantage based on how you get your own work done. Our hope is that you will use this information to help you develop a workflow or series of workflows that match your needs for various projects and clients.

In addition to the book, we also have a Website on the latest developments in imaging and workflow, tutorials, articles, and rich media downloads: www.dpBestflow.org.

Good shooting, and may all your workflows end well!

Richard Anderson

The Importance of Ergonomics

"It is only the wisest and the stupidest that do not change."

—CONFUCIUS

TAKE CARE OF YOUR BODY

Consider ergonomics as a fundamental element in your workflow. The goal should be to determine and establish a working environment that promotes safety and increases productivity.

Throughout this book we talk a lot about the life cycle of an image. While we want you to develop and maintain an efficient, coherent workflow, it means nothing if you physically can't work. Consequently, we decided to use this opportunity to proselytize the importance of ergonomics.

Our bodies need to be tended to in order to do the work we want. Computers, now a standard tool for imaging and all life matters, present a list of issues that many of us never thought about at the beginning of our careers. We retro-ites can still remember the days of working in darkrooms with no ventilation. Not only that, it seemed that everyone smoked—yes, in the darkrooms and studios. Life then was a constant mingling of toxins. Who knew we should wear gloves before sticking our hands in big trays of chemistry for batch processing or while we mixed emulsions to then coat on a variety of substrates? Now that we can be out of toxic chemical environments, we need to focus on the one thing we can control: how we use our bodies. Posture, movement, and taking the time to set up a functional, ergonomically correct work environment are critical to our working life cycle.

Our goal is to get your attention and make you mindful about ergonomics. Hopefully, you will do the research and find the solution that works best

for you. There are many choices and options out there now, and remember that what works best for one person may not be a solution for you. You need to test drive the choices for a good fit. We have included a series of links that will give you many specifics about equipment and safety.

Here is our list of key ergonomic "must dos"

- Use common sense.
- Ensure that the top of your monitor is at eye level and directly centered in front of you.
- Position the monitor at arm's length in front of you.
- Check that the level of your desk is approximately at your belly button.
- Have your elbows fall at a 90-degree angle, slightly below the desk surface, when you type. Ideally, your arm should be supported from fingertip to elbow.
- Make sure your chair armrests are level with your keyboard.
- Keep your feet flat on the floor.

Two examples of what not to do.

Example of utilizing a dropped keyboard

A much better solution—a dropped keyboard and a pressure-sensitive tablet

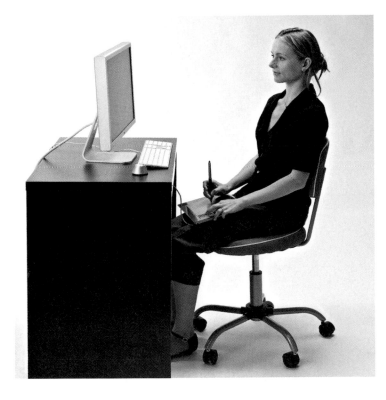

A pressure-sensitive tablet can be used on the desk itself or the drop-down portion where you would have the keyboard. The buttons on the side of the tablet can be programmed to save you from needing to mouse or in place of key commands.

This is an example of using the tablet in your lap, forcing you to sit back into the chair to support your back and keep your feet flat on the floor.

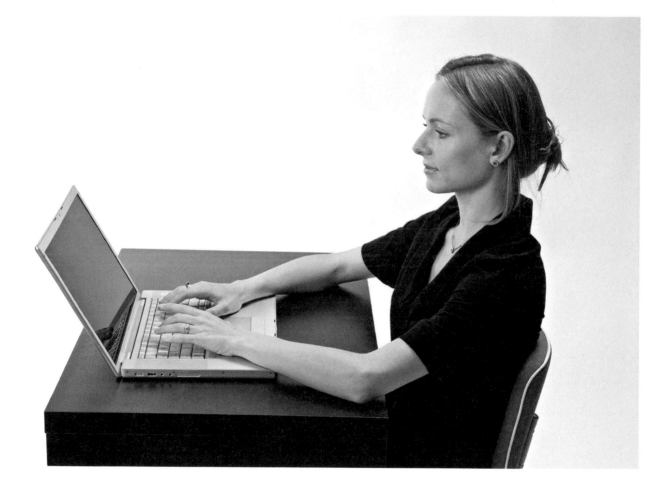

Notice that the model is looking down on the laptop; eventually, this will cause neck and spine pain.

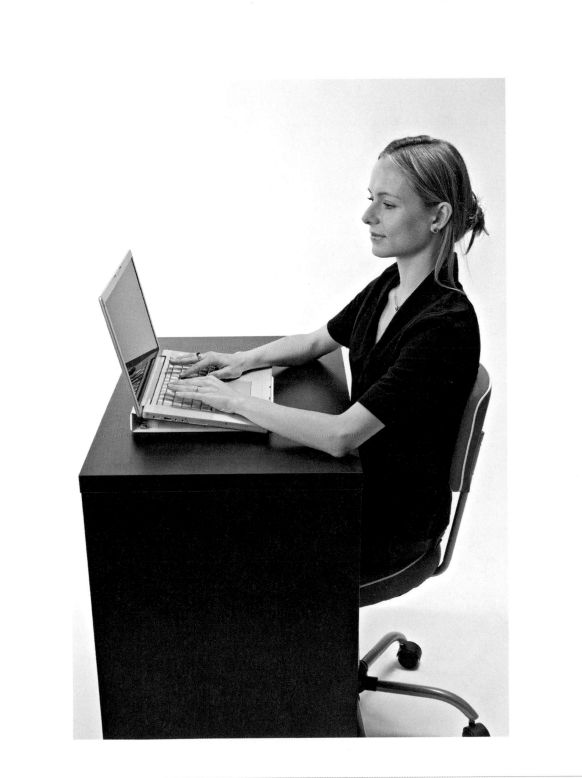

An easy solution is to prop up the laptop with something as simple as a three-ring binder

Other Considerations

Chairs come in different sizes. Depending on your height and size, you may need a chair with a longer seat length. This one change can make a huge difference in your leg comfort—where does the end of the chair line up with your leg, and is that comfortable for you?

If you sit cross legged or with one leg crossed over the other, be sure that your back is straight and that you have proper support for your spine.

Some of us like to work standing up or to have that option during a work session. Adjustable height work surfaces are available, as well as chairs and stools that will move with the table height. www.anthro.com is a good place to look for this option.

Ahh, you have two or maybe three monitors? Most ergonomic sites do not address this conundrum for us. Depending on your setup, you will need to play with keyboard position, pressure-sensitive tablet, angle and position of monitors, as well as have an easily movable, and adjustable chair.

Sit in front of your monitors and ask yourself:

- **What is the pattern you use for moving your head?**
- **Does the current setup force you to angle your head and neck?**
- **What is the relationship between your back, spine, neck, and head movements?**
- **Then add your keyboard, mouse, and pressure-sensitive tablet.**
- **Pay attention to your movements and how you feel after a long work session.**
- **Adjust elements until you can work without pain, twinges, and annoyance**

- **Some have keyboards that drop down from their desk. These allow for height adjustability, depending on the kind of work you are doing.**

Best Practice Habits to Form and Keep

These Best Practices truly will make you much healthier and more productive:

Develop the art and habit of pushing yourself away from your monitor

Blink your eyes, shift focus, refocus—do this frequently

Stand up, stretch, walk around a bit, and then begin working again. This will improve your circulation, get your blood flowing, and refresh the energy to your brain.

Pay attention—be mindful and conscious of what positions you are in and how it is impacting your body.

Have difficulty remembering to take a break? Simple. Automate the reminder. Use one of the many electronic devices that surround us and set an alarm of some kind to remind you to blink, stretch, get some air, etc. Apps abound for Ipods, cell phones, computers.

Planes, Trains, and Automobiles

Working in the field, on location, airports, planes, trains, and automobiles, and hotels or wherever you can open your laptop, can pose serious risks and potential problems. Awareness is the most important element. Pay attention to your body and become aware of what causes you to hurt, a little or all over, and then do whatever you can to remedy the problem.

Prop up your laptop with any object that keeps the machine safe and also prevents you from hurting any part of your body.

Pay attention—as soon as you feel something (not an hour or day later)—change the position. Stop what you are doing.

Use and apply common sense.

Ever notice how warm that laptop can become? Do you really want that much heat on your lap for extended periods of time? The heat it generates impacts the performance of your CPU as well as your body parts. Something to think about!

We recommend that you invest in

- A really good chair that fits your body, one with armrests and movable wrist supports whenever possible. Shop, sit in many kinds of chairs, notice how all parts of your body feel.

- Consider armrests for the chair. Many come with one arm that moves with your hand and supports your wrist.

- A pressure-sensitive tablet. This is one of the best investments you can make! Not only does it make many of the tools you use in PIEware and Photoshop more powerful, but it gives you enormous flexibility for posture options. Of course, you may also want to consider a Cintiq by Wacom; be aware: once you work on one, it is highly habit forming

- An ergonomic wireless mouse.

- Ambient lighting that does not conflict with your studio monitors. See the color management section for more details on this.

- Prop-up objects (notebooks, boxes, adjustable rolley carts, etc.) for laptop use in the studio, on the road, on location, at your favorite coffee shop. Review the list above to be sure the height and angle are good for your body.

Summary

- Take breaks—stand up, stretch, and walk around; this will revive your body and give you a better perspective as you work.

- Breathe—this calms you down, helps to clear your head and focus on the task at hand, makes you more efficient and productive.

- Invest in your body's health. Its priority level should be higher than purchasing more RAM, disk space, speedy CPUs, and the latest camera.

- Most important, pay attention to what your body is saying. Know your bodies' weak points. Be smart and treat it well; it is the only one you have, and you need it to cooperate and collaborate with you for a long and happy imaging life.

- Take care of your body.

A good compromise

LINKS TO CHECK

http://working-well.org/

www.anthro.com

www.askergoworks.com

http://lapworks.net/

http://dohs.ors.od.nih.gov/ergo_computers.htm

http://www.usernomics.com/

http://www.pcmag.com/article2/0,2817,2345859,00.asp

http://www.osha.gov/SLTC/etools/computerworkstations/index.HTML

http://www.ehrs.upenn.edu/programs/occupat/ergo/computer/default.htm

http://gadgetwise.blogs.nytimes.com/2009/05/11/how-to-make-your-own-ergonomic-computer-workstation/

http://www.webmd.com/infertility-and-reproduction/news/20041208/laptop-computers-may-affect-male-fertility

http://www.synergoarts.org/files/Synergo-Arts_in-Fiberarts-magazine.pdf

This is a PDF on ergonomics for weavers; it is nicely done and has some good reminders in it for all artists.

http://www.wacom.com/index2.php

Index